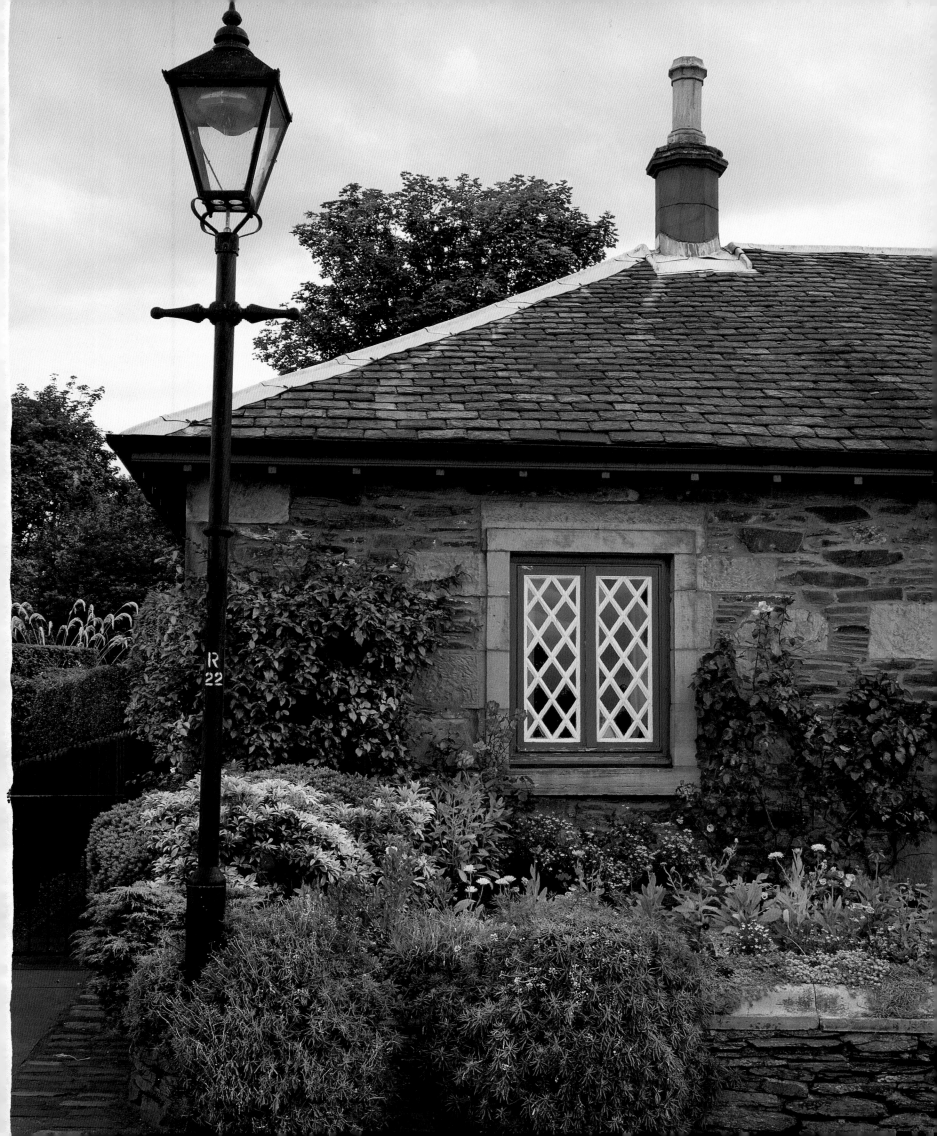

The Most Beautiful

WITH 295 ILLUSTRATIONS IN COLOR

Thames & Hudson

HUGH PALMER

Villages of Scotland

Acknowledgments

Half-title page
Luss, Dunbartonshire.

Title pages
*Catacol, near Lochranza,
Isle of Arran.*

Opposite
Moniaive, Dumfriesshire
(above); *Strathpeffer, Ross and
Cromarty* (centre); *Lochranza,
Isle of Arran* (below).

Scotland is an extremely welcoming country, and tiring journeys from the South were always forgotten the moment I arrived over the border. In particular, thanks are due to the helpful staff of the National Trust for Scotland, and to Sharon Makepeace of VisitScotland's Press Office.

My wife's mother, Rosemary Jameson Wheler, came from a family that originated in Shetland, a fact that was not uncovered during her lifetime. She always loved to visit Scotland, though, especially in the company of her daughter, and this book is dedicated to her memory.

© 2004 Thames & Hudson Ltd, London
Text & photographs © 2004 Hugh Palmer

First published in hardcover in the United States of America in 2004 by Thames & Hudson Inc., 500 Fifth Avenue, New York, New York 10110

thamesandhudsonusa.com

Library of Congress Catalog Card Number
2004100246
ISBN 0-500-51164-0

Printed and bound in Singapore by C. S. Graphics

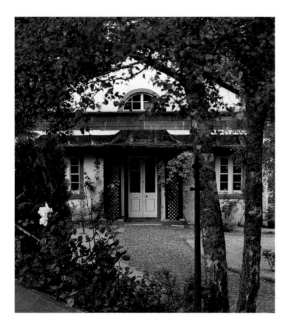

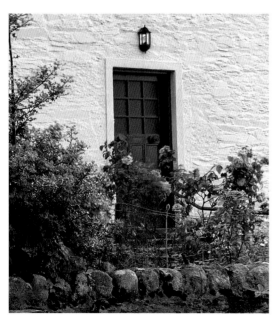

INTRODUCTION

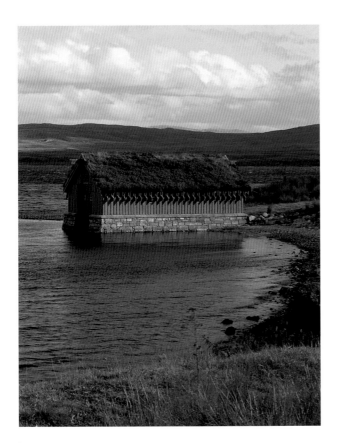

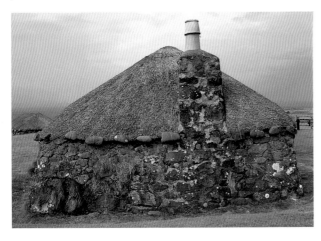

Traditional village buildings are now carefully restored and preserved: at Tongue, Sutherland (top); a crofter's 'blackhouse' on the Isle of Skye (above). Oban harbour (opposite) is the starting-point for most visits to the villages of the Western Isles.

To explore the villages of Scotland and their often dramatic settings is also to be aware that many of them were endowed with their individual characteristics by a turbulent past, curiously at one with the wild beauty of the landscape. Parts of the Highlands, for instance, can sometimes seem like a tempestuous sea, from which the vertical markers of ancient tower-houses rise up like lighthouses. These were indeed beacons of security for the clans, whose local lairds were often their only guarantors of security. For much of Scotland's unsettled history, there was no clear succession of head of state, often no clear state, and certainly no centralized framework of law and order. In practice, power was in the hands of the local chieftain; and in a society that was more patriarchal than feudal, loyalty to the clan was all-important. As well as conducting bloody campaigns against their rivals, clan chieftains often sought and gained immense political power. By the fifteenth century, for instance, the head of Clan Donald could style himself the Lord of the Isles; all the islands of the west were in his control, as well as large tracts of the mainland. He could enter into intrigues with an English king, Edward IV, before his power was finally broken by James IV of Scotland, who confiscated most of his lands.

South, in the Lowlands, the milder terrain of the Border hills was still the scene of recurrent wars and cross-border raids. The fertility of the land could improve the odds of sustaining life, but defence against sudden attack was still important. Canonbie, very close to the English border in the so-called 'Debatable Land', did not grow up on the banks of the river Esk merely because there was a crossing-place nearby; it also lay in the protective shadow of the castle headquarters of the raider-chieftain Johnnie Armstrong.

Other villages grew up later, in more secure times, along with the thriving wool trade. Their income was often boosted by a busy cottage industry of weaving, which goes on to this day in the

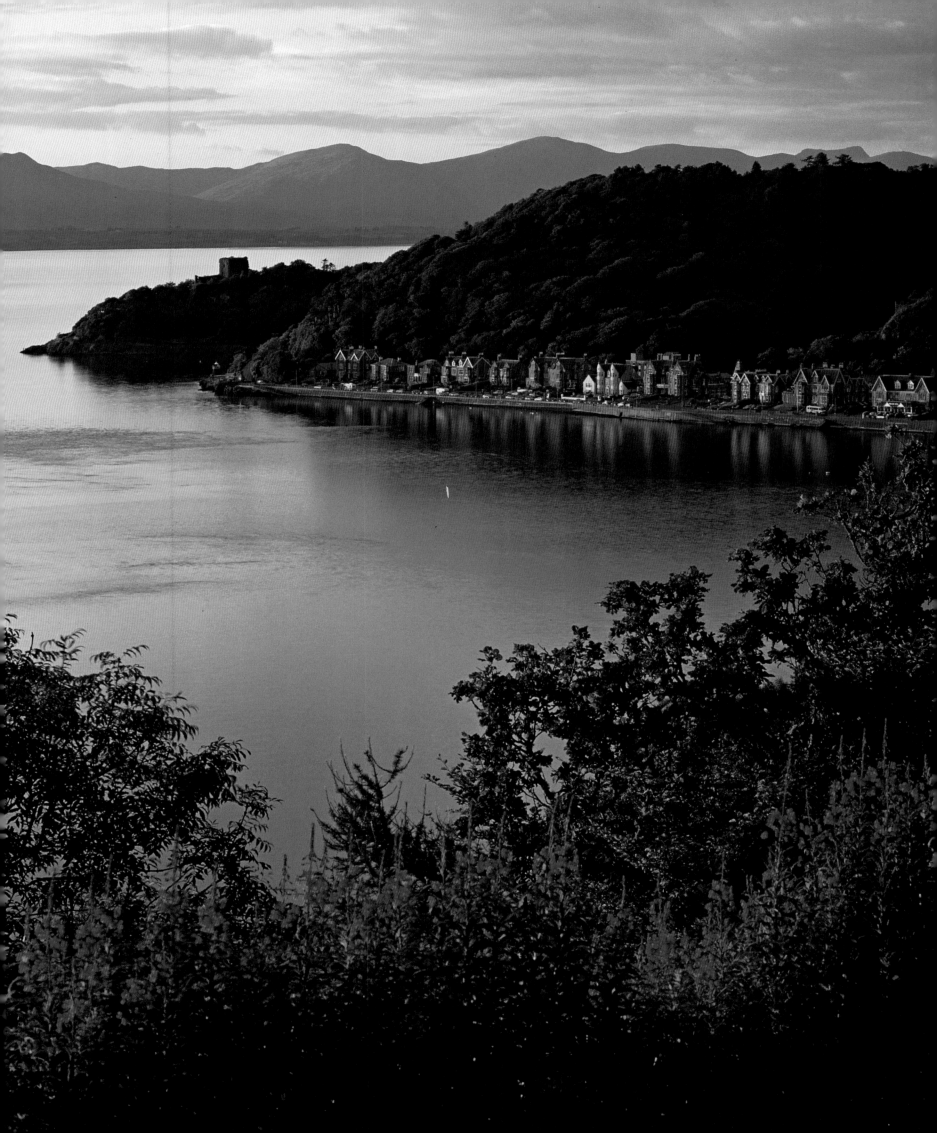

In spite of substantial changes to Scottish villages during recent decades, some things have an enduring quality: home-weaving on Shetland (top), *and two of the famously maned Shetland ponies* (above).

Roxburghshire village of Denholm. Sometimes it was the whim of an improving landowner, following the eighteenth-century vogue for planned villages, who provided communities with their first decently habitable cottages. Along the coast, fishing villages like St. Abbs and Auchmithie were marked by the struggle to live off the erratic harvest of the frequently unforgiving sea. In both these cases, generations of villagers launched and landed their craft on dangerous shores, until the philanthropy of sympathetic landlords provided them with a stone-built harbour and a secure haven.

Further north, the discovery of natural resources sometimes initiated a rapid rise to prosperity. In the case of the ancient burgh of Culross, on the north coast of the Forth estuary, the sixteenth-century entrepreneur George Bruce brought wealth to the place after taking over the local coal-mine from the monks of Culross Abbey. His engineering feats won him royal approval and a knighthood, and enough personal wealth to build himself a miniature palace. This now stands, wonderfully restored, in the jewel-box perfection of the present-day village. A visionary on a larger scale was the equally dynamic Edinburgh banker, David Dale. He saw the potential of another source of energy in the flow of the river Clyde and, at the very dawn of the Industrial Revolution, created a mill-town run on co-operative lines, which endured as a social experiment and prospered as a business for over a century. Sadly, New Lanark's commitment to the welfare of its workers was the exception rather than the rule: for many of the thousands who, willingly or otherwise, left the Highlands for the new factories of the Clyde, living and working conditions were extremely grim.

Life in the north continued to be a precarious business for many. An incisive account of the challenges facing the people of the remoter parts of Scotland can be read in Samuel Johnson's *Journey to the Western Islands*, the record of his travels with James Boswell in 1773. Although offering as idiosyncratic a view as one would expect, Johnson was moved by a compassionate curiosity to discover the habits, outlook and prospects of those who eked out a hard living on the land. He was writing at the very time when, although

a period of peace had been ushered in by the Act of Union between England and Scotland at the beginning of the century, the traditional clan-based way of life was starting to disintegrate, and what he termed the 'epidemick desire of wandering' was beginning to take hold. Johnson was critical of the strict new laws, forbidding the carrying of arms and even the wearing of Highland dress, that attempted to break the clan tradition, and with it the possibility of future rebellions. 'To hinder insurrection, by driving away the people, and to govern peaceably, by having no subjects, is an expedient that argues no great profundity of politicks', he observed acidly.

The term 'croft' was coming into use at about the same time, to denote the portion of land granted to each tenant, with the right to graze on land held in common with fellow crofters. It was when estates changed hands or were inherited by southern-educated young aristocrats with only a pecuniary interest in their land, however, that increasing pressure began to be felt by the crofters. As had been discovered in England and the Lowlands, sheep farming was a far more profitable use of land, even of marginal land, and once the flocks of sheep were brought in, the enforced eviction of the crofters began. Emigration, to an often equally wretched existence in Canada and Australia, reached huge proportions. The Highland Clearances, which reached their peak in the eighteen-thirties, resulted in terrible hardship and much actual starvation for the displaced population; on the more remote islands the situation was worse than anywhere else. The Clearances were so extreme in their effect on Skye, the character of the islanders so fiercely independent and resentful of the often brutal evictions, that troops had to be sent over from the mainland to quell the resulting riots. A Royal Commission was eventually set up by Gladstone, and in 1886 the Crofters Act was passed, at last giving security of tenure at a fair, controlled rent.

Nowadays, the future of crofting is protected by an active political body, the Crofting Commission, and there is a long waiting-list for the opportunity to take up a tenancy, and to buy the land, now the right of each crofter. The crofts can rarely produce enough food to

*V*illage crafts and practices have undergone revivals in a society newly conscious of their value; hand-knitting continues on Shetland to produce the prized woollen wares of the islands (top); and the fearsome-looking Highland cattle are still the unmistakable face of Scottish farming (above).

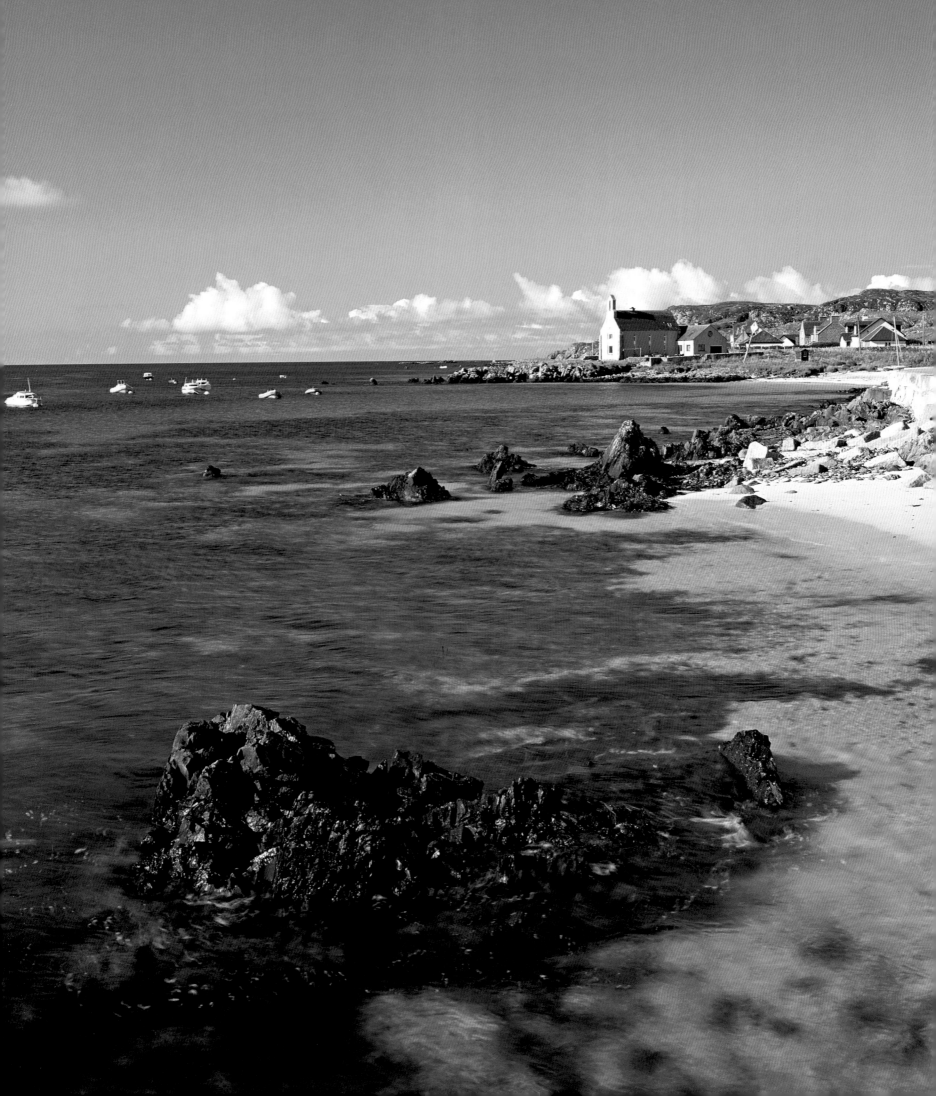

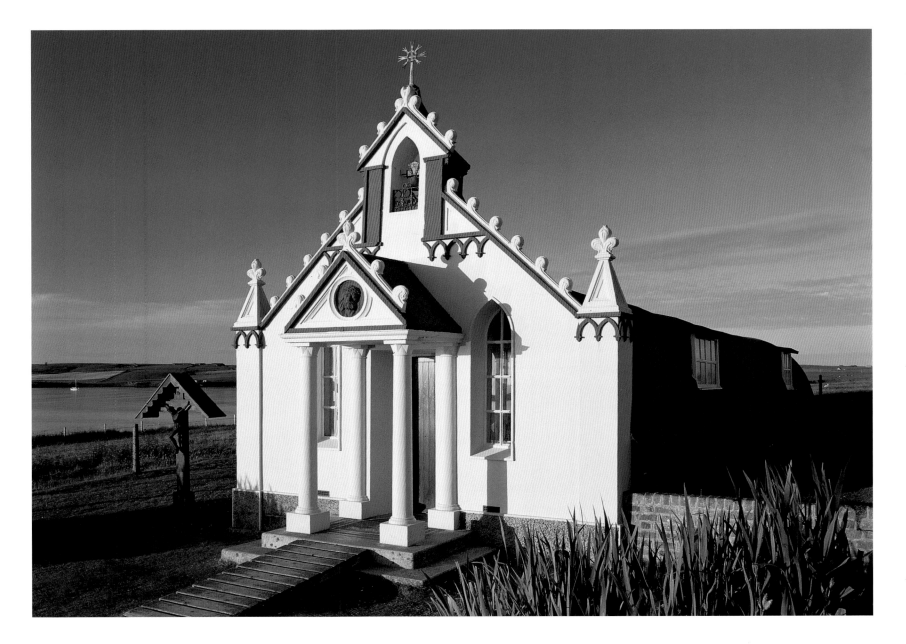

enable true self-sufficiency, so the tradition continues that each crofter diversifies in whichever direction talent or opportunity makes possible. This engaging mixture helps to make the crofting villages, although sometimes scattered geographically, extremely cohesive communities, with member families relying on each other for shared skills and support.

The more remote villages of the country are much less cut-off than they used to be. Improved communications have meant that visitors seeking to escape from urban crowds and noise can quickly find as much peace and solitude as they need. New roads have meant that the countryside can be much more quickly appreciated than was the case for Doctor Johnson, astride his diminutive pony: 'We were now long enough acquainted with hills and heather to have lost the emotion that they once raised, whether pleasing or painful, and had our minds employed only on our own fatigue.'

*R*eligious traditions of varying kinds have left their imprint on the Scottish villages, especially those of the Islands. Iona (opposite) has been considered one of Europe's most holy places for centuries. A touching outpost of the Catholic faith is the entirely unexpected form of the chapel at Lamb Holm, Orkney, fashioned from a nissen hut by Italian prisoners-of-war (above).

LOWLANDS

The comparatively mild climate enjoyed by parts of the Lowlands has meant that many a cottage garden flourishes in the villages (above). And even on the east coast, the Victorian resort of North Berwick (opposite) could rejoice in the title of 'Biarritz of the North'.

The border between England and Scotland was first defined by the occupying Romans. Not that the latter's attempts to seal off the unruly northern tribesmen by building walls lasted for long, but they did leave behind them a cultural divide between the 'civilized' peoples to the south, and the *barbari* to the north, based only on the fact that while the former bowed to imperial rule, the latter did not care to follow suit. This helped to set the pattern of an uneasy relationship that continued for many centuries.

The Borders are where much of the fighting took place, and even if nation was not at war with nation, there were constant turf wars between raider-chieftains as they attempted to assert control over the often lawless region. Despite this violent past, the Lowlands contain some of the most beautiful and serene landscapes to be found in Britain. The ocean-like swell of their spacious hills rolls across from the North Sea coast towards the quiet corners of Galloway, tucked away out of harm's way to the south-west. Quiet villages dot the countryside, while palatial mansions and the majestic ruins of once-great abbeys rise out of fertile valleys.

The tight 'waist' that pinches Scotland in, between the Clyde and Forth estuaries, places her two great cities surprisingly close to each other. Glasgow, having seen its great industrial boom come and go, is now brushed clean of the accumulated grime and squalor of those years of runaway expansion, and squares up amicably enough to its traditional adversary, Edinburgh. The capital's longer-established 'cultural' identity was also built on its brisk commercial acumen, as witnessed by the preserved mills of Dean Village right at its centre.

The great estuary of the Forth, once famous for its collieries, still has some enormous industrial sites, some functioning, some abandoned. They dwarf the remnants of the ancient kingdom of Fife and such hidden treasures as the village of Culross, with its own immaculately restored merchants' houses, also built on the profits from coal, first exploited by the monks of its ancient abbey.

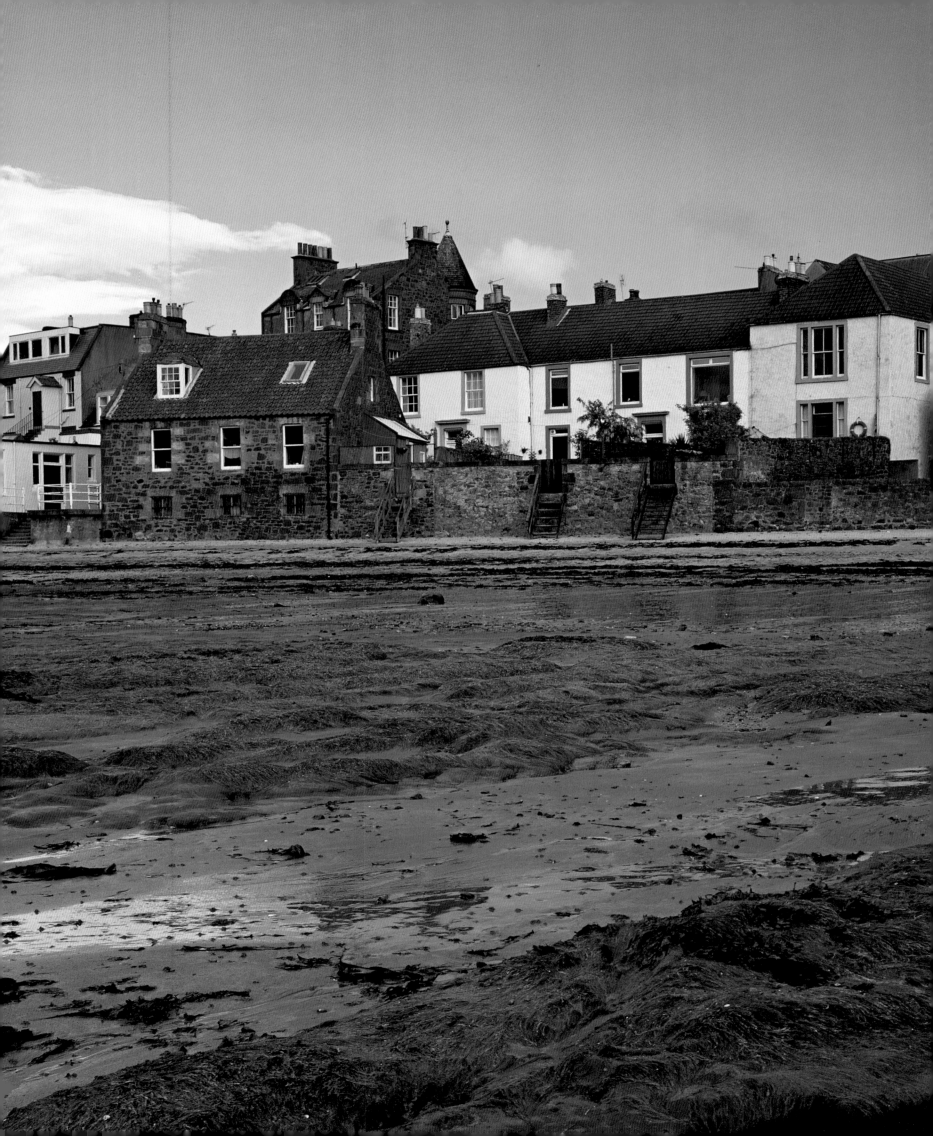

Though lacking the more extreme landscapes of the Highlands, the Lowlands are equally spectacular in their more muted way. Their rivers and waterways pass through some of the most dramatic scenery in Scotland, like that around Endrick Water, Stirlingshire (above). Fine houses abound in breathtakingly picturesque settings: here, Castle Campbell, Clackmannanshire (right), rises above the village of Dollar to look out towards the Firth of Forth and the distant Pentland Hills.

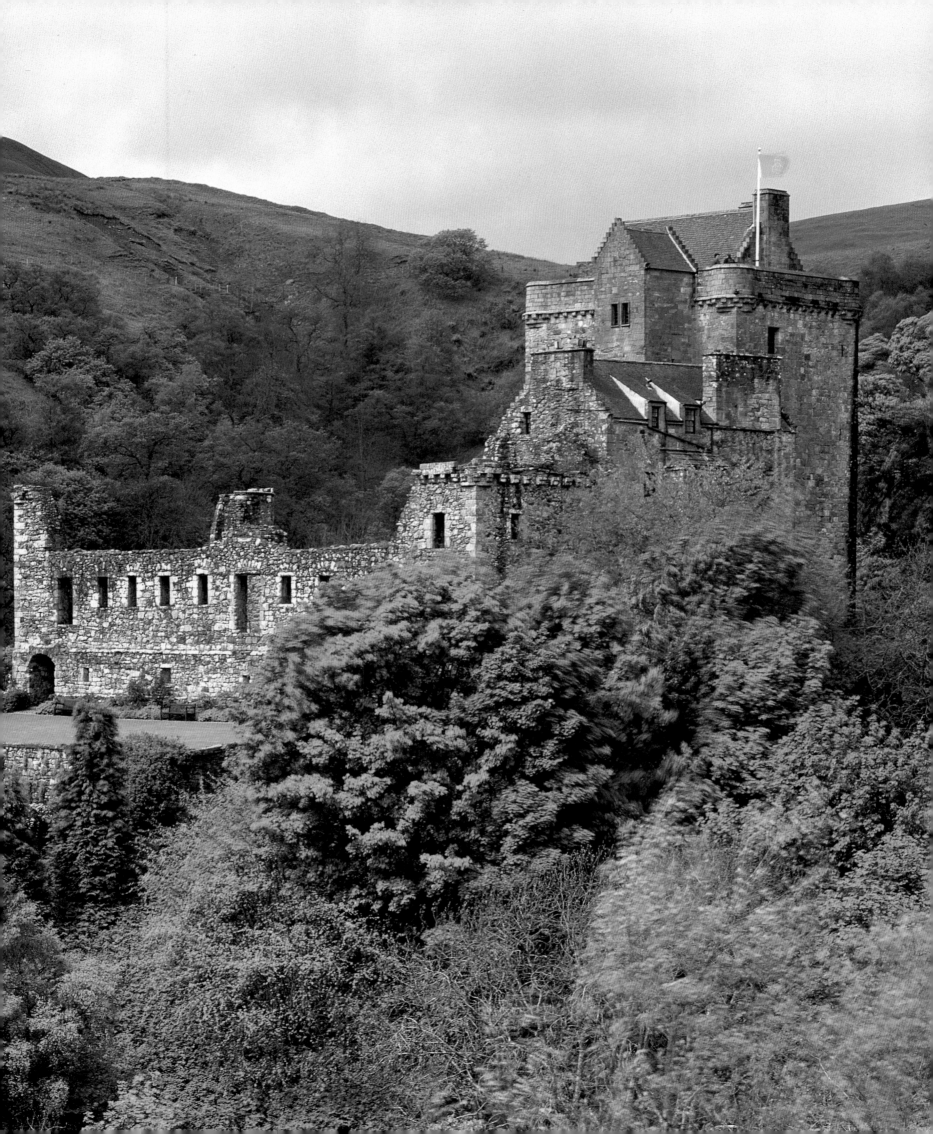

Canonbie

DUMFRIESSHIRE

CANONBIE IS A QUIET VILLAGE THESE DAYS; very
little traffic uses its stone bridge to cross the river Esk
now that the main A7 runs along a bypass to the west.
Only a few hundred souls currently live there, but a
splendid, disproportionately large Victorian parish
church dominates the peaceful scene from an
eminence on the far side of the river. So deep is the
sense of peace that it is hard to imagine that the name
of this valley was once a byword for mayhem and
anarchy; indeed, the area was known as the Debatable
Land until the Anglo-Scottish border was settled in
1552, and continued to be marked as such on maps
as late as the eighteenth century.

A reminder of those troubled times can still be
seen in the village in the form of a fine pele tower,
which stands on the west bank of the Esk. This is all
that remains of the fortress base of Johnnie Armstrong,
Lord of Gilnockie, one of the most feared and
respected of all the reivers, as the local robber barons
were known. The prolonged dispute between England
and Scotland as to where the border separating them
should actually run, in the absence of any obvious
natural boundaries, created a culture of lawlessness in
the area, which could not be contained by the forces of
law on either side. Chieftains like Armstrong, however,
did provide protection for the local populace, and he

*T*he principal buildings of the village neatly express
*both secular and ecclesiastical power. To the north
lies the Glenockie Tower* (above), *the last fortified
building of the reiver Armstrong. From the west the view
is dominated by the Victorian parish church* (right).

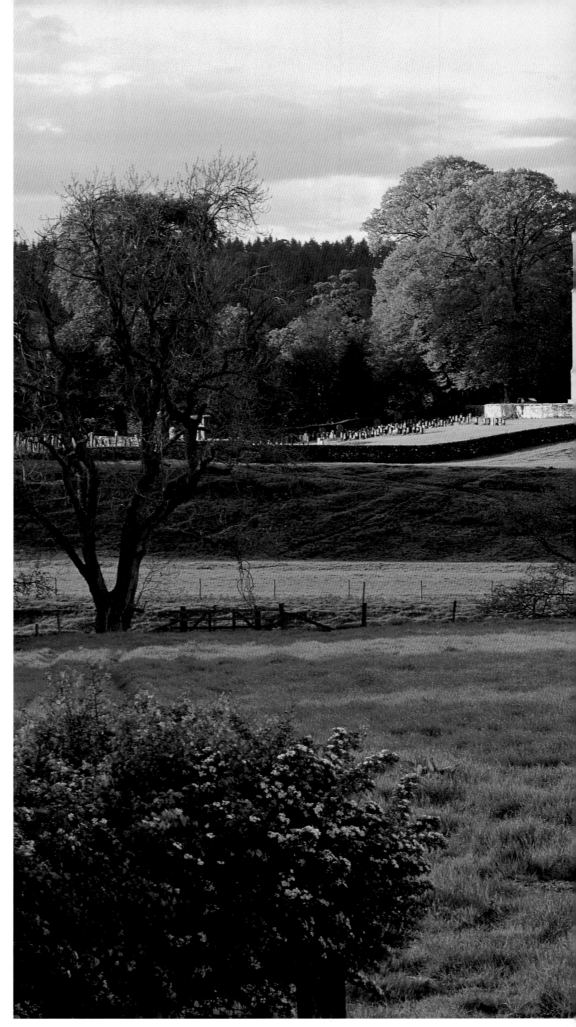

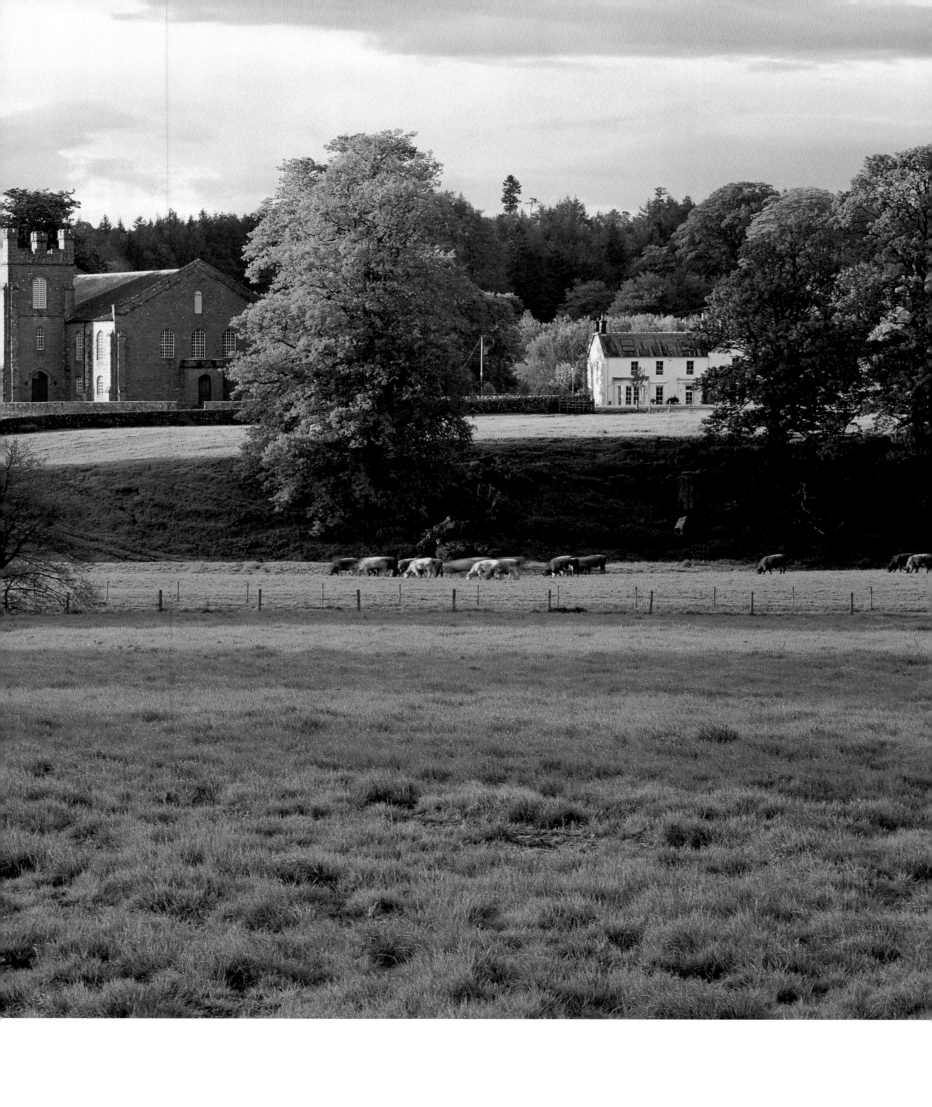

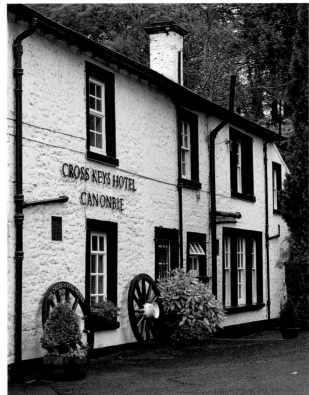

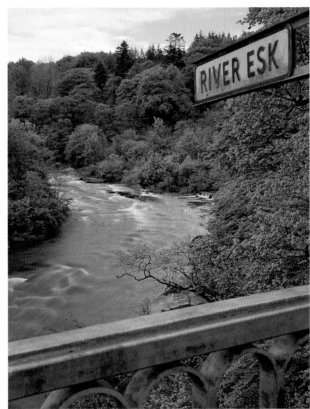

*L*ike many of the villages of the Borders, Canonbie boasts an old coaching inn named The Cross Keys; it was in such hostelries that guards exchanged the keys to the turnpike gates (above right). Other notable landmarks include a 1912 public hall (above), built in red sandstone, and the Gilnockie Bridge (right) which crosses the river Esk close to the site of Johnnie Armstrong's fortified hall.

was much mourned when he met his end in 1531, executed without trial on the orders of the boy king James V. The latter's attempts to bring order to this part of the Borders, where he was deeply unpopular, were a spectacular failure. A large army, despatched south to meet the forces of Henry VIII, his uncle, and commanded by an inexperienced royal favourite, was routed at Solway Moss, just over the border from Canonbie, in spite of being numerically superior.

Almost inevitably, the romantic element in Border brigandry attracted the attention of Sir Walter Scott, who used the folklore of the district as the inspiration for the ballad of Lochinvar in his epic poem, *Marmion*. And there is indeed a Netherby Hall, just a few miles over the Esk, from which the dashing young Scot is said to have swept the bride-to-be off her feet and into his saddle.

The peaceful atmosphere of this village of neat cottages and well-tended gardens (above) makes it hard to believe that these lands were once the scene of lawlessness and anarchy. Even as late as the eighteenth century, this area was marked on maps as the Debatable Land.

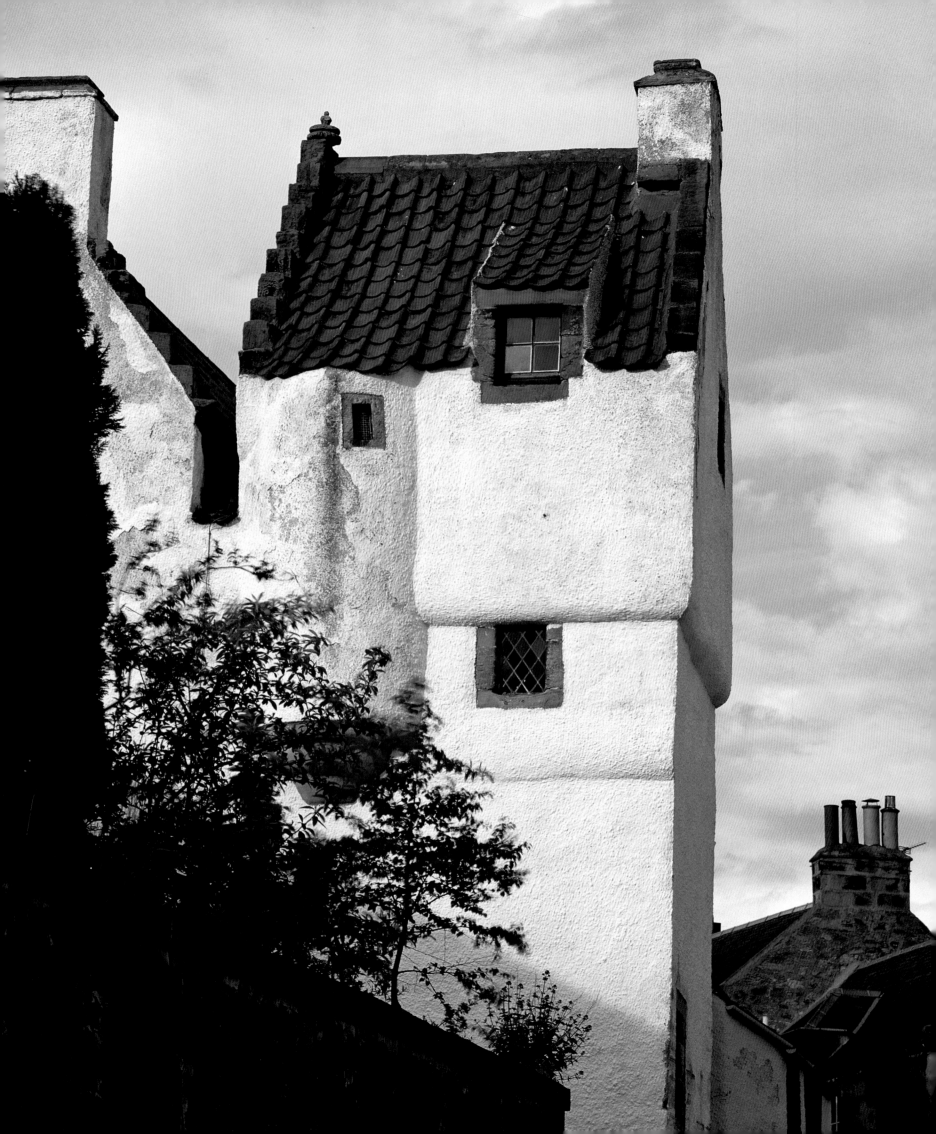

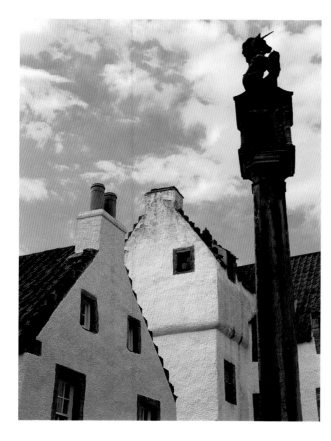

Culross FIFE

Upstream of the road and rail bridges of the Forth crossing, the river opens up again, as the vast petrochemical plant at Grangemouth looms on the southern shore. Opposite, the coast of the ancient kingdom of Fife shows signs of its own industrial past: power-stations, ironworks and collieries, many now fallen into disuse. Tucked away in this occasionally dispiriting landscape is a remarkable survival, a wonderfully preserved and restored sixteenth-century village. There, on the banks of the Forth, a tiny, cobbled market square, dwarfed by the expanse of water that it overlooks, once witnessed a level of trade that made the name of Culross famous throughout Scotland.

The Cistercian monks of Culross Abbey, founded in the thirteenth century, long made use of the plentiful reserves of coal from both banks of the Forth, but they were always defeated by problems of ventilation and drainage when they attempted to venture deeper than eighty feet. In 1575, the abbey granted the colliery's lease to a remarkable entrepreneur, George Bruce. He had travelled widely in Europe and had evidently made himself aware of the many engineering innovations taking place abroad. In the same year, work began on sinking the Moat Pit from an artificial island constructed offshore. The increase in the production of coal came to the notice of James VI, who granted Culross leave to enter the export trade by conferring the status of Royal Burgh on the village.

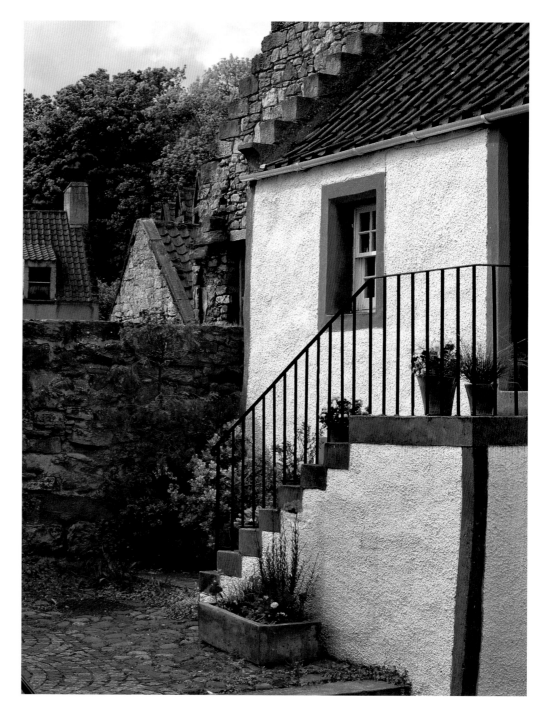

*S*ubstantially restored in the nineteen-thirties, the terraces and lanes of the village are full of architectural eccentricities. The tall house known as 'The Study' (opposite) is said to have been used as a 'study' by a Bishop of Dunblane in the late seventeenth century; the study room at the top has splendid views over the Forth. One characteristic of the old houses (above left) which strikes the visitor are the strangely Dutch-looking gables, an influence due to trade with the Netherlands, when ships would return to Culross with a ballast of Dutch pantiles. The original network of old lanes, or 'wynds', threads a way through quiet courtyards (above) behind the main market square, known as 'The Tron'.

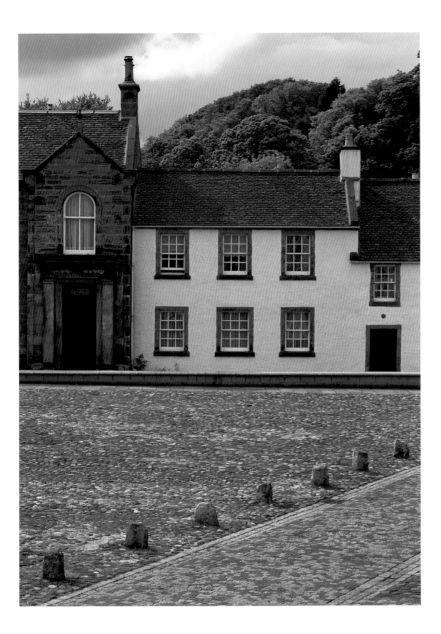

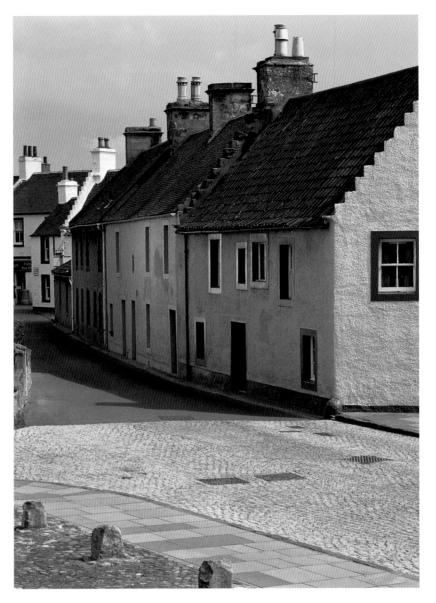

Industries such as salt-panning and iron-founding also boomed. Ships returning from the Low Countries carried Dutch pantiles as ballast, and the distinctive, steeply pitched roofs of the merchants' fine houses, with their crow-step gables, give the network of narrow lanes, or 'wynds', an unmistakably Dutch flavour. A step away from the site of the harbour is the splendid mansion built by Sir George, as Bruce had later become. It is a perfect merchant's house of the period, now resplendent in its original mustard-yellow render. Inside, there are rooms of great stateliness, panelled in wood and painted with allegorical scenes in the Flemish style. It later became known to the locals as Culross Palace, a nickname suitable to the prestige of its first owner, who often entertained his royal protector here. In the year of Sir George's death, 1632, the Moat workings were disastrously flooded, and the fortunes of the place began their decline, which was slow but comprehensive, and the once-proud merchant houses mouldered quietly through the centuries, until in 1932, the newborn National Trust for Scotland used a part of its very first legacy to restore the Palace.

*E*vidence of Culross's past prosperity is ample in the houses around The Tron and along the main street (above left *and* right). *One of the more substantial ones, now known as The Palace* (opposite), *belonged to Sir George Bruce, the entrepreneur who brought prosperity to Culross in the late sixteenth century. Its yellow-ochre façade and Flemish-style interiors have now been carefully restored.*

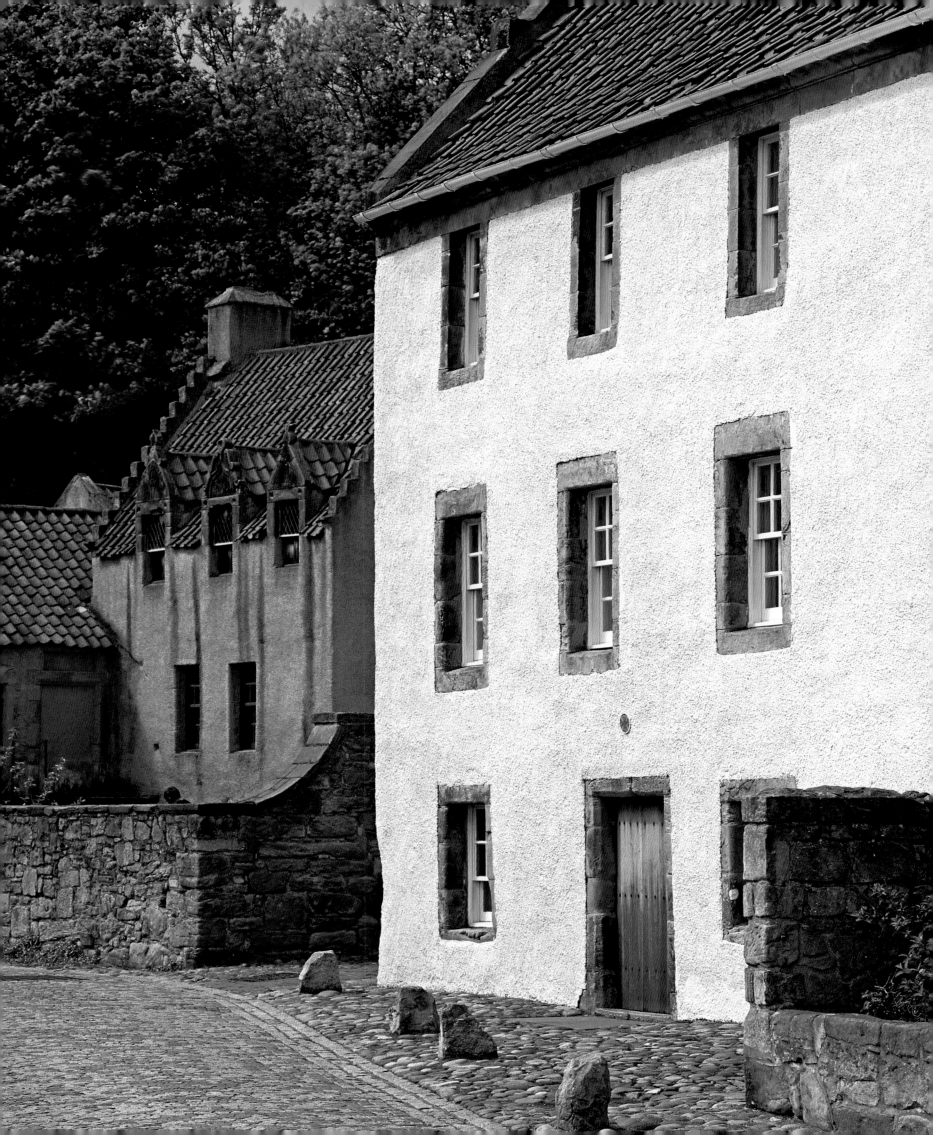

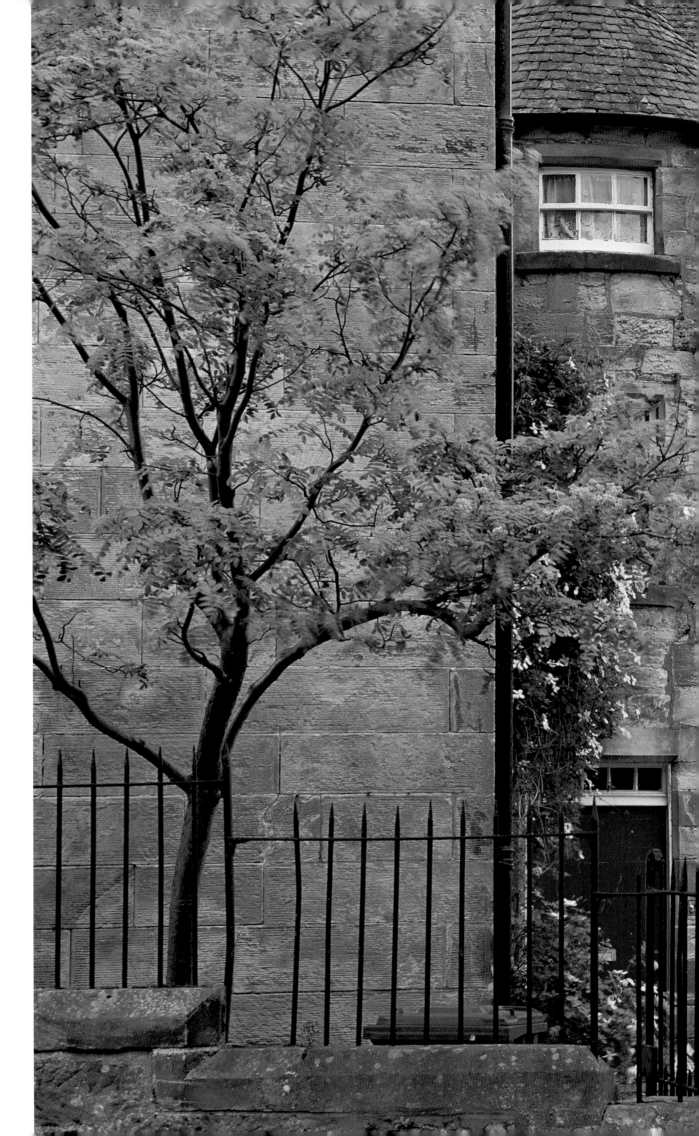

*T*he Manse (right), *yet another
substantial building in Culross,
is oddly baronial in style. It adjoins the
present-day parish church, which itself
adjoins the remains of the famous abbey.*

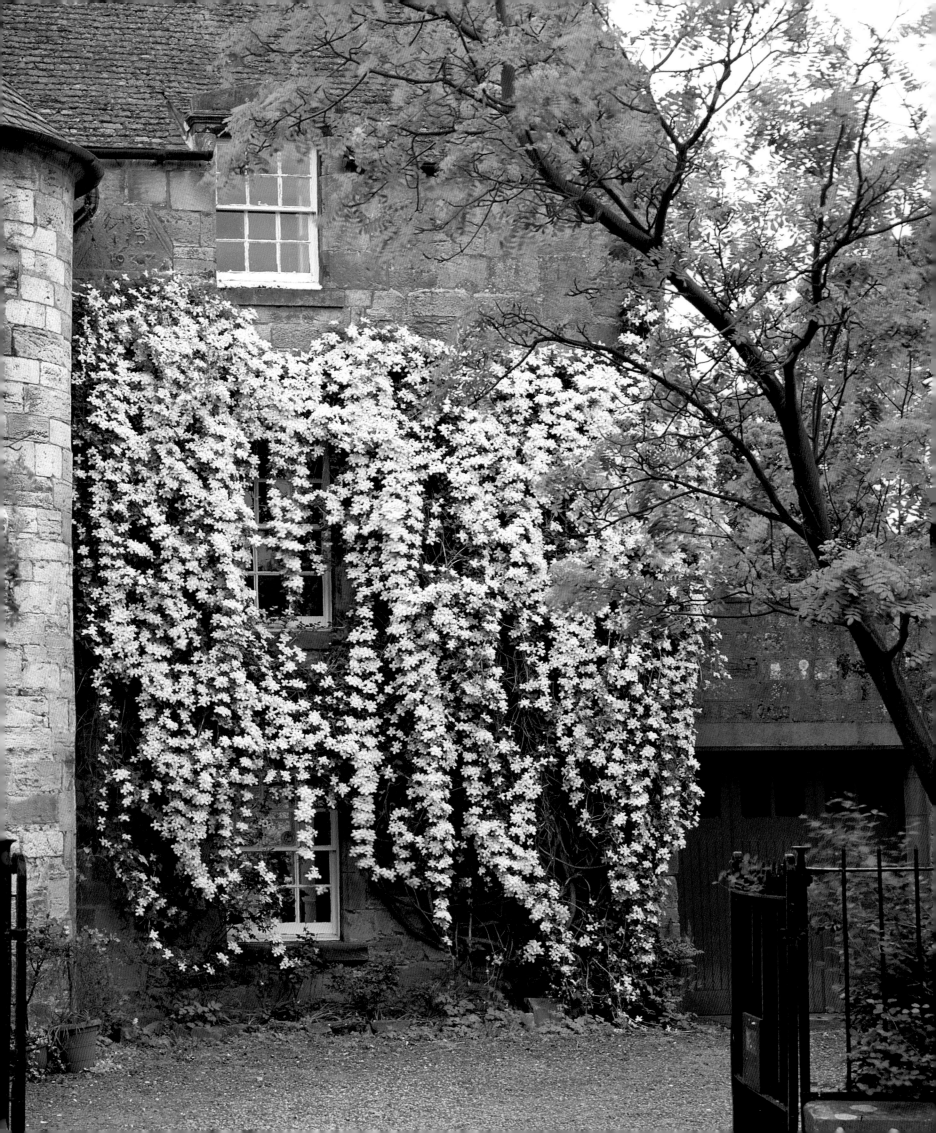

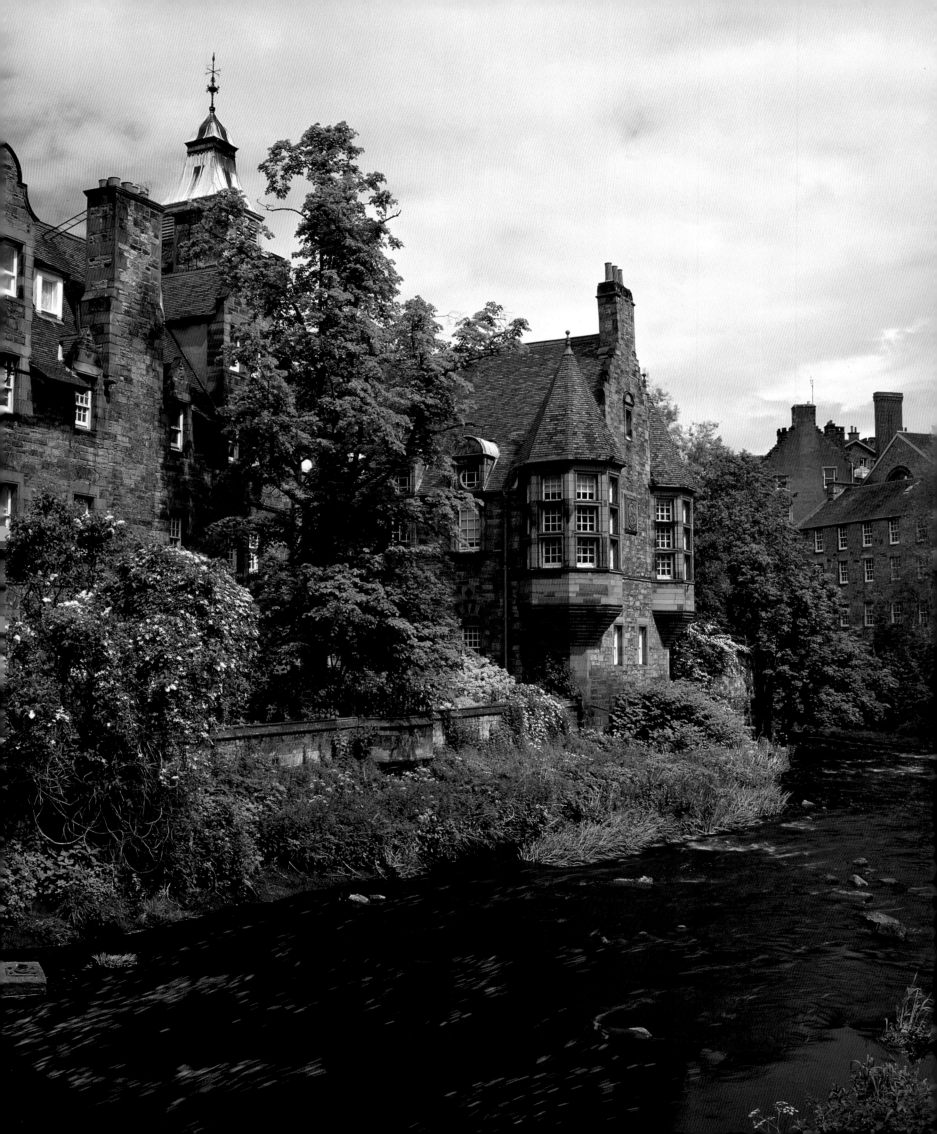

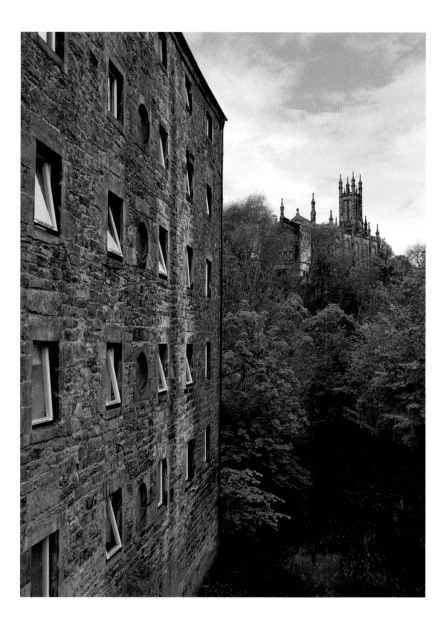

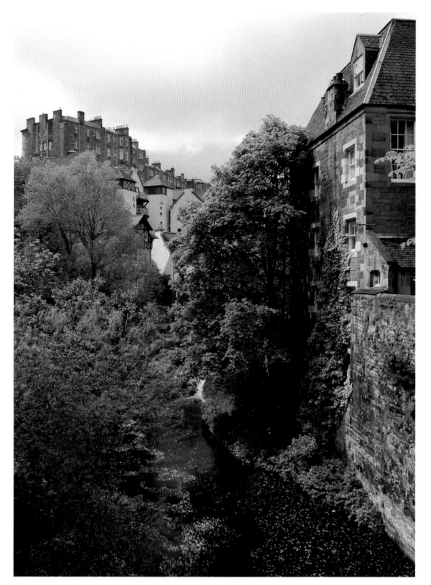

Dean Village MIDLOTHIAN

*O*nce a squalid mill settlement by the Water of Leith, Dean Village has become a remarkable, and very desirable, residential area within a great city. Former tenements and factory buildings now house fashionable apartments, all within a distinctive river environment (opposite *and* above).

EDINBURGH'S FAMOUS NEW TOWN was laid out in the eighteenth century, a fit celebration of the city's mercantile success, as well as of its emerging status as an intellectual centre ('the Athens of the North'). No one can walk through its tree-lined squares and witness the classical perfection of the terraces without being impressed. These are the grand statements to be expected of a true capital city. But just to the west, after the majestic sweeping curves of the later Moray Place and Randolph Crescent, one comes across a curious sight. Look down from the parapet of the Dean Bridge (a monumental piece of eighteen-thirties engineering, designed by Thomas Telford himself); a hundred feet below, a small stream winds between willow trees and a cluster of redbrick mill-houses, one of the tiny settlements absorbed by the city's expansion.

Despite its relatively humble appearance, Dean Village is as much a part of the history of Scotland's capital city as the imposing terraces above it. For the ribbon of water spanned by Telford's bridge is in fact

Edinburgh's principal river; its modest width belies the contribution the Water of Leith has made to the city. Where it enters the Firth of Forth at Leith, just over two miles distant, it offered safe anchorage for shipping for centuries before the present harbour was built. As well as encouraging the flow of goods into the city, the stream also provided the energy for Edinburgh's earliest industrial activities.

In its rushing, twenty-mile journey down from the Pentland Hills, the Water of Leith once supported more than seventy water-mills, which in turn supported a string of mill-villages along its length. The closest of these to Edinburgh was Dean Village, where at one time there were eleven mills providing the flour for all the city's bakeries. Conditions must have been grim for the mill-workers, who were housed in shadowy tenements crammed into the narrow confines of the gorge. Now, the Water of Leith, reborn from its insalubrious past, is a lovingly cherished urban green space, a wildlife corridor where strollers along its

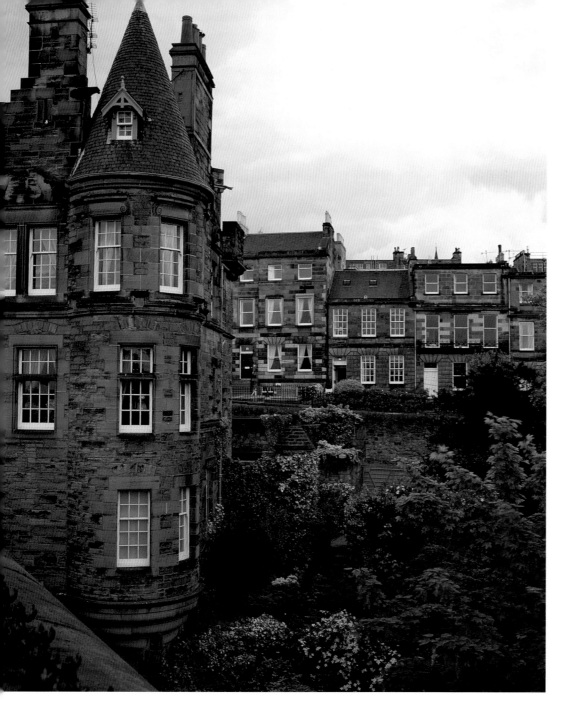

popular walkway can be rewarded by the glimpse of a kingfisher. Its mills, once as dark and satanic as any, have been converted into airy loft spaces, to house a new generation of Edinburgh's merchant classes.

*T*he view from Telford's Dean Bridge (above left) *encompasses the elegant townhouses of Edinburgh's West End. Within the village itself, former tenement courts* (above right) *now form attractive paved spaces between the traditional buildings. Modern developments, too, have come to the village* (opposite), *taking advantage of the pleasant and secluded environment along the banks of the river.*

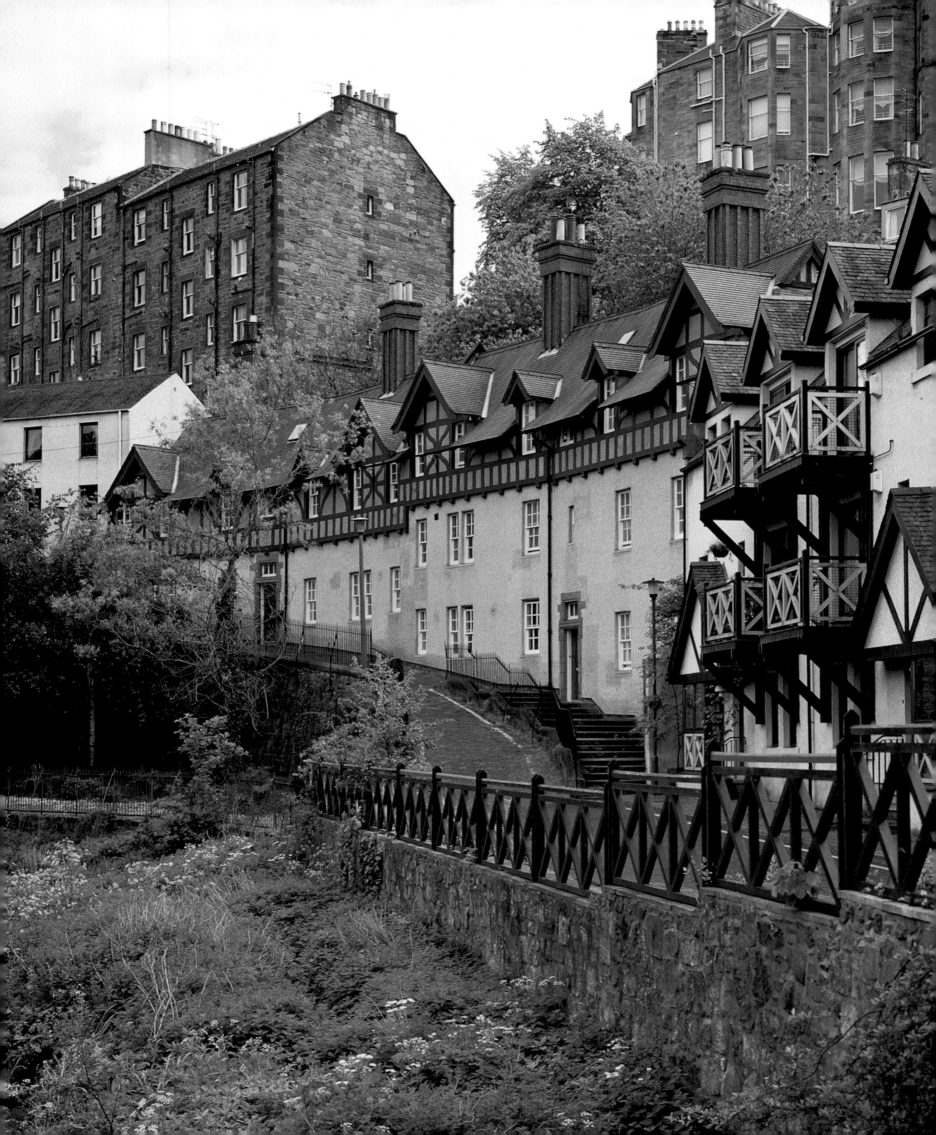

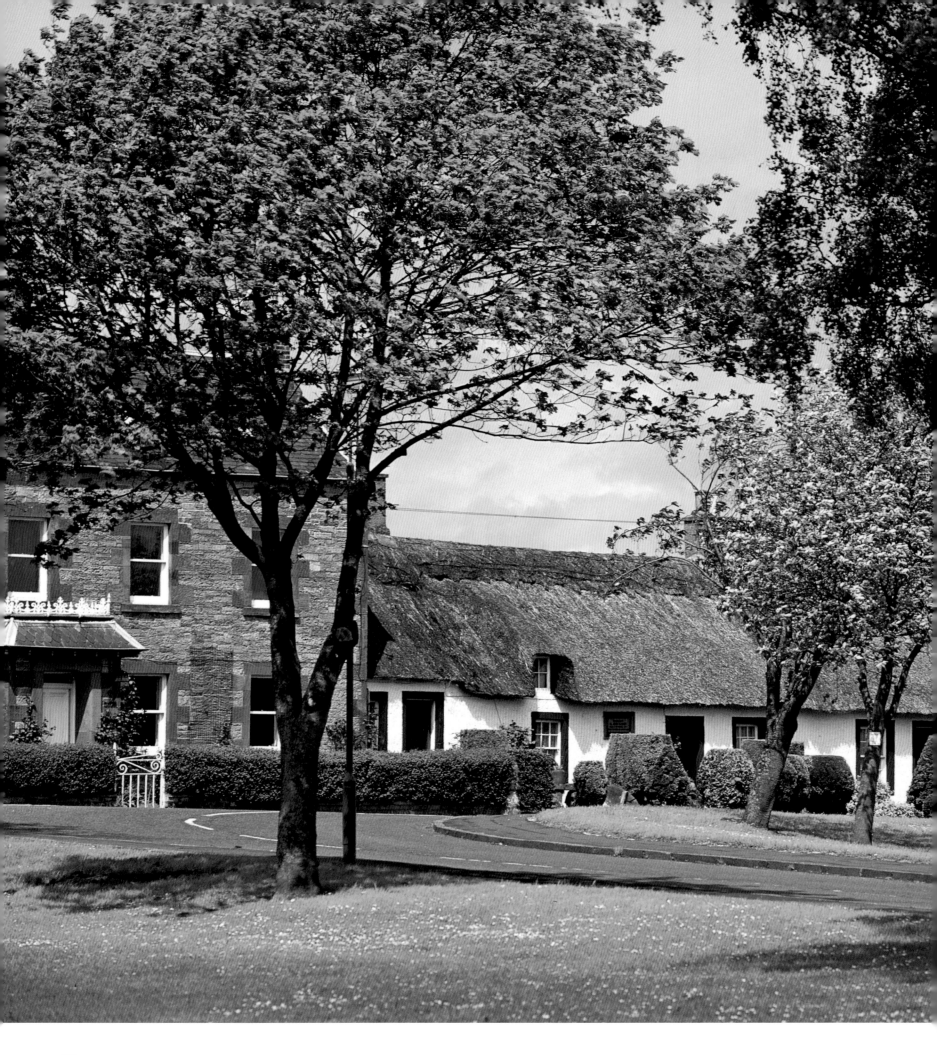

Denholm
ROXBURGHSHIRE

THE RIVER TEVIOT, as it makes its way to meet the better-known Tweed at Kelso, passes through some of the most attractive countryside of the Borders. About half-way along its length, where the narrow valley of the Dean Burn tumbles in from the south, the original hamlet of Denholm grew up haphazardly, like most of the other Teviotdale villages. The first settlement there was burnt to the ground during one of the frequent plundering raids from the English side. In the early years of the more peaceable seventeenth century, the village was rebuilt on its present site.

This is rich sheep-farming country, and for centuries there has been a constant demand for the weaving skills of the residents of Denholm. The local speciality was the production of stockings, which could be made in the workers' homes. Many of the cottages on the Green were built as both workshops and habitations; other, existing houses were converted – all recognizable by their square windows, designed to give optimum light for the stocking frames which were positioned just inside. In 1844 it was reported that as many as eighty-seven of these machines were clattering away in the village. A small designer knitwear factory still operates there, employing more than twenty of the residents.

Another valuable resource was the local stone, which was quarried on the lower slopes of Rubers Law, the volcanic outcrop that rears up to the south of the village. Denholm's sandstone was easier to quarry and easier to work than the harder whinstone found more commonly along Teviotdale. It also has an attractive red colour, which can be seen in many of the houses in the village itself; it was guaranteed a much wider distribution when the railway line to nearby Hassendean was built in 1849. The station, however, was on the wrong side of the Teviot, which meant a long detour for the wagons when the river was high, an inconvenience only remedied when the imposing Teviot bridge, with its sturdy piers, was built in 1864.

Carefully maintained houses line Denholm's Wee Green (left), once the site of a livestock market and later a market garden.

*O*ther houses on Wee Green (above) *adjoin the parish church* (far right), *built in 1845 by the villagers themselves. On the main green of the village stands the monument to locally born John Leyden (1775–1811)* (right); *the son of a shepherd, Leyden went to Edinburgh where he met Walter Scott, with whom he later worked to produce* Minstrelsy of the Scottish Borders. *The spinning traditions of Denholm are recalled in such houses as 'Rosecroft', Dean Road, where the square windows were specifically positioned to illuminate individual looms* (opposite).

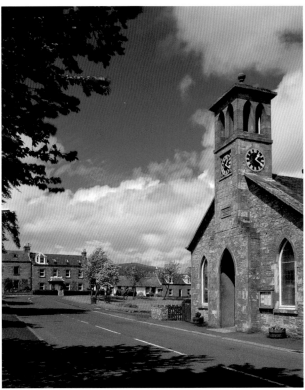

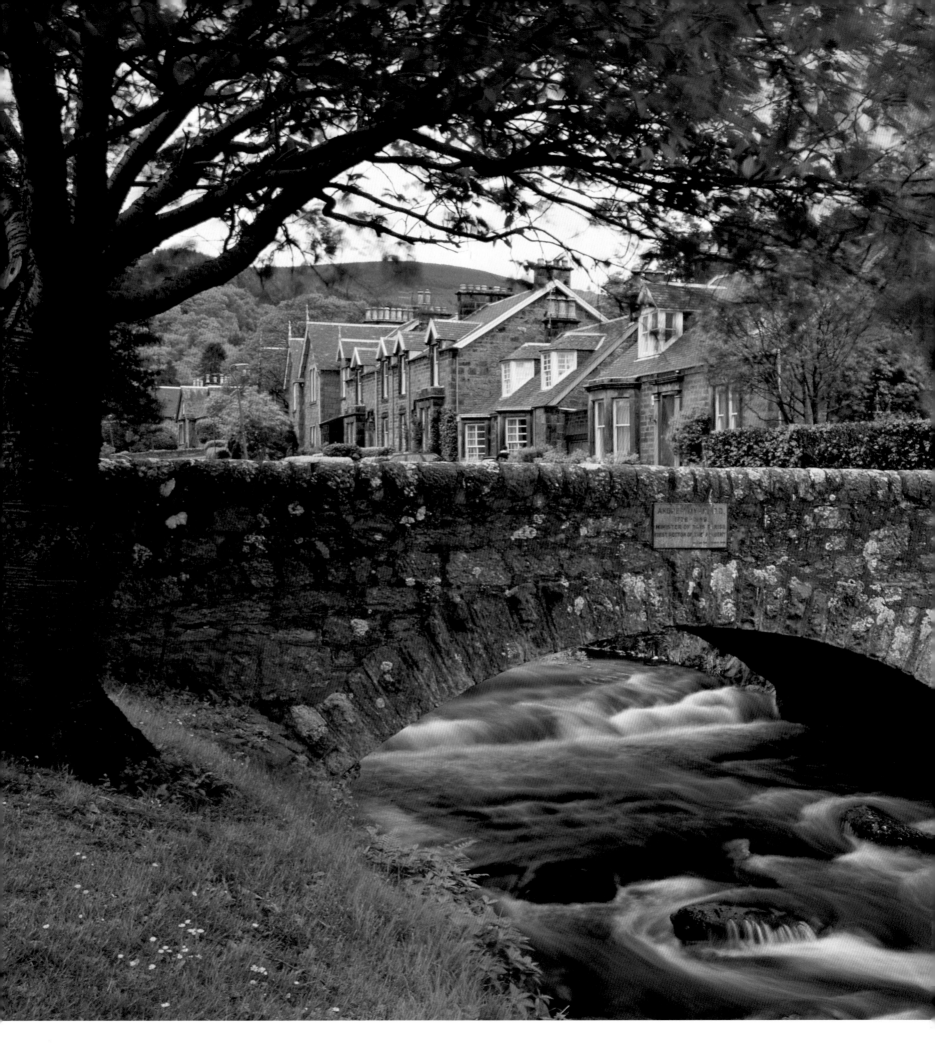

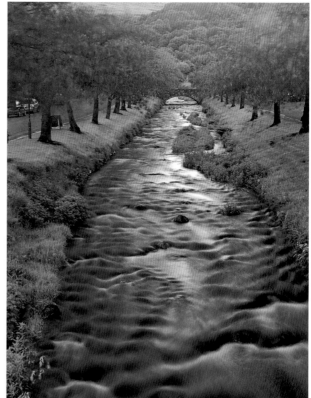

Dollar
CLACKMANNANSHIRE

THE HIGH STREET IN THE VILLAGE OF DOLLAR is hidden away in the old village, where the visitor would least expect to find it. A more obvious candidate for its title is the more recent Bridge Street, a straight, wide thoroughfare, lined with shops and sporting two hotels, which runs along the southern edge of the village between two of its more modern amenities, the railway (now defunct) and the Dollar Academy (very much a going concern). This last was the brainchild of John McNabb, a local man who started his life as a herdsman and ended it a wealthy sea-captain. When he died in 1802, he left £40,000 in trust (a sizeable fortune in those days) to endow 'a charity or school for the poor of the parish of Dollar wheir I was born'. The school opened in 1818, its forward-thinking trustees creating the first co-educational school of its sort in Scotland, as well as having the good taste to hire the celebrated architect, William Playfair, to design its splendid Neoclassical frontage. Rebuilt and enlarged after a recent fire, this main building is an impressive sight, rising above the surrounding playing-fields.

The Dollar Burn flows rapidly down the steep descent of the Dollar Glen (above), *then continues directly through the centre of the village* (left).

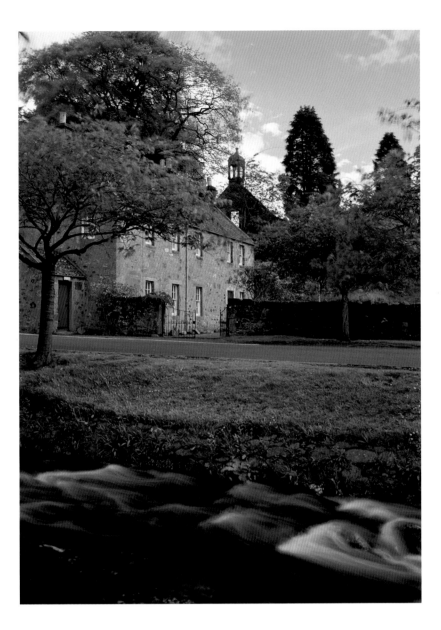

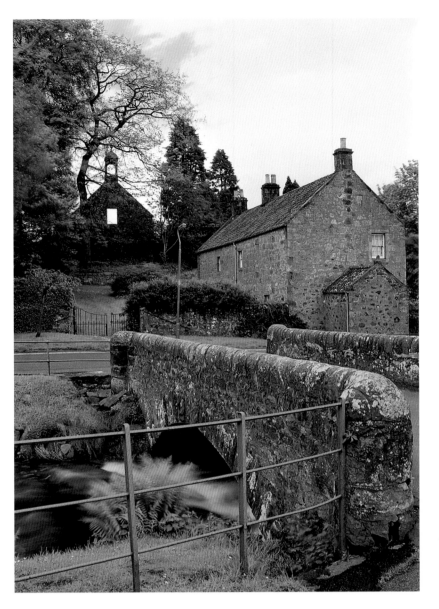

The old centre of the village, together with the elusive High Street, is to be found on higher ground, beyond a bridge that crosses over the tree-lined Devon Burn, which rushes precipitately down from the Ochil Hills. This original settlement grew up in the shadow of the famous Castle Campbell, which sits still higher up, on a crag that overlooks the village, as well as most of Clackmannanshire. The setting for the castle could not be more romantic – it looms up from the steep slope as if in one of John Bunyan's wildest fantasies, wedged between two steep-sided burns that meet below its battlements. The names of the two streams could certainly have been dreamt up by the author of *The Pilgrim's Progress*: the Burn of Care and the Burn of Sorrow. The castle itself was originally known as Castle Gloom, but this delightful title turns out, disappointingly, to be merely an anglicized version of an old Gaelic place-name.

Traditional stone constructions, including a bridge dating from 1775, line the course of the Burn (above left *and* right). *Viewed from the heights of Castle Campbell, up the Dollar Glen, the centre of the village yields the impression of a compact, well-ordered community* (opposite).

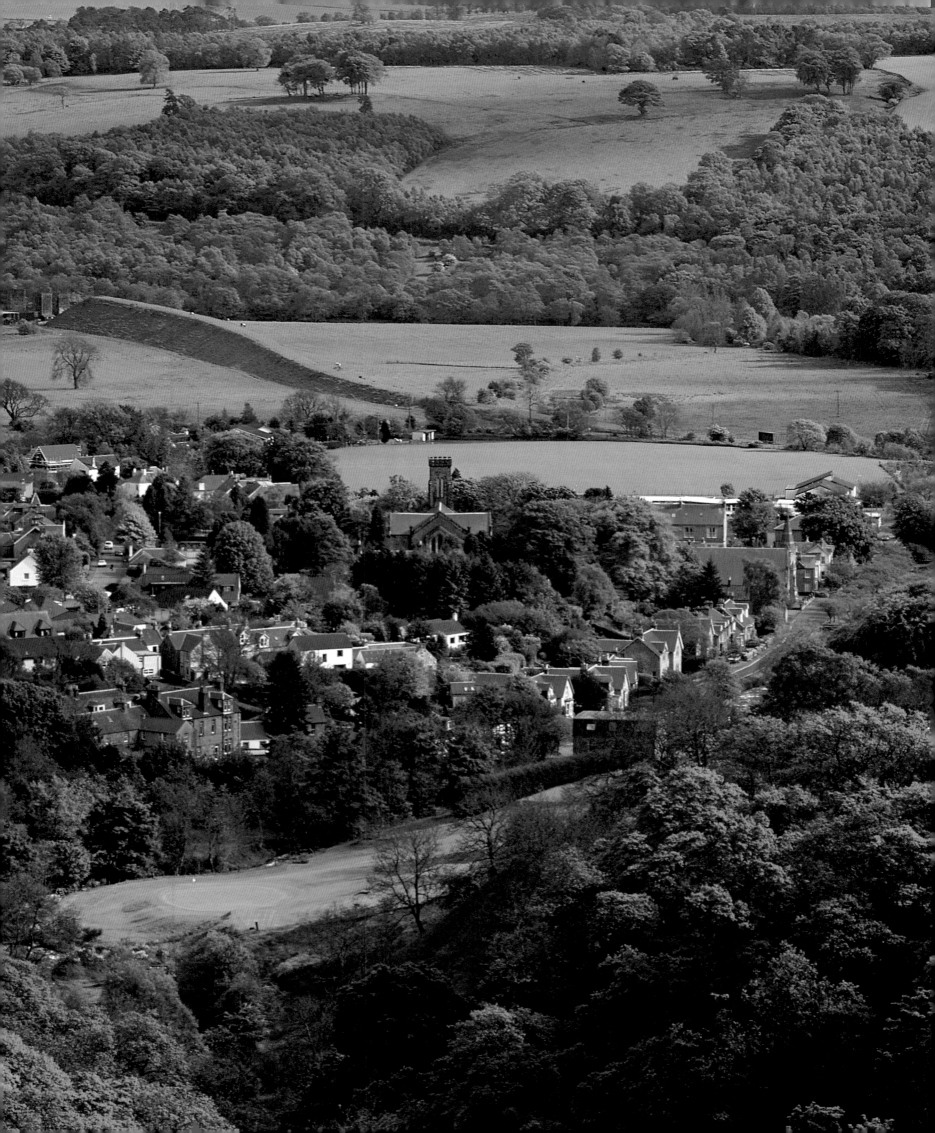

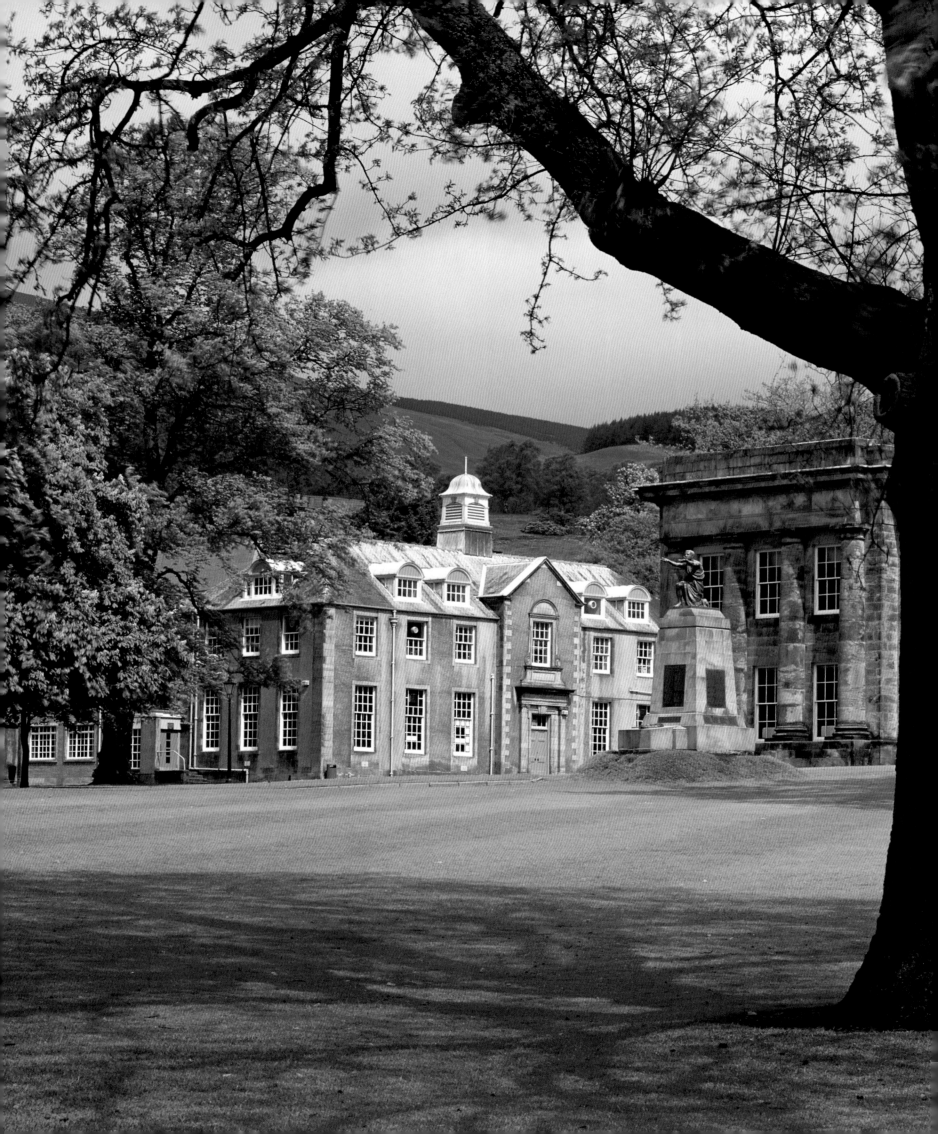

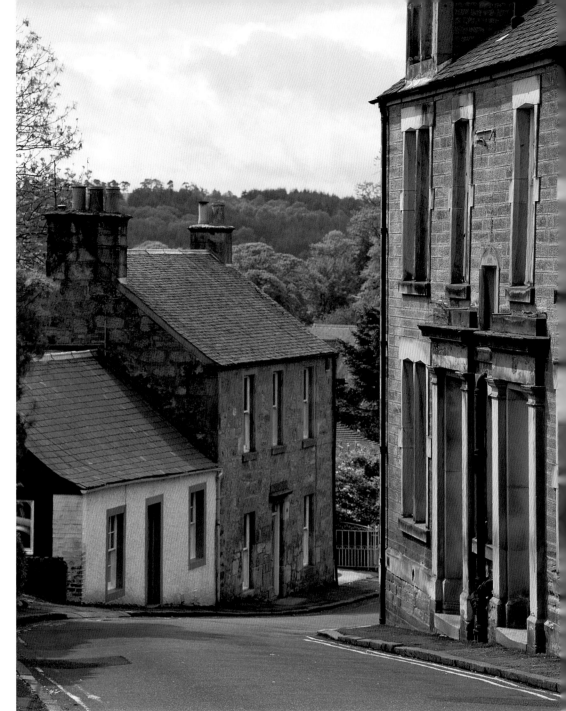

*O*ne of Scotland's most distinguished schools,
the Dollar Academy opened in 1818; its original
Neoclassical frontage (opposite) *was designed by William
Playfair, architect of some of Edinburgh's finest buildings.
Less grand, but equally pleasing are the finer details of
Dollar, like the clock tower on Bridge Street* (above left),
*at the foot of the Dollar Burn, or the stern yet elegant
houses in the upper part of the village* (above right).

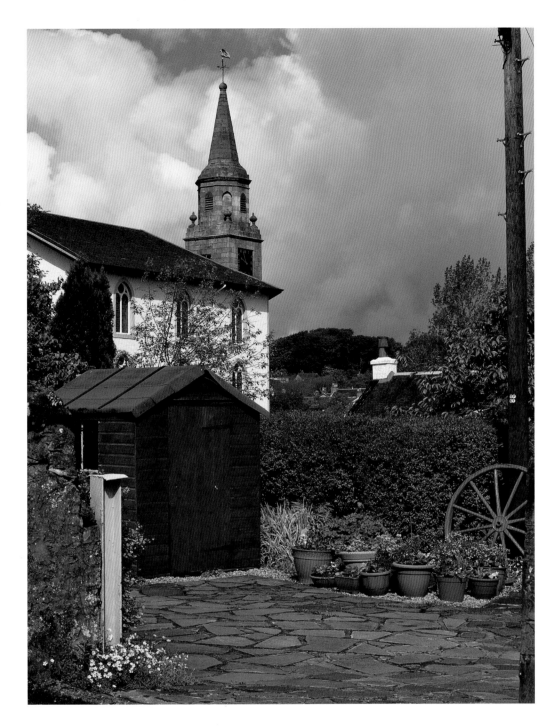

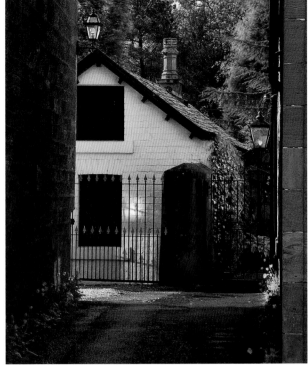

become so bad by the late nineteen-thirties that a scheme was mooted by the local council for the whole village to be demolished and rebuilt as a public housing scheme. The Second World War intervened before this dubious parallel to Lord Eglinton's scheme could be put into effect. After the war, pioneer residents who had bought up some of the old houses formed themselves into a strong association to preserve the heritage of the place; through their efforts Eaglesham came to be designated Scotland's first conservation village.

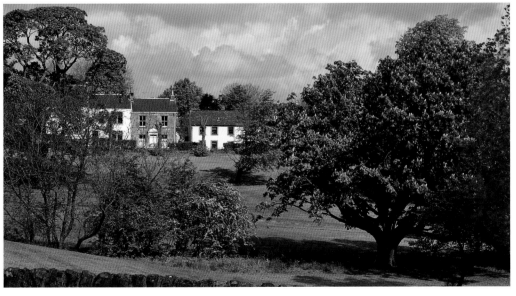

*T*he other main axis of this bright and colourful village is Montgomery Street, the location of the present-day church (above left) *and pretty detached houses with well-kept gardens* (above *and* opposite). *A large communal green separates the two principal streets* (left).

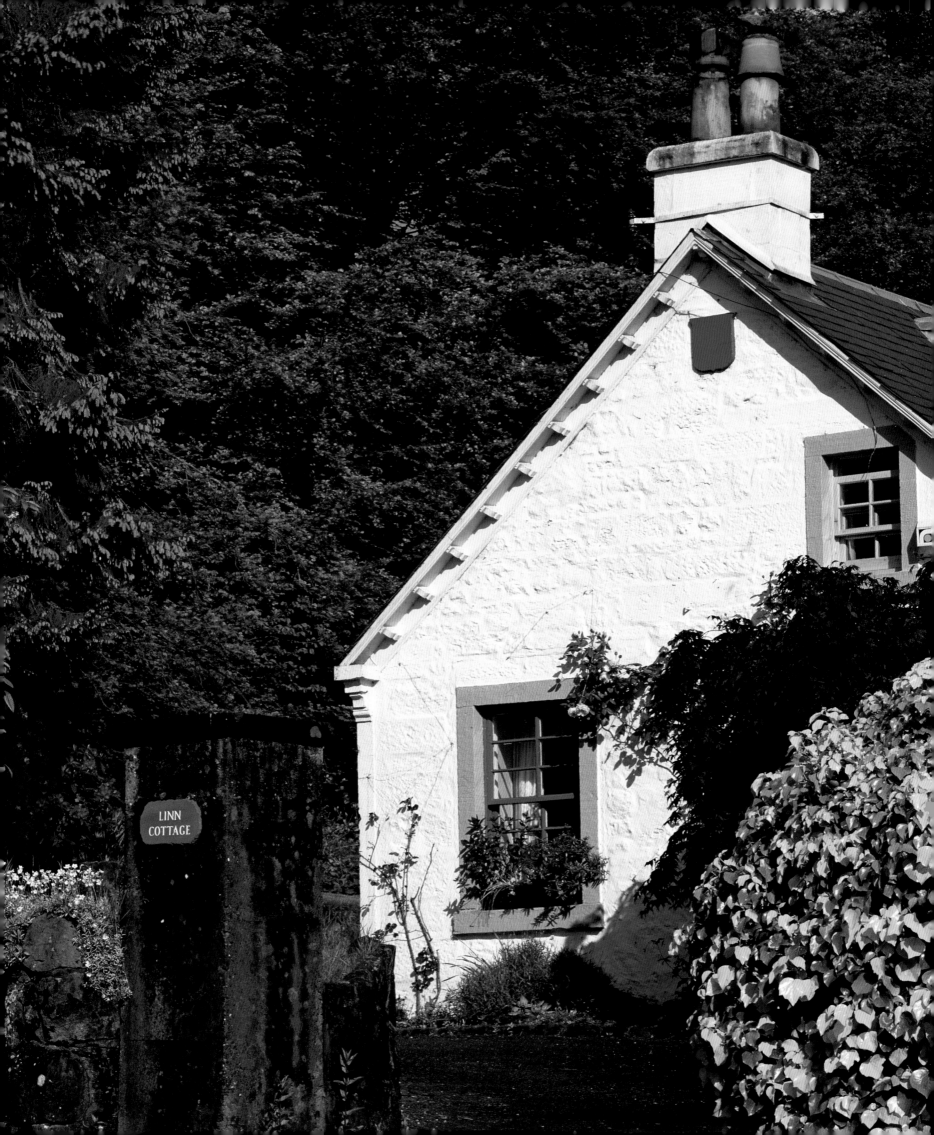

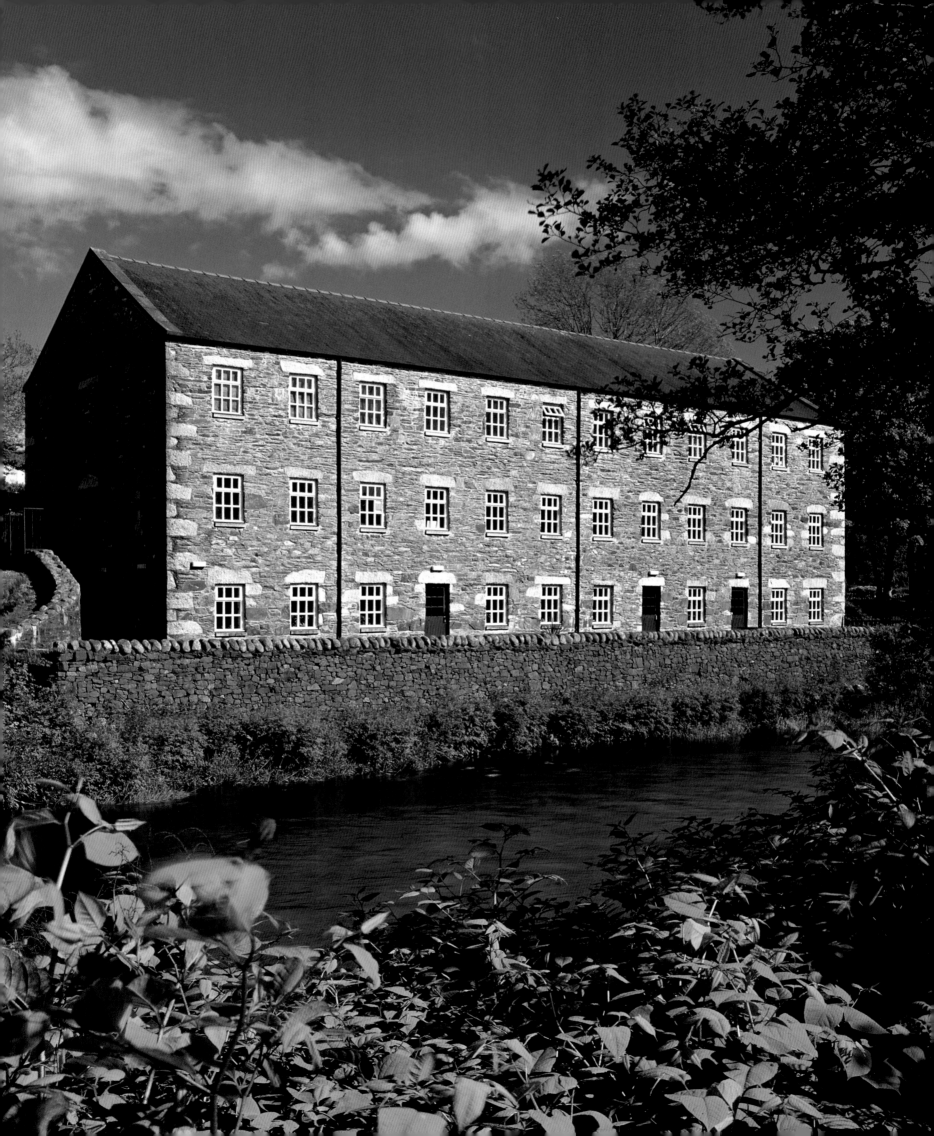

Gatehouse of Fleet
KIRKCUDBRIGHTSHIRE

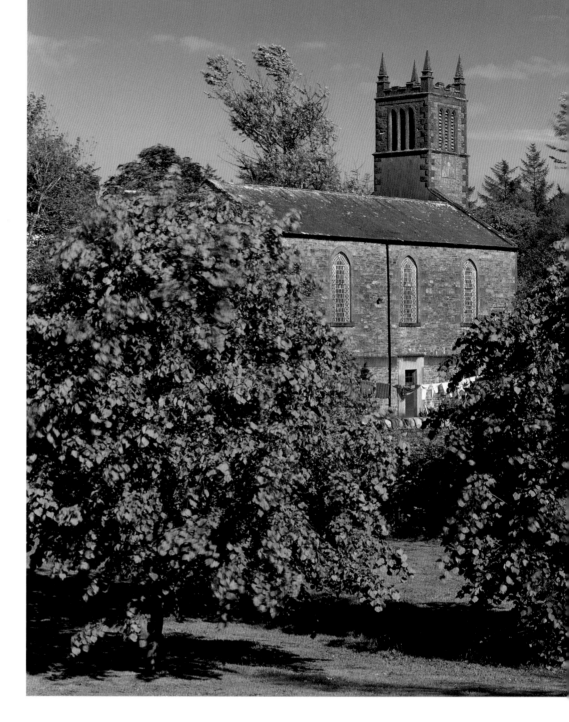

QUEEN VICTORIA, on being told by Thomas Carlyle that the most beautiful route in her realm was the road between Gatehouse of Fleet and Creetown, asked him which was the second most beautiful. 'Why surely, ma'am,' he replied, 'it is the road from Creetown to Gatehouse of Fleet.' The celebrated historian had good credentials for giving so emphatic a recommendation to this lovely stretch of Kirkcudbrightshire's coast. He was born in the hamlet of Ecclefechan in neighbouring Dumfriesshire, and spent his early married life in a hill farmhouse that belonged to his wife, at Craigenputtoch, just over the border.

The setting of Gatehouse of Fleet itself is indeed perfect; the Water of Fleet winds gently towards the shore between soft, enfolding hills, from the mass of the granite Cairnsmore of Fleet, the village's picturesque backdrop. The novelist John Buchan, himself a great enthusiast for the Borders, chose this wild granite bluff, which rises to over two thousand feet, as the setting for one dramatic sequence in *The Thirty-nine Steps*, in which the hero, Richard Hannay, makes his escape over the moors. The road mentioned by Carlyle has been a busy one for as long as the sea-crossing to Ireland has been a practical proposition. In the early days, ferries sailed from Portpatrick and so it was there that the main road west from Dumfries led. Prior to the mid eighteenth century, there was little to mark its crossing of the Water of Fleet, other than the ancient Cardoness Castle, built there by the MacCulloch clan in the fifteenth century and, later on, a single coaching inn.

But the good communications of the place, as well as its natural resources, had attracted the attention in the mid eighteenth century of a wealthy landowner named James Murray, of Broughton House in Kirkcudbright. He bought the Cally Estate and built a sumptuous country house between the village and the Carrick shore. To house the local population displaced by his farming innovations, he laid out a model village to a neat rectangular plan, and invited investors from Yorkshire, notably the Birtwhistle family, to build cotton mills on the banks of the river. The Water of Fleet was deemed too feeble to supply sufficient power to the mills, so three miles of water-channels, or 'lades', were constructed to connect with Loch Whinyeon nearby. By the seventeen-nineties, the village could boast not only three mills on the river, but also a brass foundry, two tanneries, a soap-works and a brewery. One of the mills, which amazingly stayed in production until the nineteen-thirties, making bobbins from local timber, has been restored as a museum celebrating the industrial history of the village. The neatly restored streets are a delight to explore, the more so now that Carlyle's favourite road thunders past to the south, almost out of earshot.

Now home to the local Visitor Centre, this restored eighteenth-century mill (opposite) *ceased the production of cotton goods in 1850, but then converted to manufacturing bobbins until 1938. Another local example of a change of use is this mid-nineteenth-century church* (above), *now offices and apartments.*

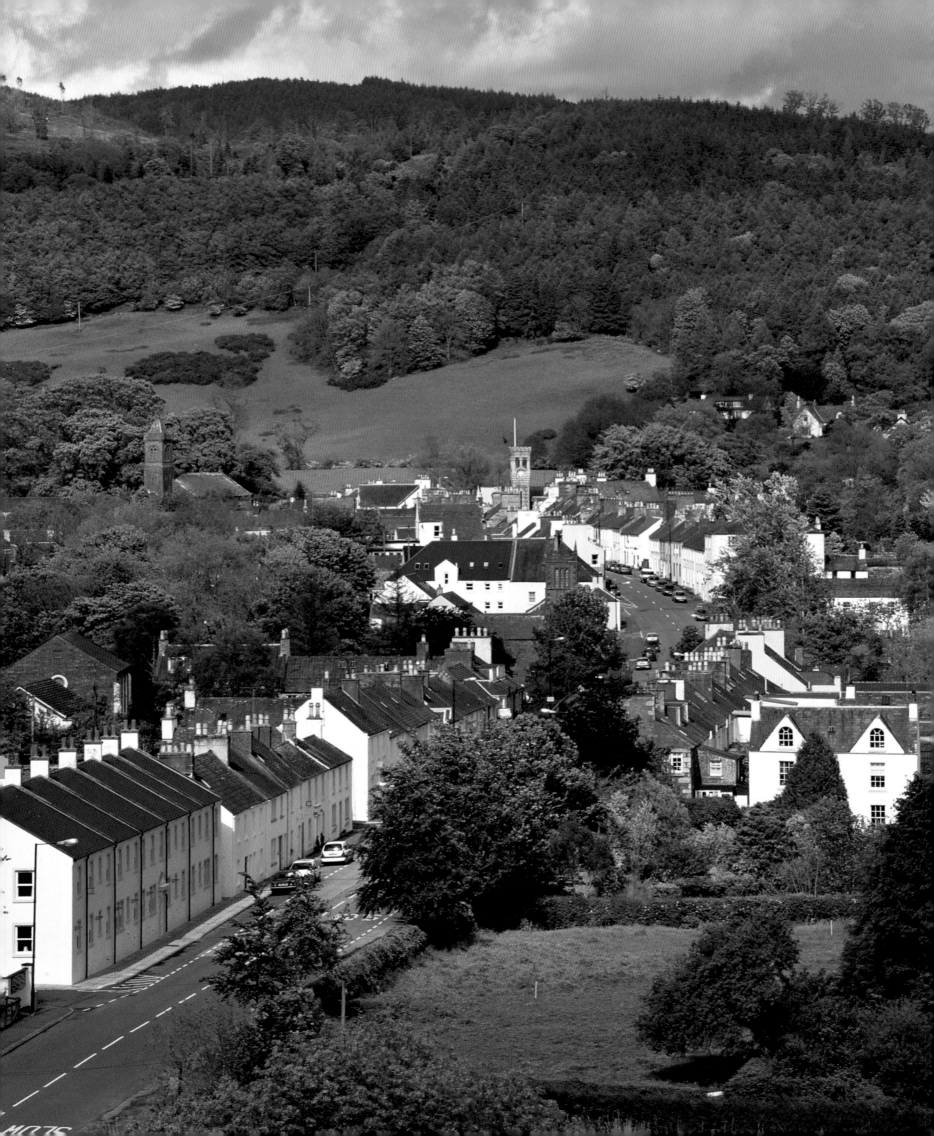

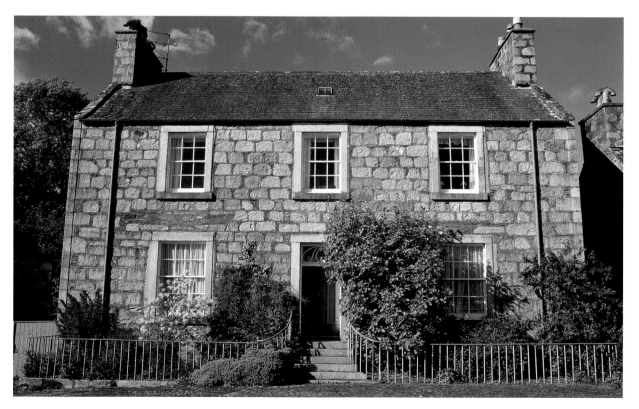

*F*leet Street cuts through the centre of this traditionally prosperous village, after crossing the Water of Fleet (opposite) and progressing towards the Clock Tower, a dominant symbol of civic pride. Other signs of well-being include the former Town Hall, the parish church and a number of handsome houses (this page).

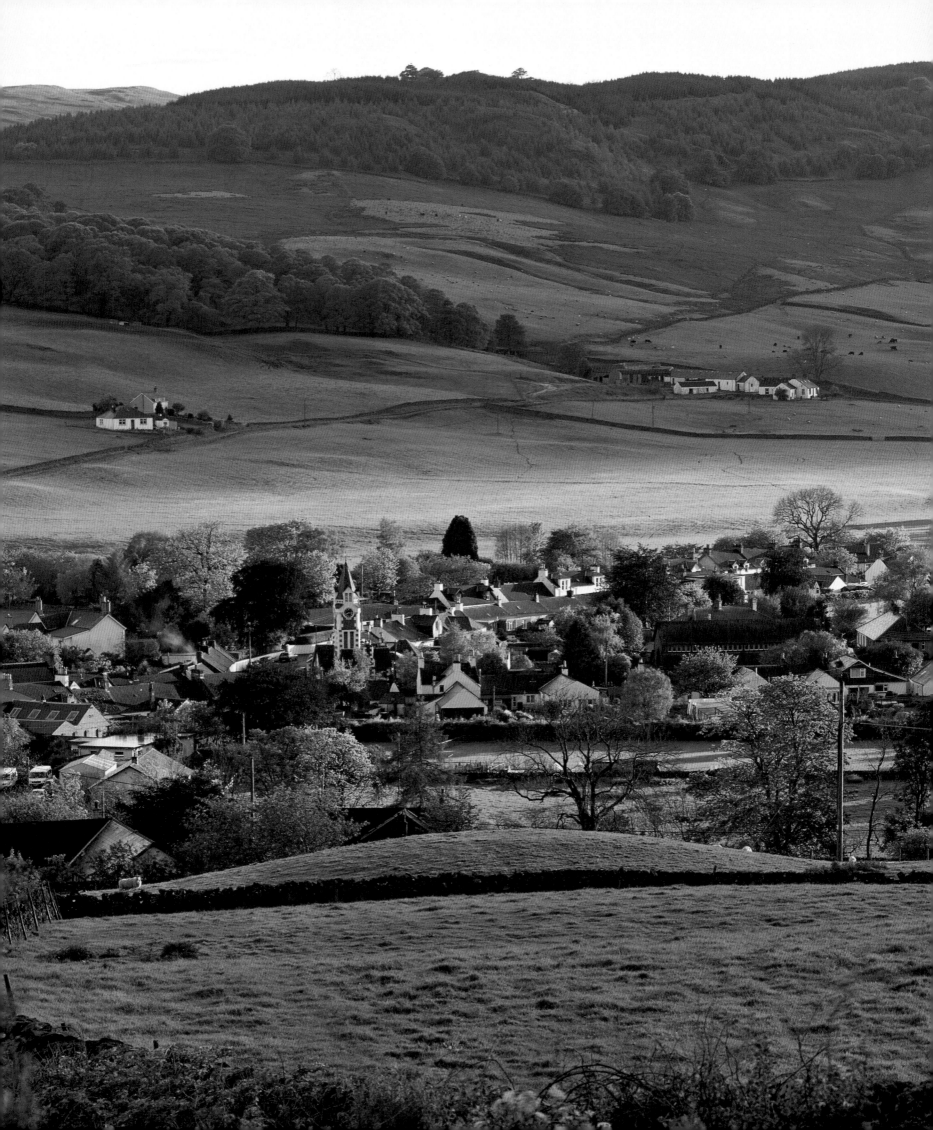

Moniaive
DUMFRIESSHIRE

THE GAELIC NAME OF THIS REMOTE VILLAGE, Monadh-abh ('Hill of Streams'), is suitably romantic, as well as apt. Three streams do actually meet here, and in early times two separate communities, Minnyhive and Dunreggan, faced each other across the Dalwhat Water. Today, the village is a friendly, engaging place, with plenty of smart, whitewashed houses fronted by flower-filled gardens. One oddity is what looks from afar to be the village clock tower turns out on closer inspection to be part of a private house. Whether its original Victorian owner was motivated by public-spiritedness or by sheer vainglory remains unclear. Another curiosity is Moniaive's former railway station, whose remains survive in a farmyard close to the village's centre. Even when the mania for expanding the railway network was at its height, it must have stretched belief that a branch line connecting the town of Dumfries to this remote spot could ever make economic sense. It may have been doubts about its viability that delayed the execution of the scheme, but by the time the Cairn Valley Light Railway was finally running in 1905, it was already doomed to a short life. However, it must have seemed a wonderful novelty for the villagers to be whisked to Dumfries in an hour, and for the townsfolk to be able to take day-trips out to this charming part of their county. But the internal combustion engine soon overtook the struggling venture; bus routes passed closer to people's houses, and road hauliers could obtain access to the local stone quarries more easily, as well as adapt to the seasonal demands of the hill-farmers, transporting lambs to market in early summer, for example.

By whatever means of transport, Moniaive has always been able to attract visitors, as the flourishing trade of its three hotels testifies. The pretty countryside has an additional draw: it was the setting for that most famous of Scottish love stories, the wooing of the fair Annie Laurie, immortalized in song. As in all good romances, the story has increased in appeal as successive flights of imagination have taken it further away from the original facts. In this case, the true story is that in the sixteen-eighties, the youngest daughter of Sir Robert Laurie of Maxwelton (just to the east of Moniaive) was wooed by William Douglas of nearby Fingland. Douglas, however, was a known Jacobite, a hot-headed duellist of some notoriety, and not an

attractive son-in-law for the recently ennobled Sir Robert. As for his daughter, whether or not she made any promise to Douglas, she certainly did not pine away; after marrying Alexander Ferguson of neighbouring Craigdarroch, she lived on in great respectability to the age of seventy-nine.

This tranquil community lies in the folds of a valley where three glens meet (opposite). *Its houses are carefully maintained, many of them fronted by flower-filled gardens* (above). *One curiosity is the high tower which dominates the village; it is in fact part of a private house built in 1865.*

New Lanark
LANARKSHIRE

Today's visitor to New Lanark will first of all be struck by the sheer beauty of its setting, a steep wooded gorge cut through by the fast-flowing river Clyde. For the two men who stood there in 1785, aesthetics were a secondary consideration. The founders of this model industrial community – Glasgow banker, David Dale, and Richard Arkwright, inventor of the 'Spinning Jenny' – had their eyes on the motive power offered by the fast-flowing river. A decade later, New Lanark had the largest and most productive of all Scottish cotton mills, with over a thousand employees living and working in the valley.

Dale was a committed and philanthropic Christian, as well as a hard-nosed businessman. He put great store by the conditions in which his employees lived and worked, the more so as so many of them were children; more than a third of the work-force had not even reached their teens. His enlightened approach was taken several stages further by a young, idealistic Welshman who took over the site (and married Dale's daughter Caroline) in 1798. Although Robert Owen's

T he sturdy stone houses and workshops (above) *of the village have now been carefully restored as habitations and business premises for the present, including the dwellings of David Dale and Robert Owen* (right).

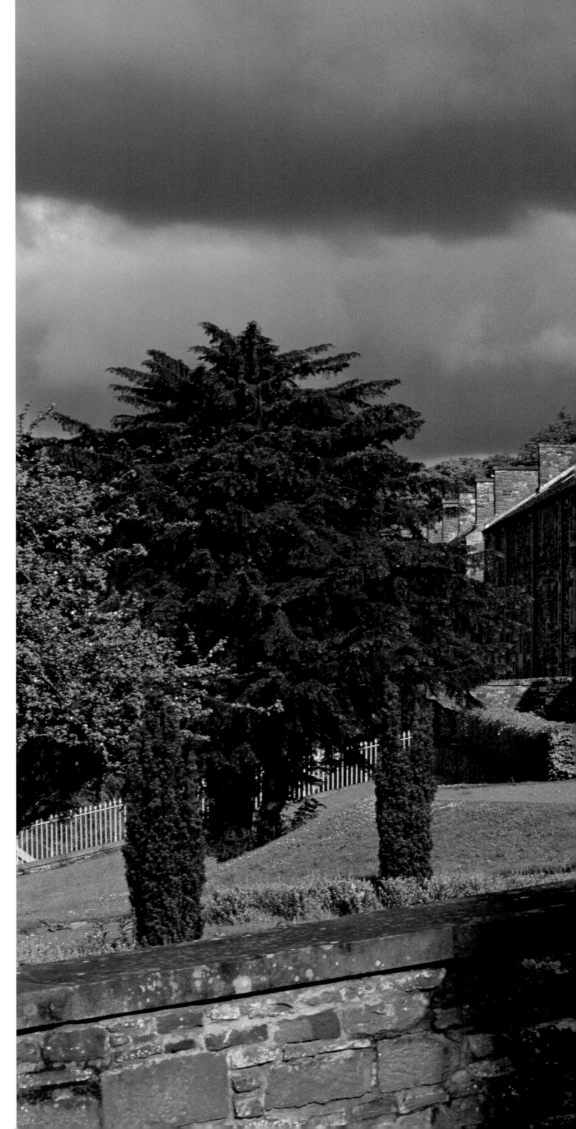

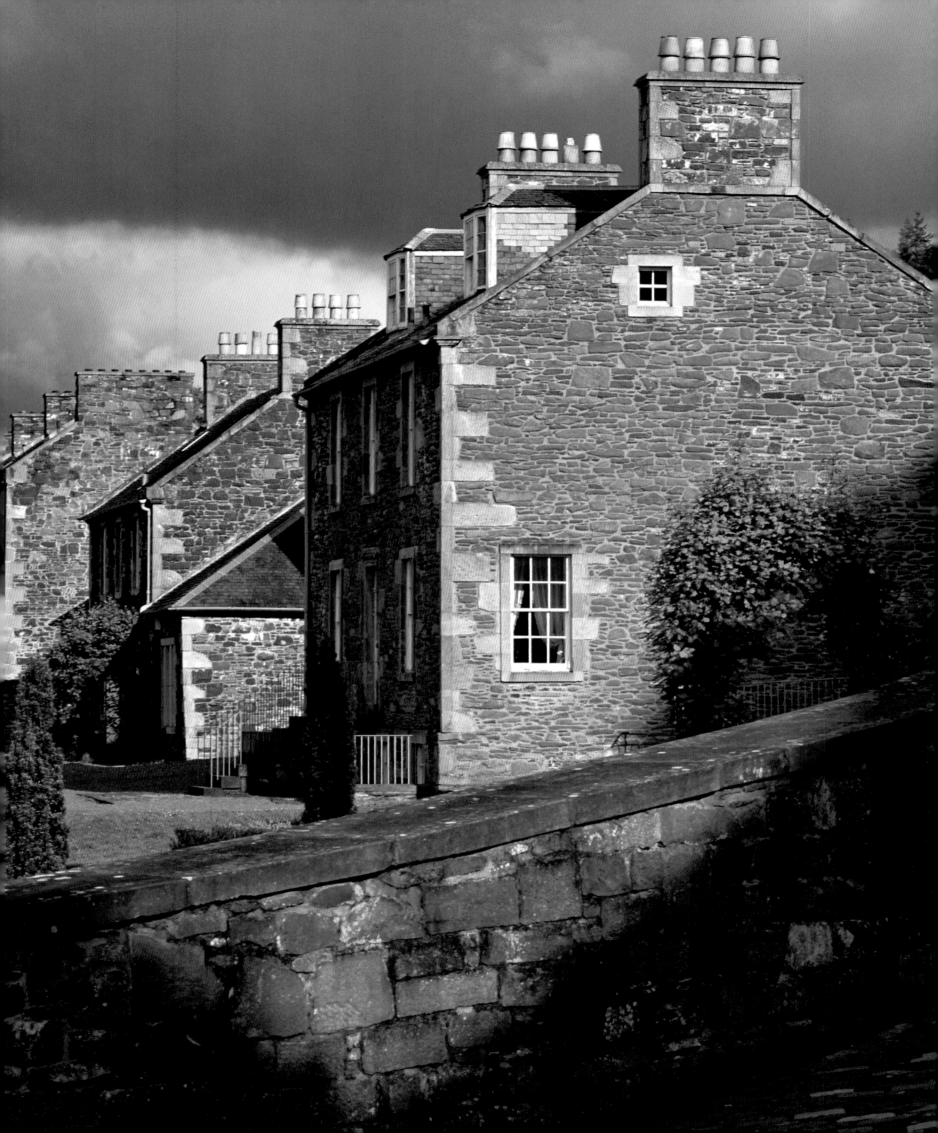

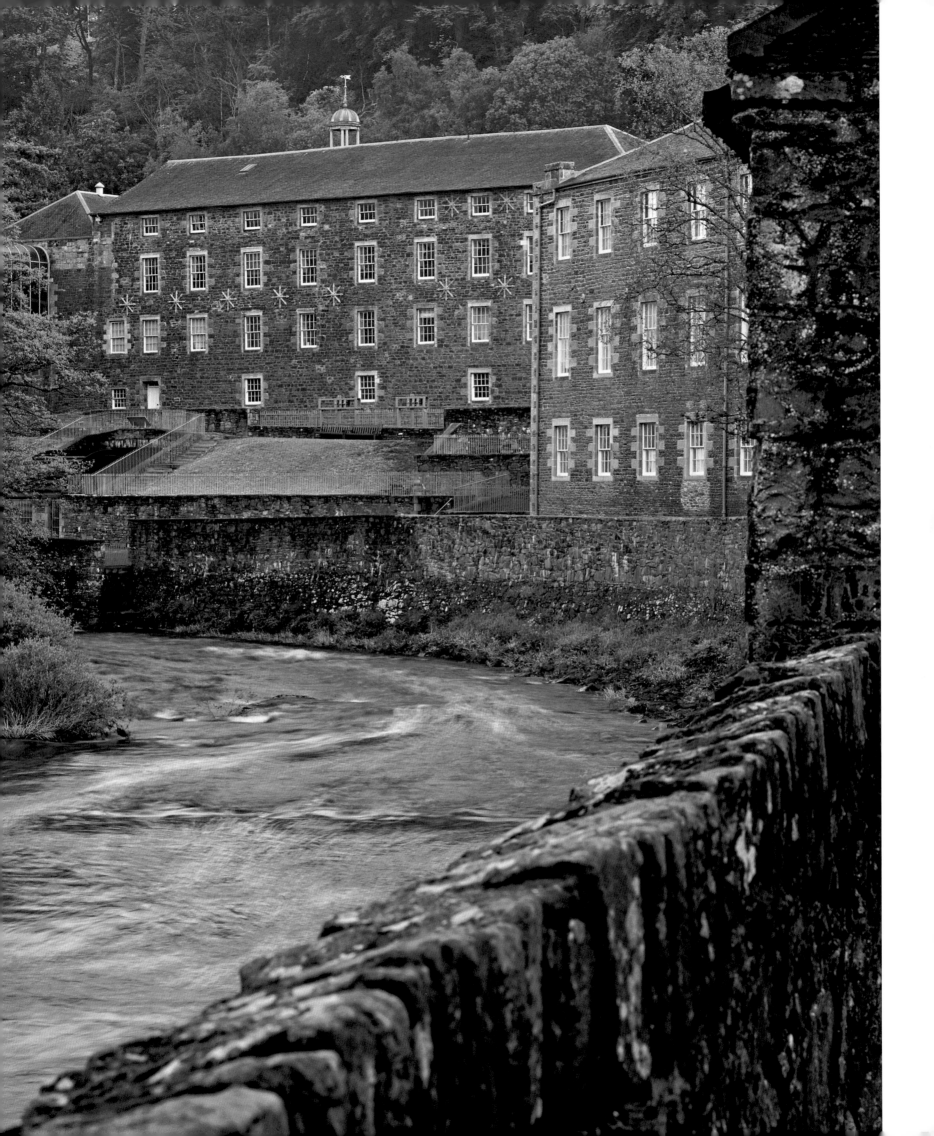

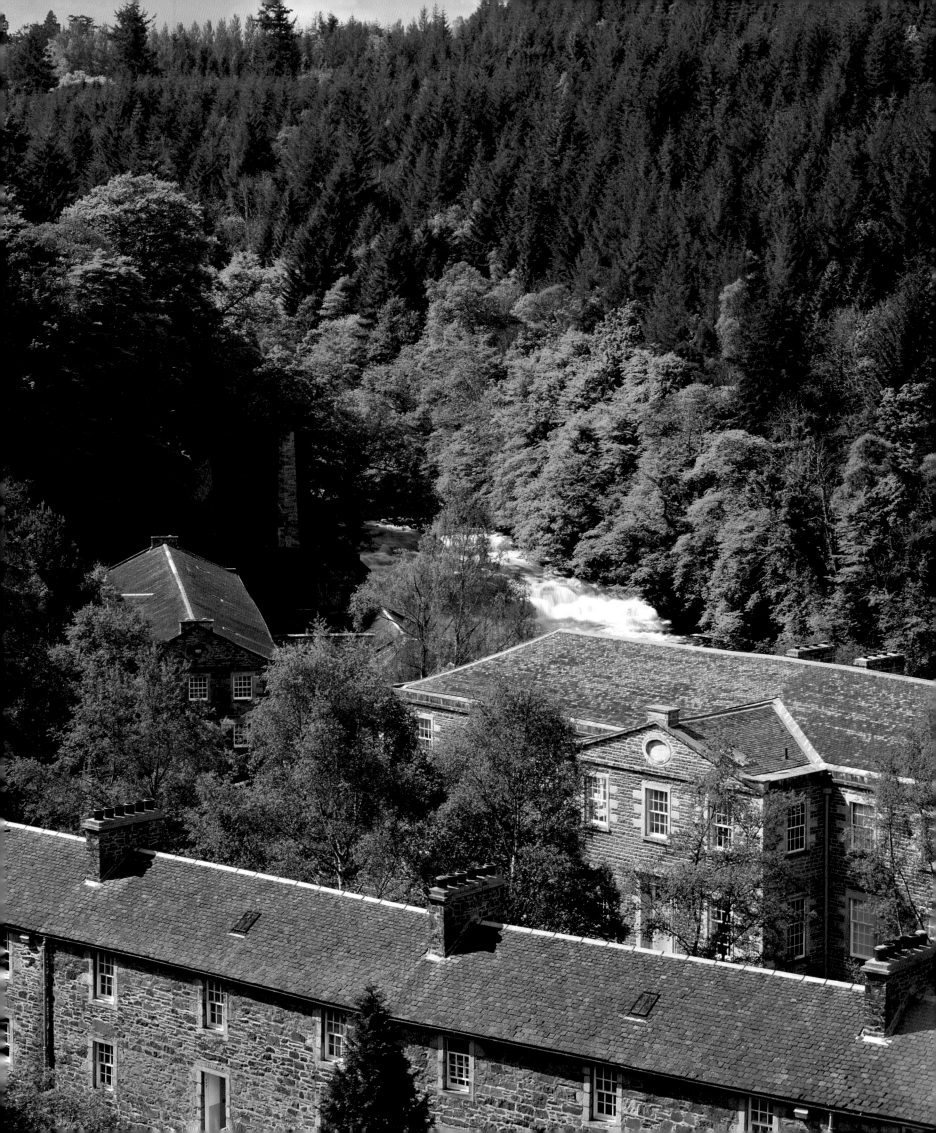

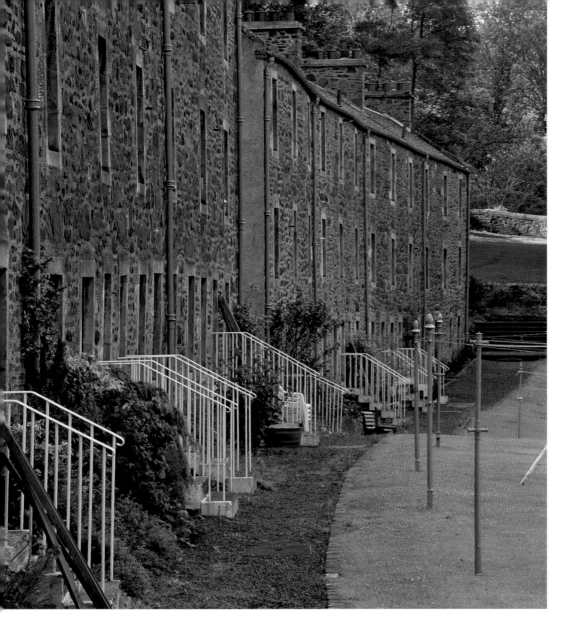

interests, like his father-in-law's, were firmly grounded in the commercial realities of business, his socialist beliefs (which included a fervent distrust of organized religion) were extremely radical for his times.

Apart from ensuring humane working hours, safer working conditions and good housing, Owen's main preoccupation was the provision of education. In one of the plain, classically proportioned buildings at the foot of the cobbled approach road is his 'Institute for the Formation of Character'. The title may sound old-fashioned, but Owen's ideas were ultra-modern and forward-thinking to an extraordinary degree. He was utterly convinced that happiness in the work-force would improve production, and that escape from the indignity of inherited ignorance was possible if children were properly educated. So this was the birthplace of the play-school, where children were taught from the age of eighteen months, incidentally providing a pioneering child-care system that allowed mothers to continue working at the looms.

The success of Owen's visionary scheme, founded on the productivity of his mills, became famous world-wide. After he sold his interest in New Lanark, happily to some benign Quakers, he continued to pursue his Utopian vision. 'Owenists' became pioneers in many radical fields, from trade-unionism to the formation of the Britain's first Co-operative Society. His own, later schemes met with less practical success – the ideal community of New Harmony in the United States succeeded only in parting Owen from what remained of his fortune, and he died disillusioned that his ideas had not gained more general acceptance.

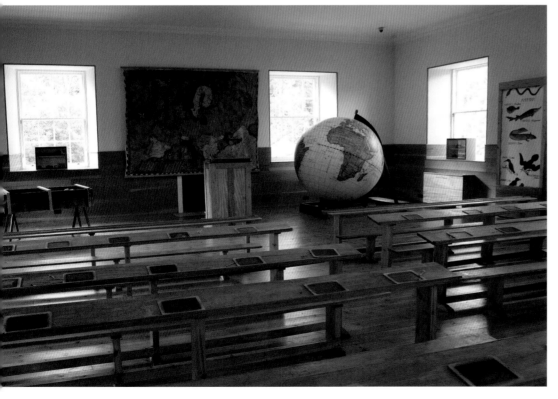

Preceding pages

Two of the most important buildings of the village are the Institute and the School, where Robert Owen's rationalist approach to education was put into practice. All village children aged from one to ten received full-time education.

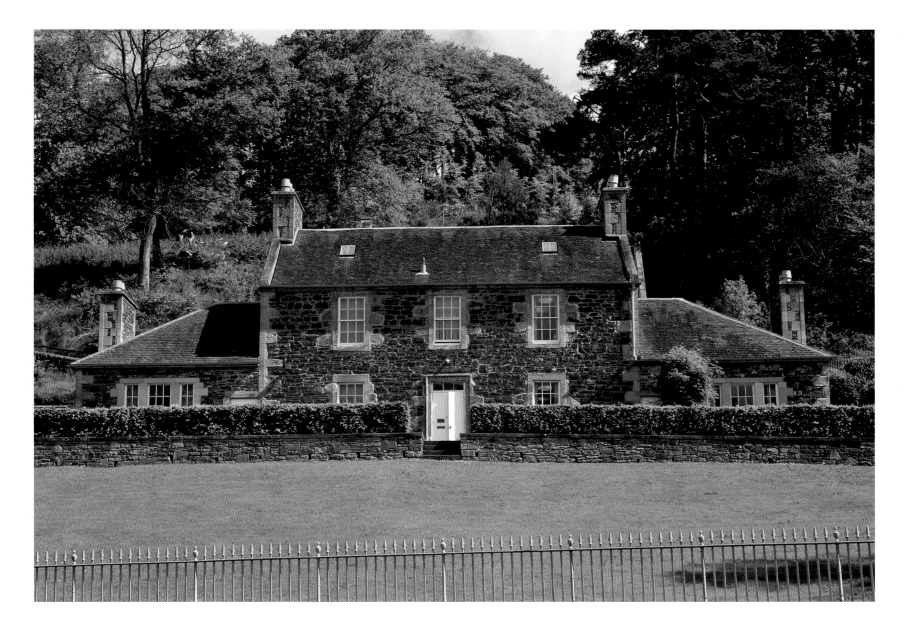

*C*aithness Row (opposite above) *once housed 300 workers, most of them emigrant Highlanders whose ship had foundered shortly after leaving for America. Some idea of the enlightened nature of the School can be gained from the clean, airy classroom in this reconstruction* (opposite below). *The same sense of worthiness is somehow present in the clean lines of the houses* (above) *and the simple but imposing portico of the Institute* (left).

North Berwick

EAST LOTHIAN

These days, North Berwick is well known as a resort; its wide, sandy beaches are thronged with bathers throughout the summer months. But its history as a tourist destination goes back many hundreds of years before anyone had the novel idea of entering the sea voluntarily, let alone for the good of one's health. As early as 950, a passenger service was plying from there to Earlsferry on the opposite side of the Firth of Forth. The boats were mostly carrying pilgrims heading for the holy shrine at St. Andrews. This was an embryonic form of mass-tourism: huge numbers of ordinary people making the arduous and often dangerous journey, their feudal owners obliged by law to honour their right to undertake a pilgrimage.

The pilgrimage boom lasted well into the sixteenth century before it dwindled away. North Berwick then had to make do with beach fishing and the intermittent export of grain from its small harbour, but not before a celebrated witch trial brought it some notoriety: a lively coven of witches was alleged to have been operating here, and they were held responsible for the fierce storms which almost drowned King James VI and his new bride on their return voyage from Denmark. In a case as serious, and treasonous, as this, some dozens of suspects came to trial in 1595, when they were accused of meeting at the Auld Kirk to conjure up the storms. According to the testimony, the devil 'appeared to them in the likenesse of a man with a redde cappe, and a rumpe at his taill.' The nobleman Earl Bothwell, known to have been plotting against the king in his absence, was later accused of complicity with the witches.

Publicity of a more wholesome sort helped North Berwick achieve its present status: the nineteenth-century craze for sea-bathing and golf on the nearby links attracted growing numbers of well-off holidaymakers. By the time the railway line had connected this lovely part of the coast to Edinburgh, the future of the resort was fixed, and the fine, substantial villas that overlook the sea-front began to appear. The lists of distinguished visitors promenading along the sea-front each season grew to such an extent that before long North Berwick had acquired the title of 'Biarritz of the North'.

*I**ts proximity to Edinburgh made North Berwick (right) an obvious choice as a resort during the Victorian era, and its sandy beaches still enjoy popularity during the summer months.*

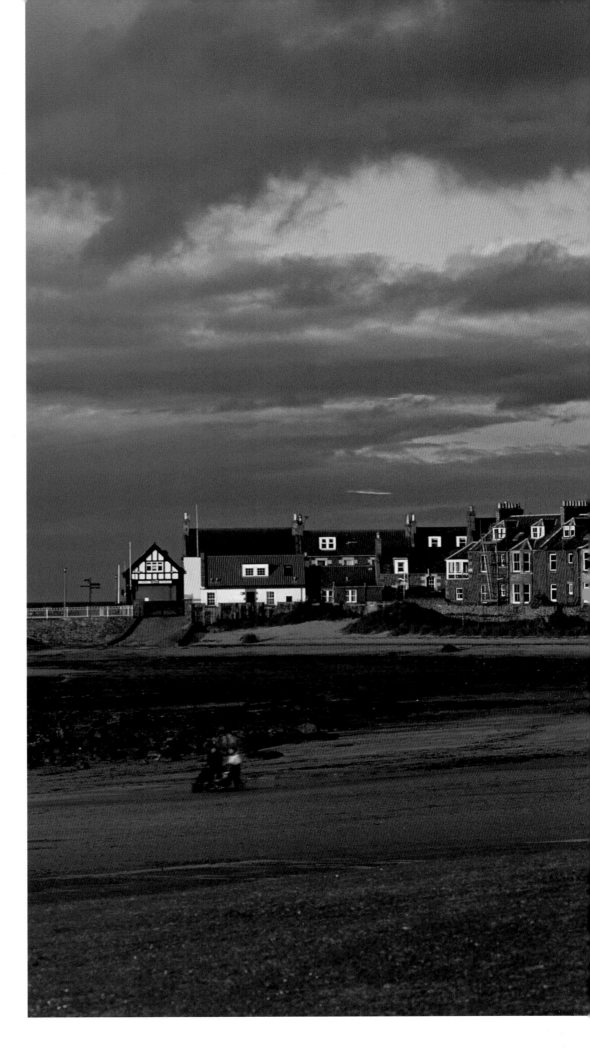

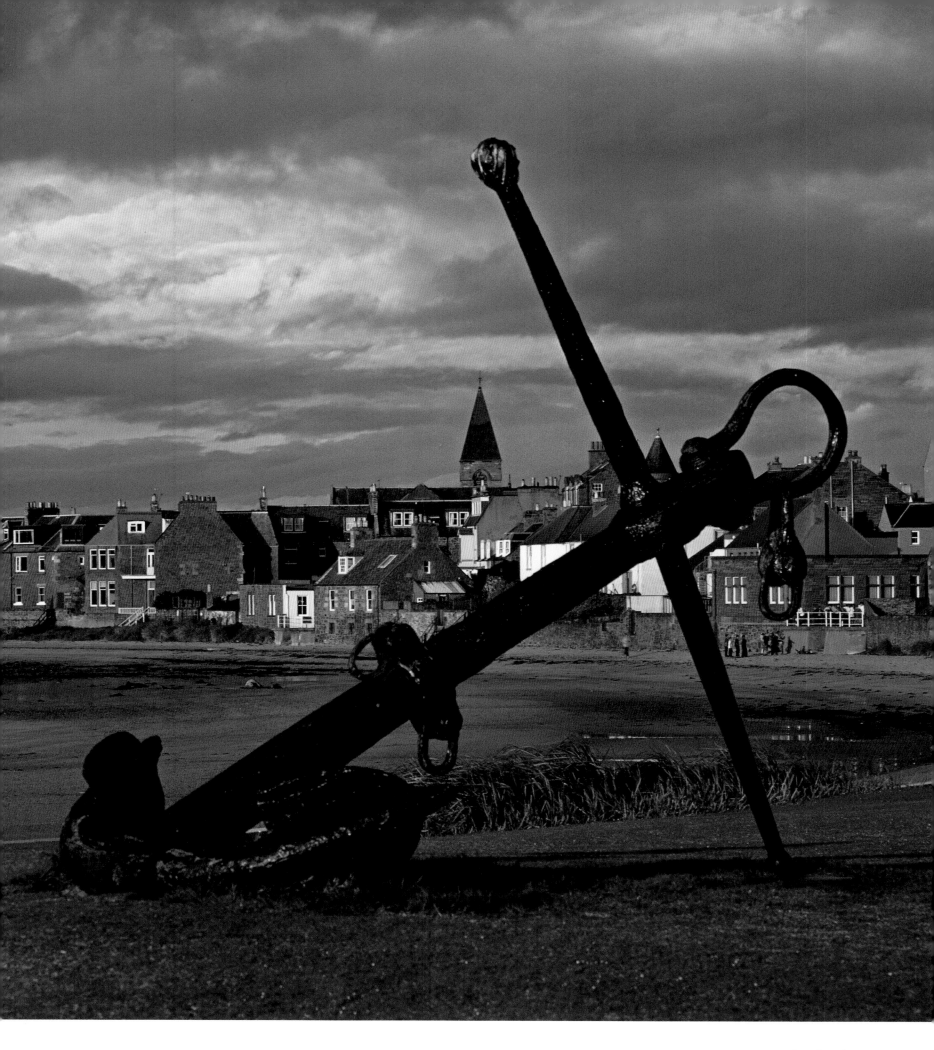

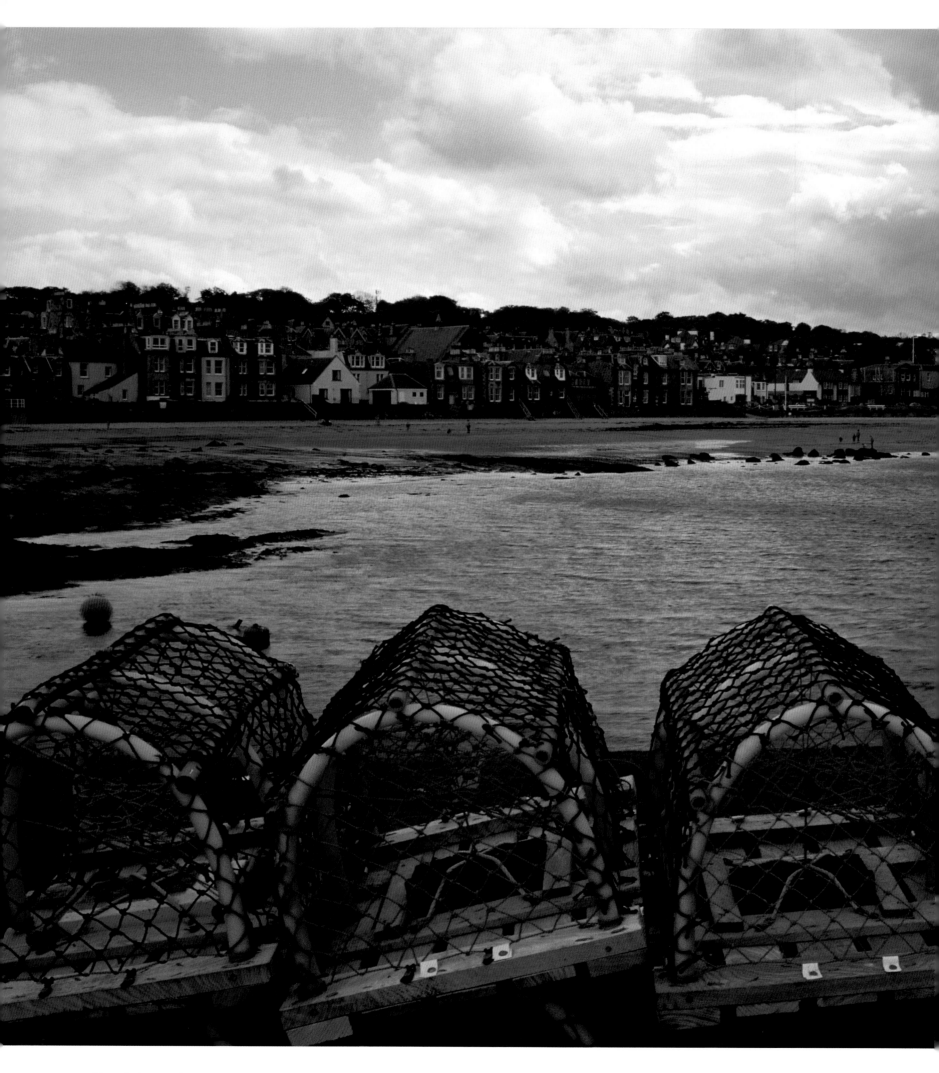

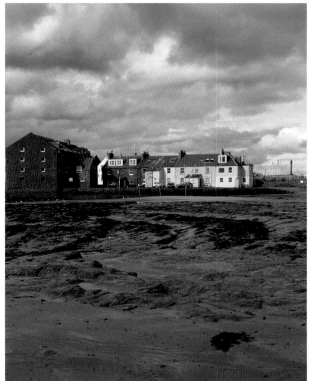

*T*he sea-front houses at North Berwick have delightful views across the sandy beach (left); an old grain store is now home to the East Lothian Yacht Club (above).

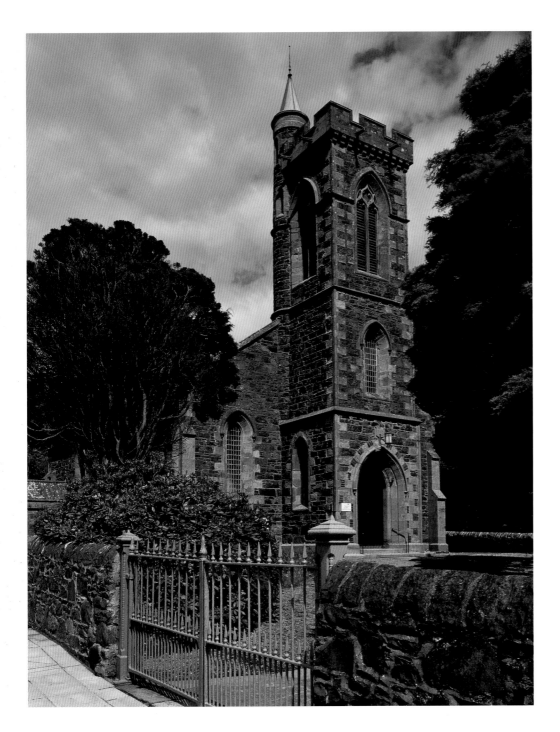

Portpatrick
WIGTOWNSHIRE

AT THE EXTREME SOUTH-WEST TIP OF SCOTLAND is a promontory, or rather a hammer-shaped island joined by an isthmus to the coast; it goes by the name of The Rhinns of Galloway. Only twenty-one miles across the sea lies Northern Ireland, and it was Portpatrick's good fortune to offer a natural harbour to ships making the crossing. The village's name, taken from the dedication of its parish church to the evangelizing St. Patrick, has led to legends that this was the heroic saint's first landing-place in Scotland and, almost as inevitably, that he made the crossing in a single stride. It has been suggested that the unusual round tower of the church, now in ruins, which stands close to Portpatrick's harbour, also served as an early lighthouse. The church itself certainly had a further use: as a destination for couples eloping from Ireland, whom the local minister would join in matrimony for the fee of ten pounds.

Portpatrick first came into general use for the sailing ships making the crossing to and from Ireland after the military road was built across Galloway from Dumfries, a vital supply route for the colonizing of Ulster. It continued as the main route for mail, passengers and livestock until the eighteen-thirties, by which time Admiralty workshops had been set up here, and the harbour had been rebuilt with a lighthouse and massive sea-walls to supplement the protection offered by the rocky island at the mouth of the existing natural harbour. Despite these efforts

Once the main crossing-point to Northern Ireland, Portpatrick has now re-invented itself as a stylish little resort of well-kept streets (above right) *and carefully preserved older buildings. These include the church on Holm Street* (above) *and the much older ruin near the harbour, whose cylindrical bell-tower may once have served as a lighthouse* (opposite).

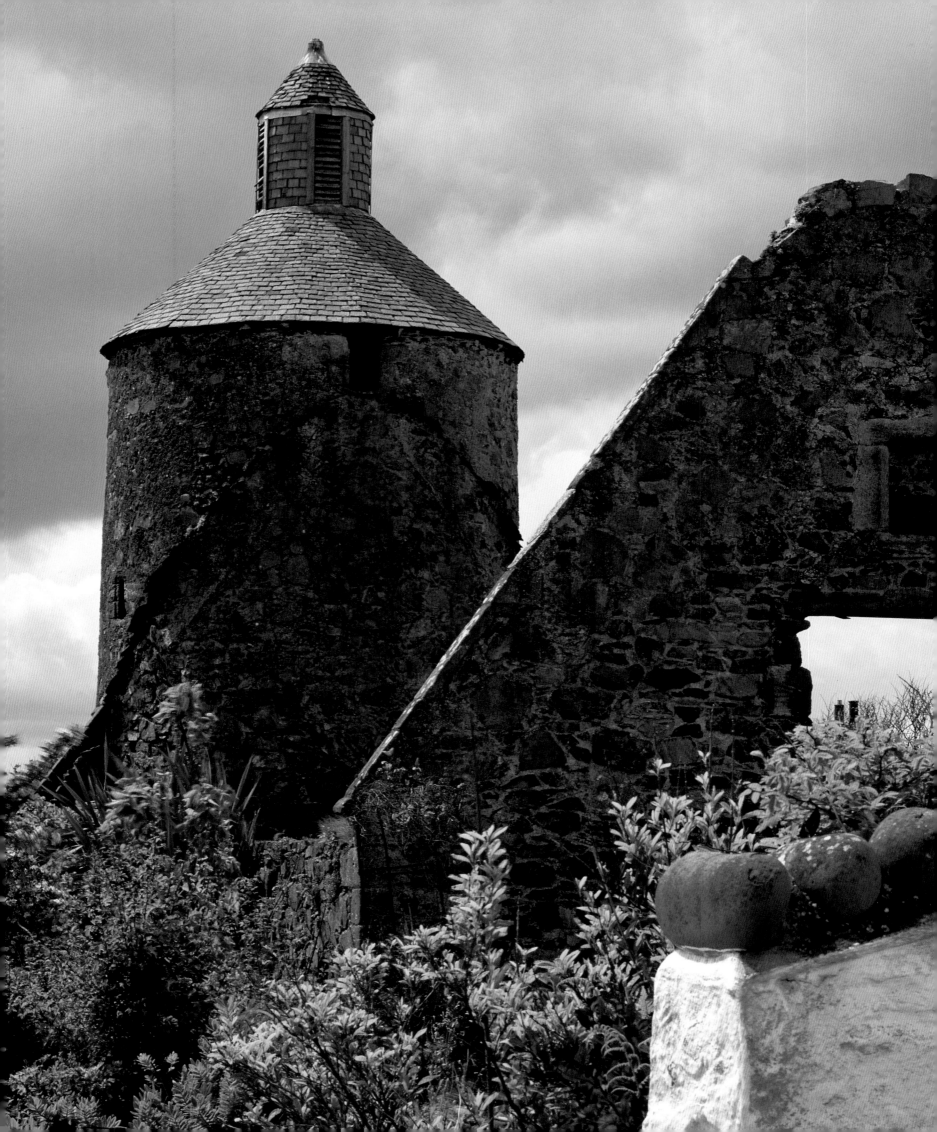

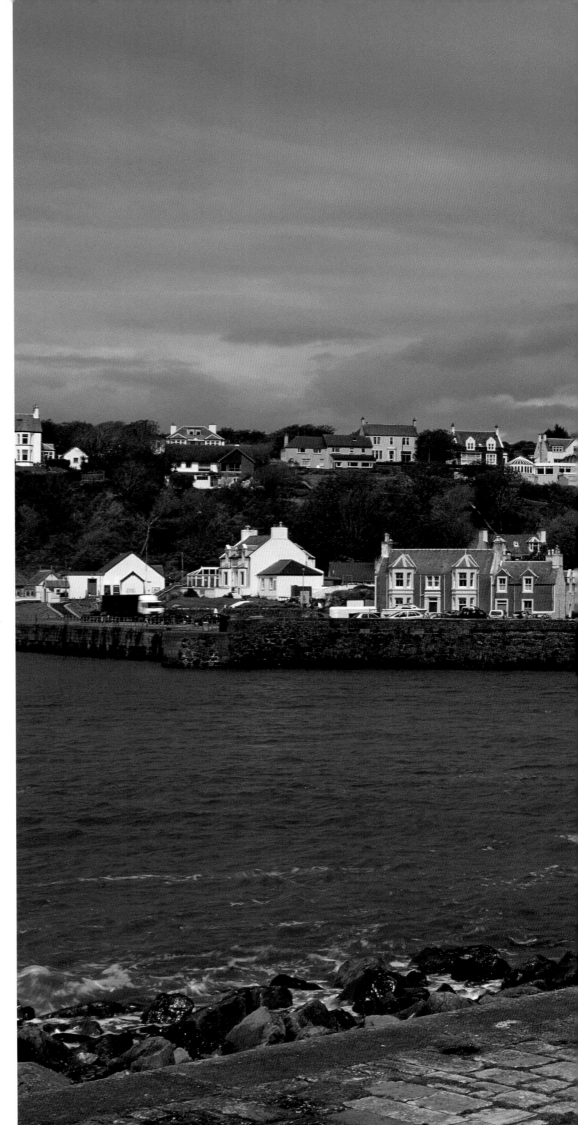

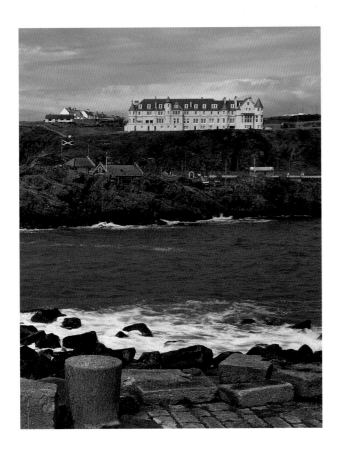

to rebuild and expand the port, it became clear that
Portpatrick was not destined to continue as the main
link for the North Channel. Its position was too
exposed to the south-westerly gales that frequently
damaged the sea-walls, as well as threatening the safety
of the ships using the harbour. The same innovations
that brought the steam train (a line was built to
connect the port to Stranraer in 1862) also brought
the steamship. Shortly afterwards, the steam packet
company that was to take over the crossing to Larne
began to operate from Stranraer.

Nowadays, the tiny scale of the harbour has become
an asset rather than a drawback. Encircled by a sweep
of fine terraced houses, it presents a charming picture,
with the rest of the village sitting snugly behind it in
a natural amphitheatre. Portpatrick has now become
a holiday destination in its own right. In one sense,
though, it remains a jumping-off point, owing to its
position at one of Scotland's extremities – this is where
walkers set off on the Southern Upland Way, which
ends at St. Abb's Head on the North Sea coast.

*A fine hotel (above), holiday villas and a lighthouse,
which was in use until 1900, all share the
delightful view over Portpatrick's harbour (right).*

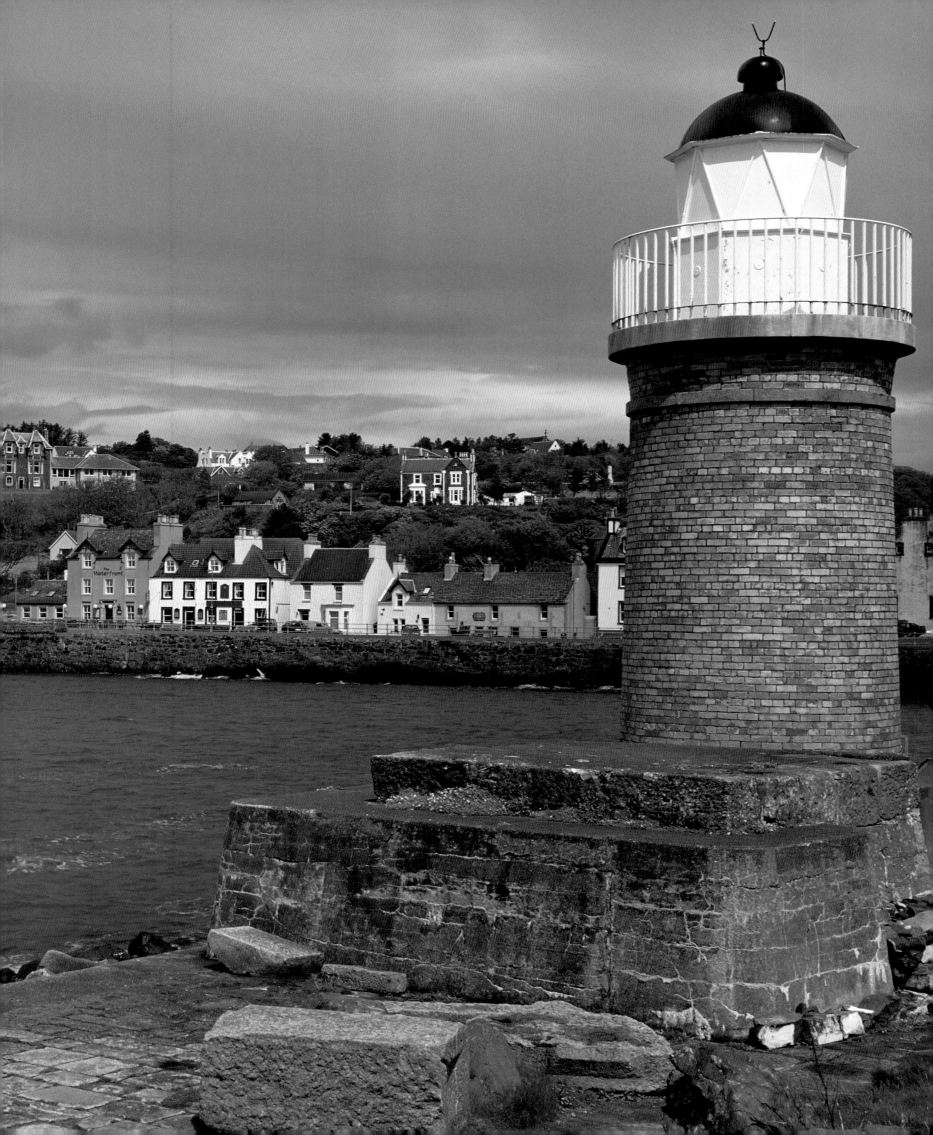

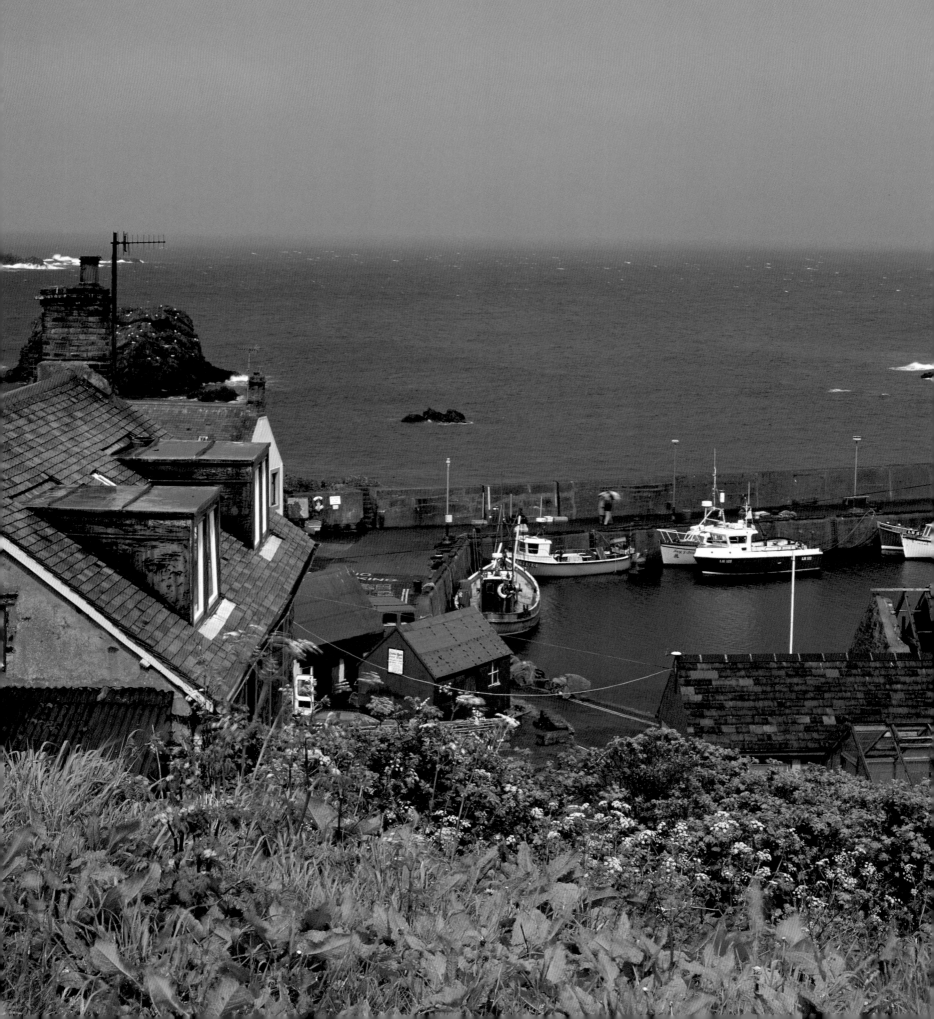

St. Abbs BERWICKSHIRE

The harbour at St. Abbs (opposite) still presents an animated scene, although many of the boats are more likely to be chartered by divers rather than to be actively engaging in fishing. For the owners of some of the small craft, though, the lobster catch is still an important part of their business (below).

AFTER PURSUING A MORE-OR-LESS northerly course all the way up from the Wash, the North Sea coast takes an abrupt left turn, ten or so miles after crossing the border at Berwick. It is at the famous promontory of St. Abb's Head that the Firth estuary begins its great incision westwards. A more exposed position could hardly be imagined. Hundred-metre cliffs rear out of the sea, bearing the full brunt of the ferocious seas from the north-east. These volcanic outcrops were once layered with softer sandstone, which has been worn away over millions of years, to leave the present gaunt and beautiful rock formations.

In such an exposed and rocky shoreline, shelter for shipping has always been both desirable and scarce. The harbour at St. Abbs was not built until 1832, by which time engineering advances had made it possible to add sea defences to the natural rocky inlet. There were plenty of local fishermen to use the harbour, but most lived in neighbouring Coldingham. Nothing that could be called a village existed here, until the

surrounding estate was bought in 1885 by Andrew Usher, heir to the celebrated family of Edinburgh brewers. He enjoyed supporting the fishing community at St. Abbs, and provided the neatly arranged rows of cottages, stacked one above the other, which look over the harbour below. He also put up the money for the 'commodious triple harbour' that was opened with great ceremony in 1890. In the old harbour, a maximum of twelve boats could be sheltered; now there was room for a hundred, with access at all stages of the tide.

Today the larger trawlers tend to be based at nearby Eyemouth, although a number of their skippers and crew still live in St. Abbs. Even so, the pretty harbour often presents an animated scene: smaller local boats chug back and forth with their lobster pots, and charter boats take divers out to sample the beauties of the rock formations below. When they emerge from the deep, the underwater tourists have to repair to the Anchor Inn at Coldingham to exchange stories.

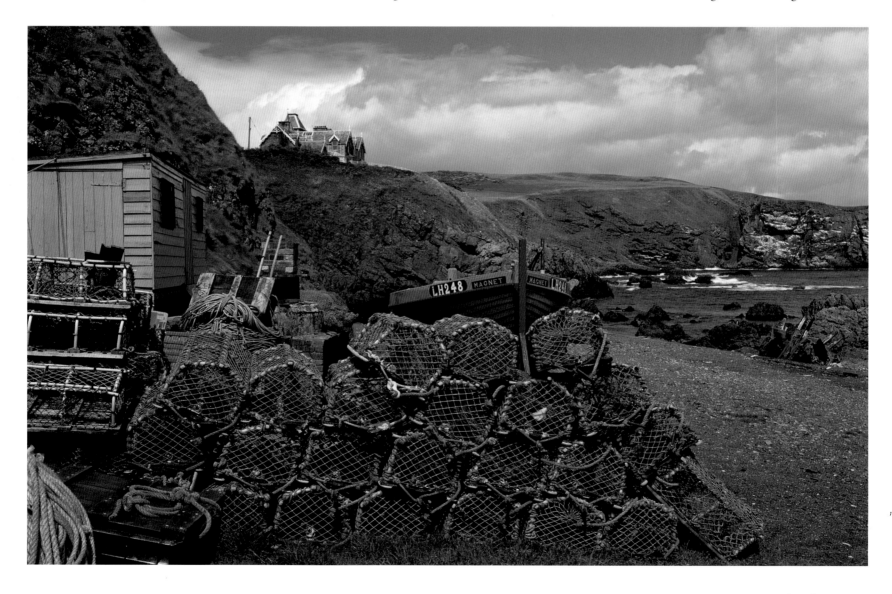

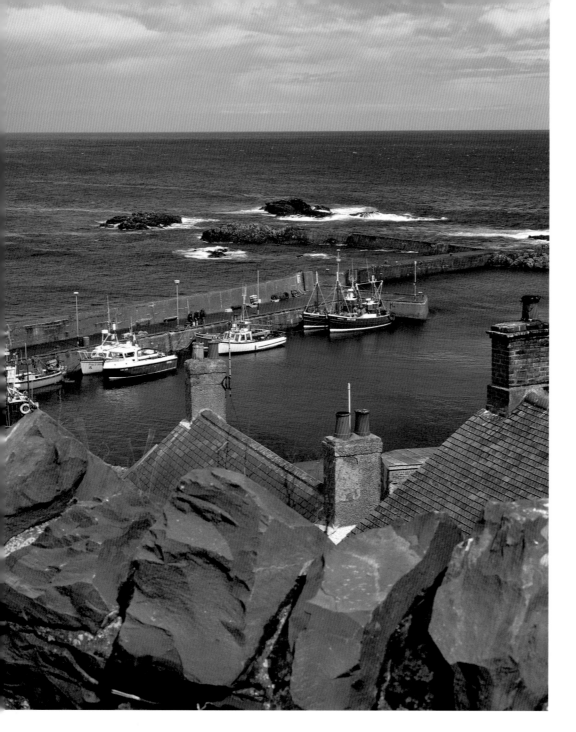

*T*he triple harbour (above *and* opposite) *was opened in 1890, built with funds provided by the drinks magnate, Andrew Usher of Edinburgh. Usher was also responsible for ensuring that the local community was decently housed* (above right *and* right).

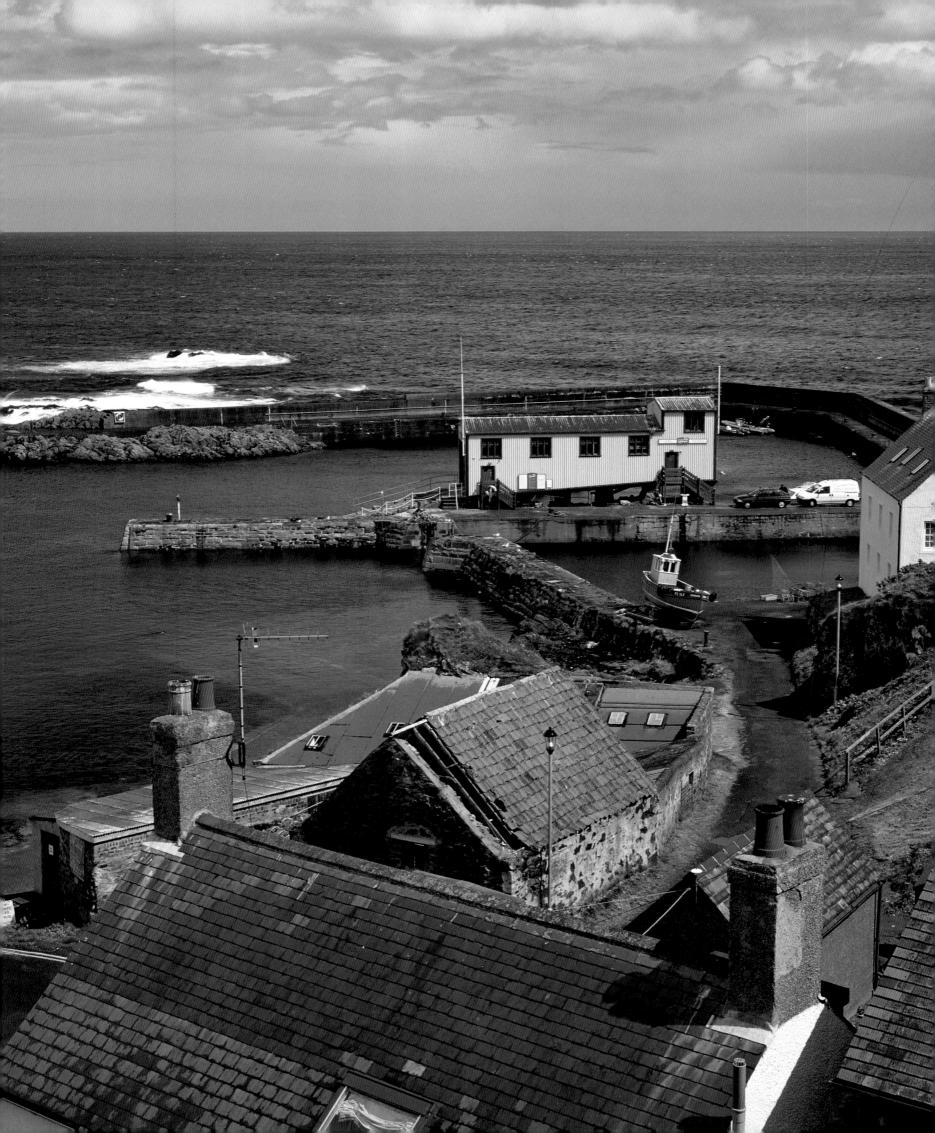

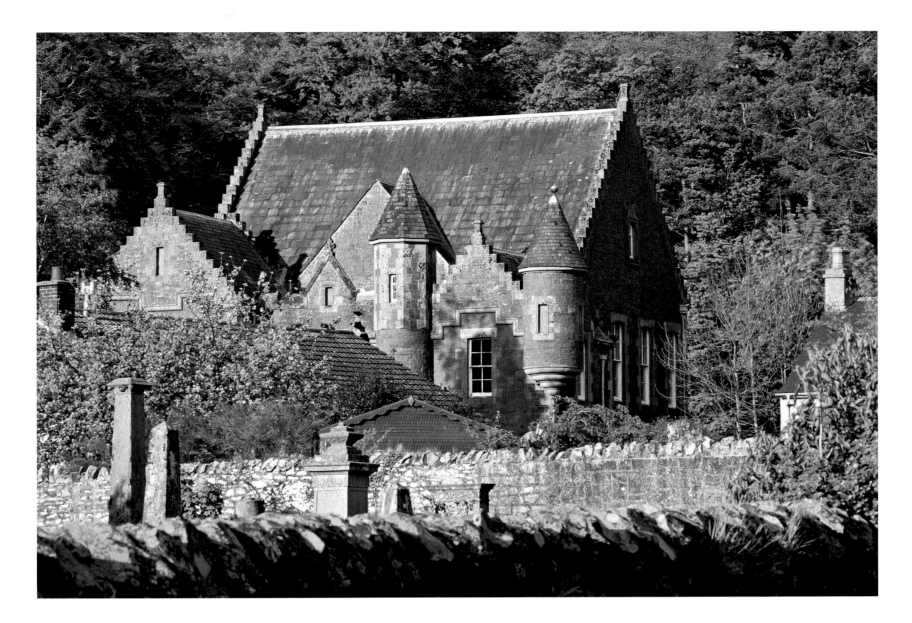

Stow MIDLOTHIAN

For a small village, quietly settled by the Gala Water, Stow boasts some interesting architectural sights, like the very baronial village hall (above) and the elegantly soaring spire of St. Mary's church (opposite).

NESTLED IN THE HEART of the old county of Midlothian, Stow, or Stow-in-Wedale to give it its full and ancient name, sits astride the Gala Water twenty or so miles south of Edinburgh. Despite its tranquil setting, dominated by the elegant spire of St. Mary's church, the village is surrounded by some wild and thinly populated country. To the east, a steep road winds up to a stretch of empty moorland that reaches eleven hundred feet in elevation before dropping down into Lauderdale and to the small town of Lauder. To the west rise the lonely Moorfoot hills, and the commanding peak of Windlestraw Law, a thousand feet higher still, where the three counties of Midlothian, Peeblesshire and Selkirkshire meet. Amid such hilly country, the flat valley at Stow was the natural crossing-point of the river, which gave the village its early importance as a trading post. A handsome stone bridge, built in the sixteen-fifties, still survives, its distinctive low parapets designed to allow a heavily laden packhorse to pass over the narrow span.

The medieval monk-historian Nennius tells us that the British king Arthur won an important battle in this valley in his long campaign to break the power of the Saxons. During the battle Arthur 'carried the image of holy Mary ever virgin on his shoulders; and the pagans were put to flight on that day.' It is no surprise, therefore, that the Auld Kirk, whose ruins lie in the village centre, was also dedicated to St. Mary, and that an even more ancient chapel nearby was said to have been founded by Arthur himself.

Stow's ecclesiastical importance does go back a long way, even if not to the fifth century. With Lesmahagow in Lanarkshire it was listed as one of two prime sites of sanctuary north of the border, in the days when much legal power was vested with the politically powerful church authorities. Stow also had a connection with the powerful see of St. Andrews, whose bishops owned much of the surrounding land. Their enduring presence and power, derived from their election by the Pope, were key elements in the

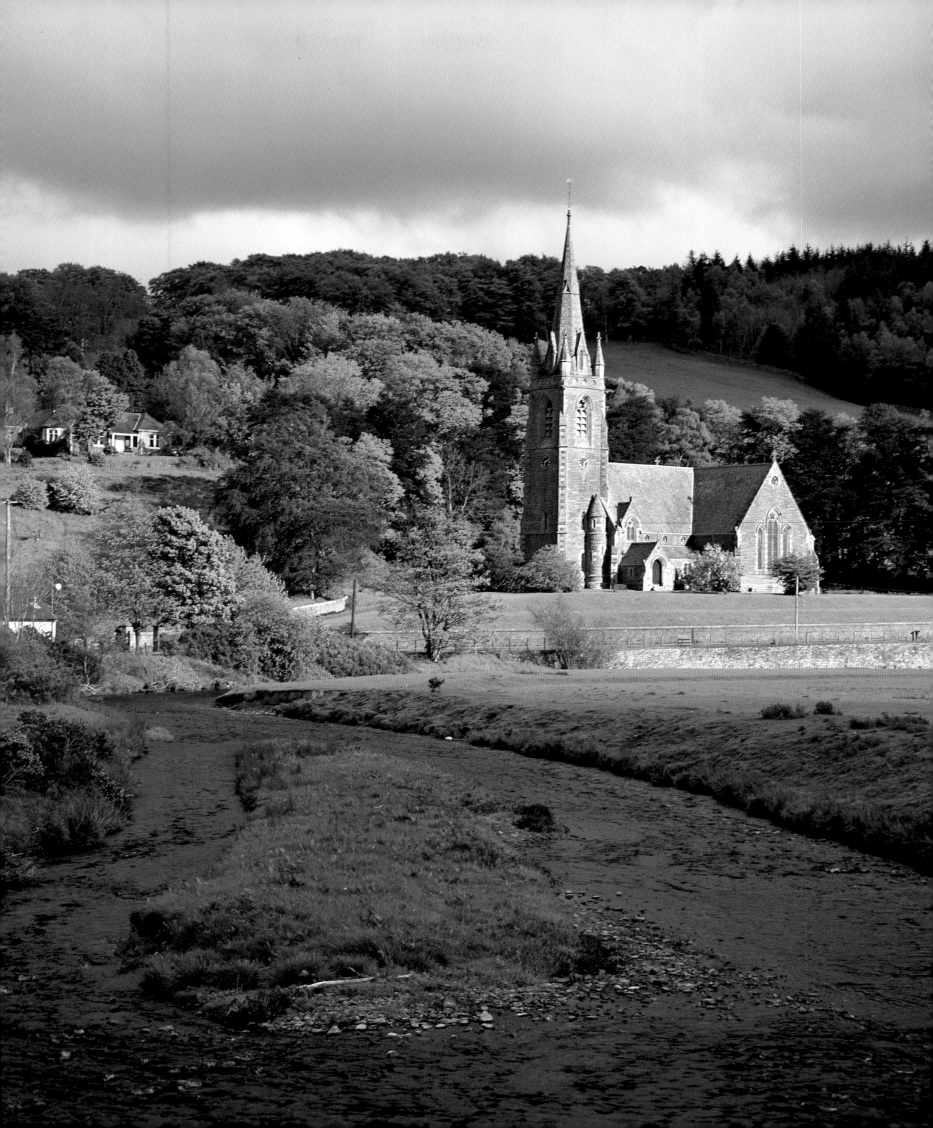

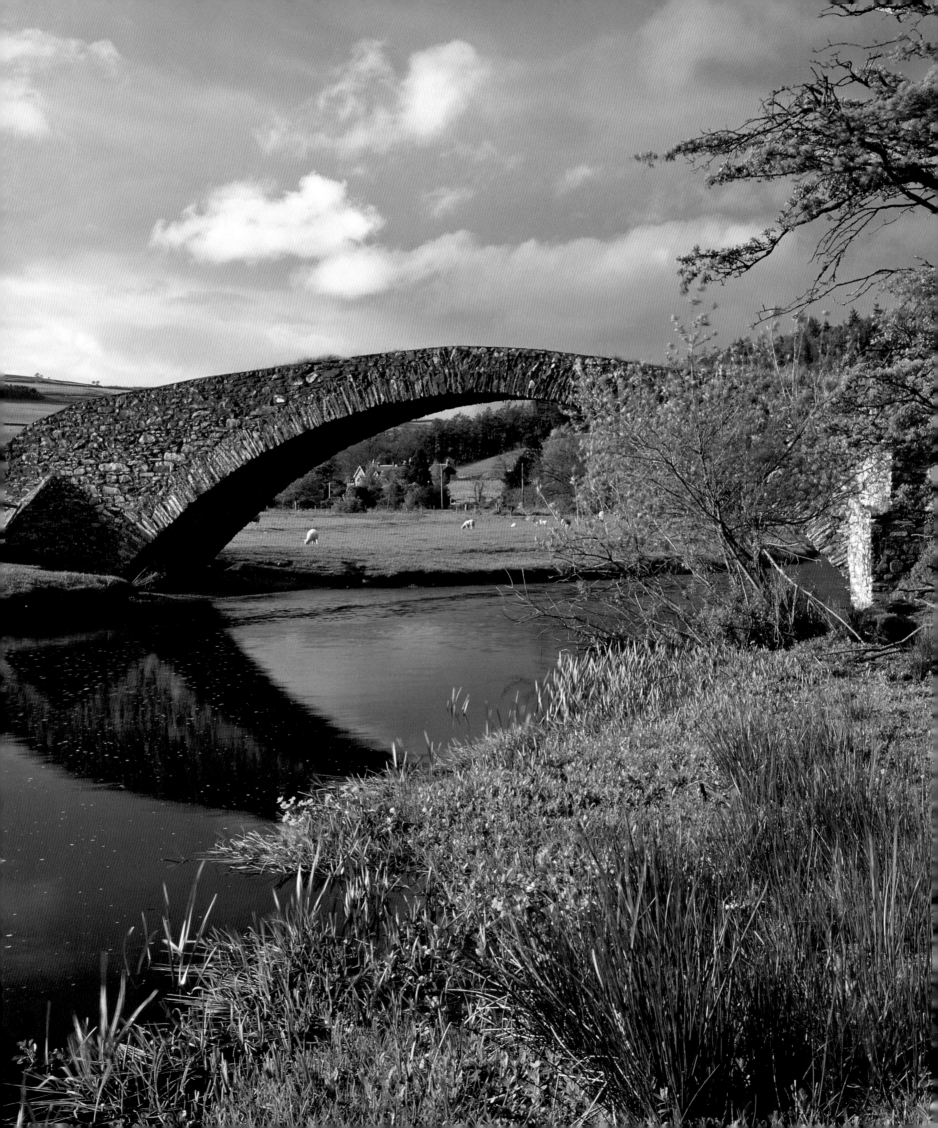

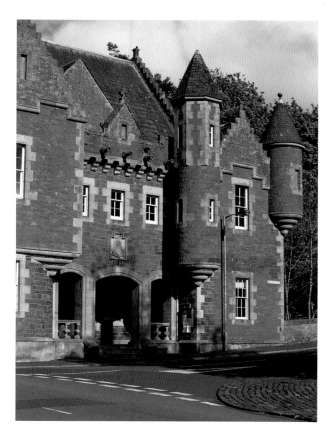

unfolding of medieval Scotland's political history. At the end of the thirteenth century, for example, it was William Lamberton, Bishop of St. Andrews, who financed the Braveheart, William Wallace, in his struggle against Edward I, and later crowned Robert the Bruce as King of Scotland.

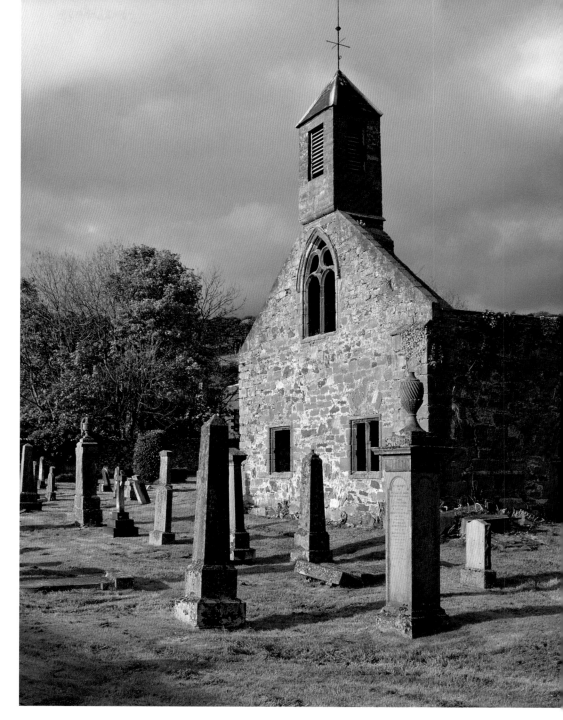

Another of Stow's architectural treasures is one of the best surviving examples of a packhorse bridge in the whole of Scotland (opposite). The bridge crosses the Gala Water (right), beyond which stretch the Moorcroft Hills. The façade of the village hall is a wonderful arrangement of corbel-towers (above), in rather better state of repair than the atmospheric ruin of the old church (above right).

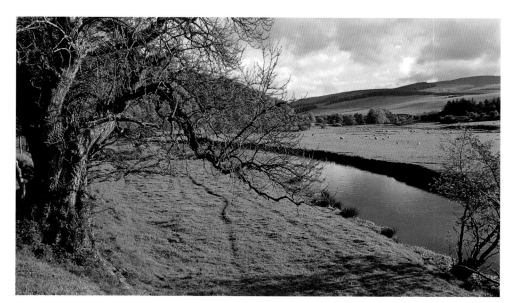

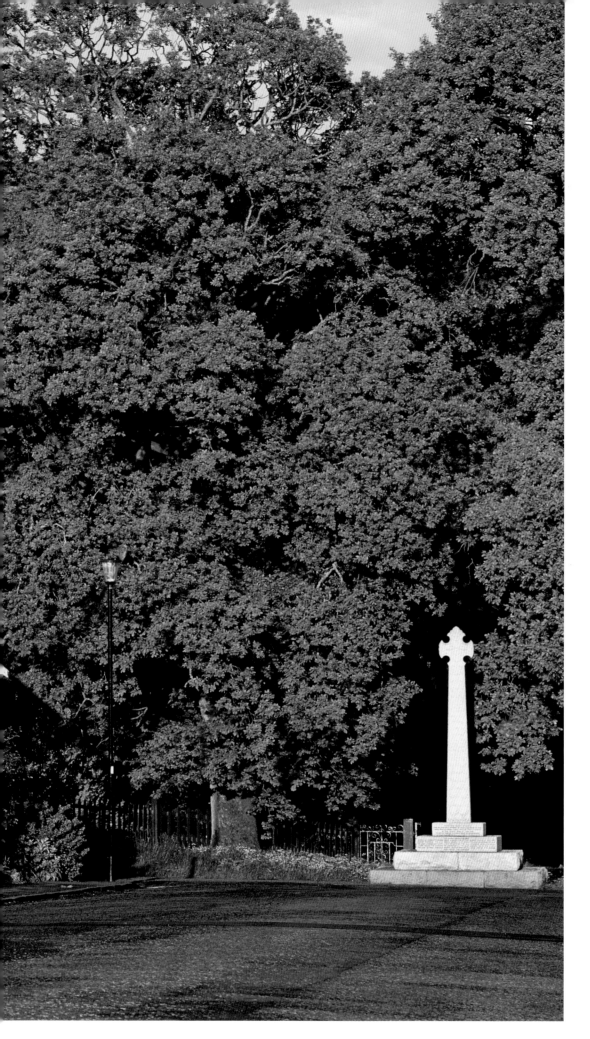

Straiton AYRSHIRE

Straiton is one of Ayrshire's largest parishes, presenting, as the ecclesiastical survey of 1845 records, 'many agreeable landscapes', including romantic glens that 'may vie with any of the most celebrated Highland scenes'. The main village of the parish sits comfortably, and less dramatically, in the tranquil Girvan valley. Its present layout dates from the mid eighteenth century, when the laird of Ballochmyle and Blairquhan, Sir John Whitefoord, rehoused his tenants here. The neat rows of one-storey cottages still face each other along the length of the main street, as it slopes gently towards the bridge over the Water of Girvan. Sir John was a keen innovator on the estates he owned, and a strong advocate of self-sufficiency and the dignity of labour among his own tenants. He also gave some timely advice to a young acquaintance of his: the Ayrshire poet Robert Burns, who had developed, alongside his versifying talents, a strong desire to escape from the poverty-stricken social class into which he was born. The celebrity that followed the publication of his first volume of poems in 1786 did not, however, ease his material circumstances, although he certainly relished the often dissipated company of his dashing new friends in Edinburgh.

Sir John unfortunately lost most of his money in the dramatic Ayr Bank Crash, which ruined many members of the Ayrshire gentry besides the Whitefoords. In contrast, the Hunter Blair family, who had set up their own bank in partnership with the first Mr. Coutts, profited greatly through the turbulent seventeen-eighties. They bought the Blairquhan estate in 1798, and are still the lairds of Blairquhan; they have been as good to their tenants as their predecessors, renovating all the houses of Straiton village and building a smart new country seat on the site of the original castle. The grounds include the picturesque Lambdoughty Glen, through which 'Lady Hunter Blair's Walk' passes alongside a lively stream through some fine woodland. A waterfall along its course has acquired the title of 'Rossetti Linn', supposedly being the spot at which Dante Gabriel Rossetti contemplated suicide during a visit to the neighbourhood in the autumn of 1868.

*N*eat rows of single-storey cottages (left) *mark Straiton as a planned village, the result of Sir John Whitefoord's determination to provide decent housing for his tenants and workers in the mid eighteenth century.*

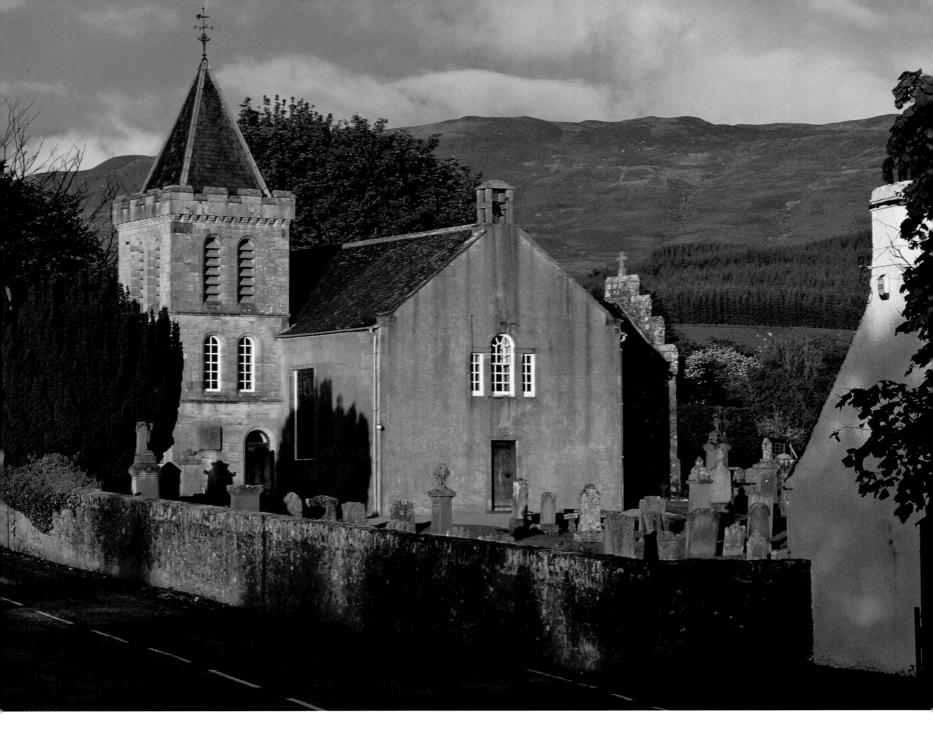

76 · *Straiton* AYRSHIRE

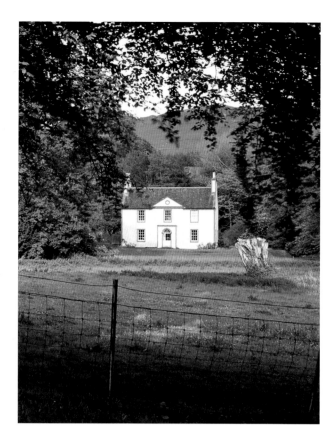

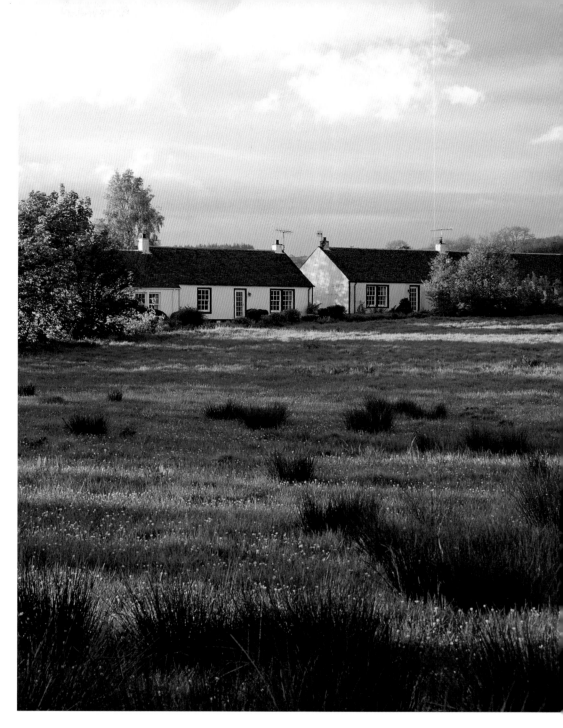

*I*n keeping with the generally small-scale appearance
of Straiton (opposite below *and* this page), *the
church of St. Cuthbert* (opposite above), *parts of which
date back to 1510, has a dainty air against the back-
ground of the wild-looking fells to the south.*

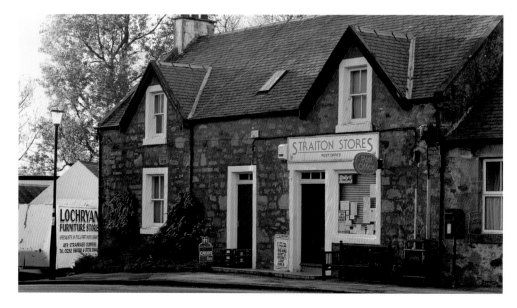

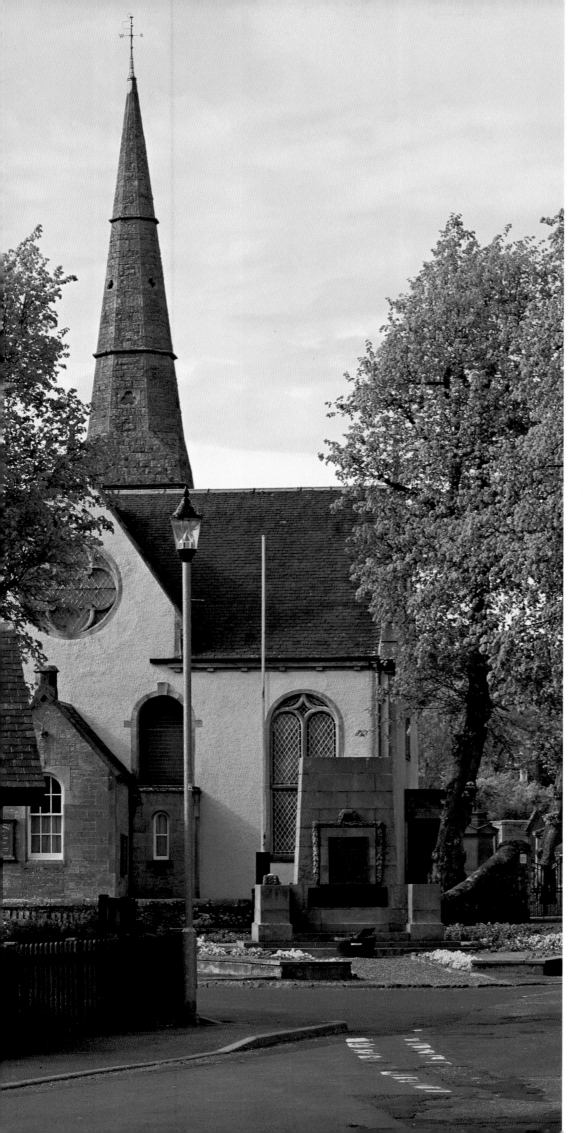

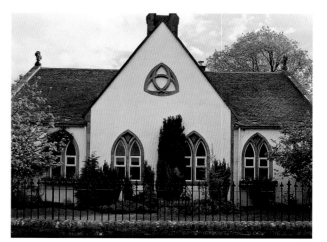

West Linton
PEEBLESSHIRE

For centuries, the old drovers' roads from the Highlands formed an extended network of routes which finally converged on Crieff and Falkirk. Until the steamers and the railways took over the transport of cattle, the long journey southwards was an arduous trek through wild country to take advantage of free grazing and to avoid heavy tolls and dues. From Falkirk, the main route passed over the Pentland Hills by Cauldstane Slap and descended into Peeblesshire to cross the Lyne Water at West Linton.

Although small, the village became an important market-place, attracting buyers from the south for Highland cattle and for the prized sheep of the locality. By the beginning of the nineteenth century, more than thirty thousand sheep and cattle were sold there each year. By that time, the site of the market had moved westwards from the village green, but all had to pass by the toll-house, still standing at the foot of the Lower Green, to pay their dues.

The medieval layout of West Linton remains unchanged, with enchanting miniature alleyways and lanes running off the main square, which itself is barely the size of a courtyard beside the Victorian houses that have replaced the original dwellings. The principal street runs roughly parallel to the Lyne Water, though separated from it by the two greens; the meandering course of the street is said to reflect its previous role as the bed of another stream, the Rumbling Tam, which was diverted to run into the Lyne at the spot now known

*A*s an important market for Highland cattle, West Linton could exact dues from the drovers, payable at the toll-house which still stands (left) close to St. Andrew's church. Some fine houses (above) remain as a legacy of the village's trading prosperity.

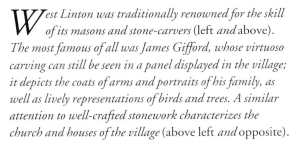

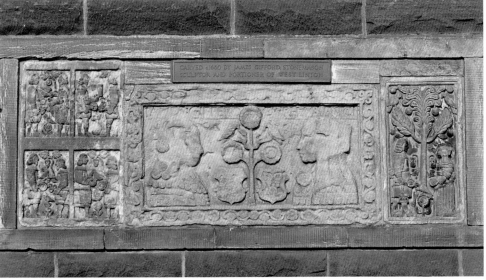

*W*est Linton was traditionally renowned for the skill of its masons and stone-carvers (left *and* above). The most famous of all was James Gifford, whose virtuoso carving can still be seen in a panel displayed in the village; it depicts the coats of arms and portraits of his family, as well as lively representations of birds and trees. A similar attention to well-crafted stonework characterizes the church and houses of the village (above left *and* opposite).

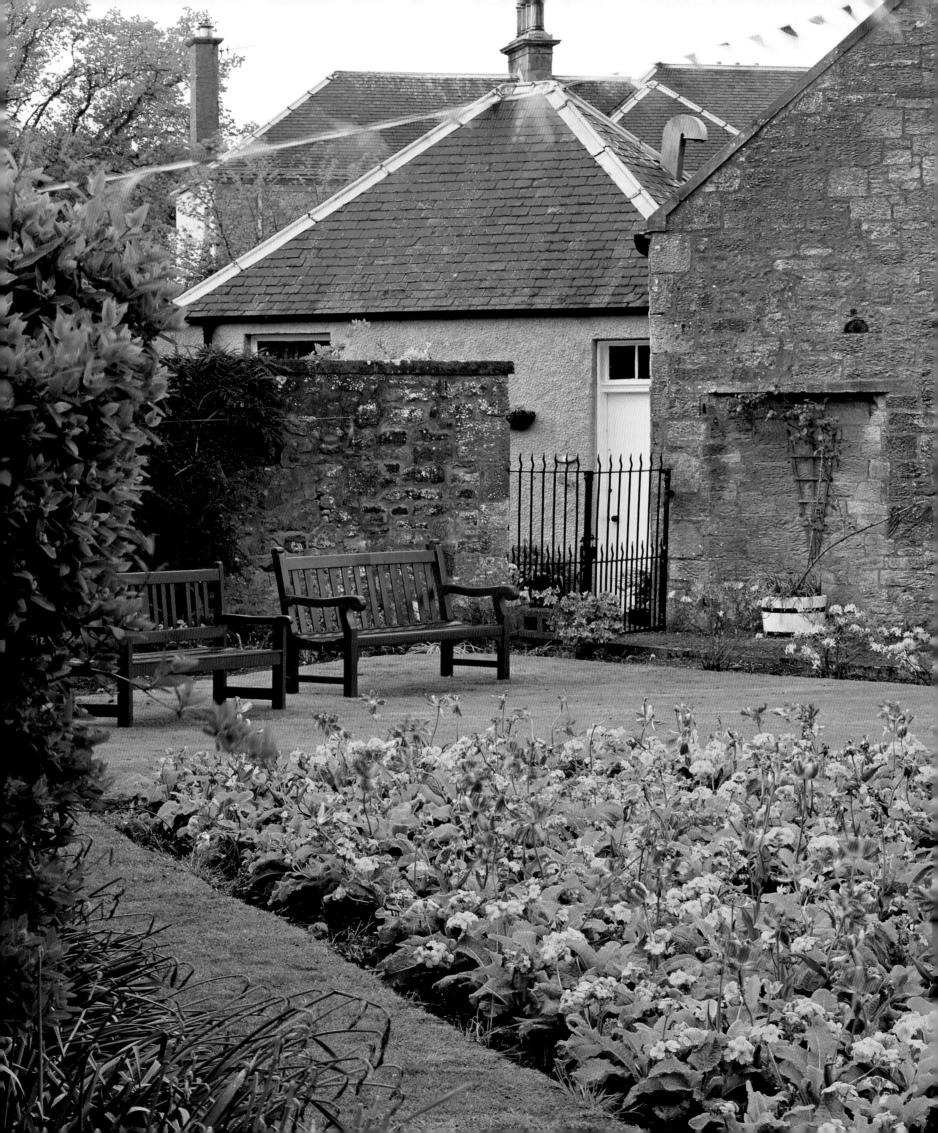

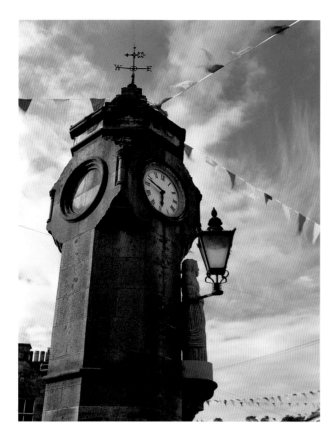

as the Tam Well. On market days, the supposedly health-giving water was sold to the public at a halfpenny a glass.

The villagers' income also came from more productive sources. There was a good deal of weaving in the village, and boot-makers were kept busy supplying those who worked in the local quarries and collieries. West Linton was also celebrated for the skill of its stone-carvers, whose work can be seen in the old graveyard by the parish church of St. Andrew. The most celebrated of these was James Gifford, who seems during the course of his career to have established himself as unofficial laird of the place, commemorating his self-elevation with numerous examples of his art.

*A*lleyways, lanes and tiny squares, lined with solid stone houses and enlivened by well-tended patches of garden, lead off the main street (opposite, right and right above). The clock tower of 1894 (above) replaced a market-cross erected by James Gifford in 1660, featuring a statue of his wife, with images of their four children, one at each corner of the pedestal.

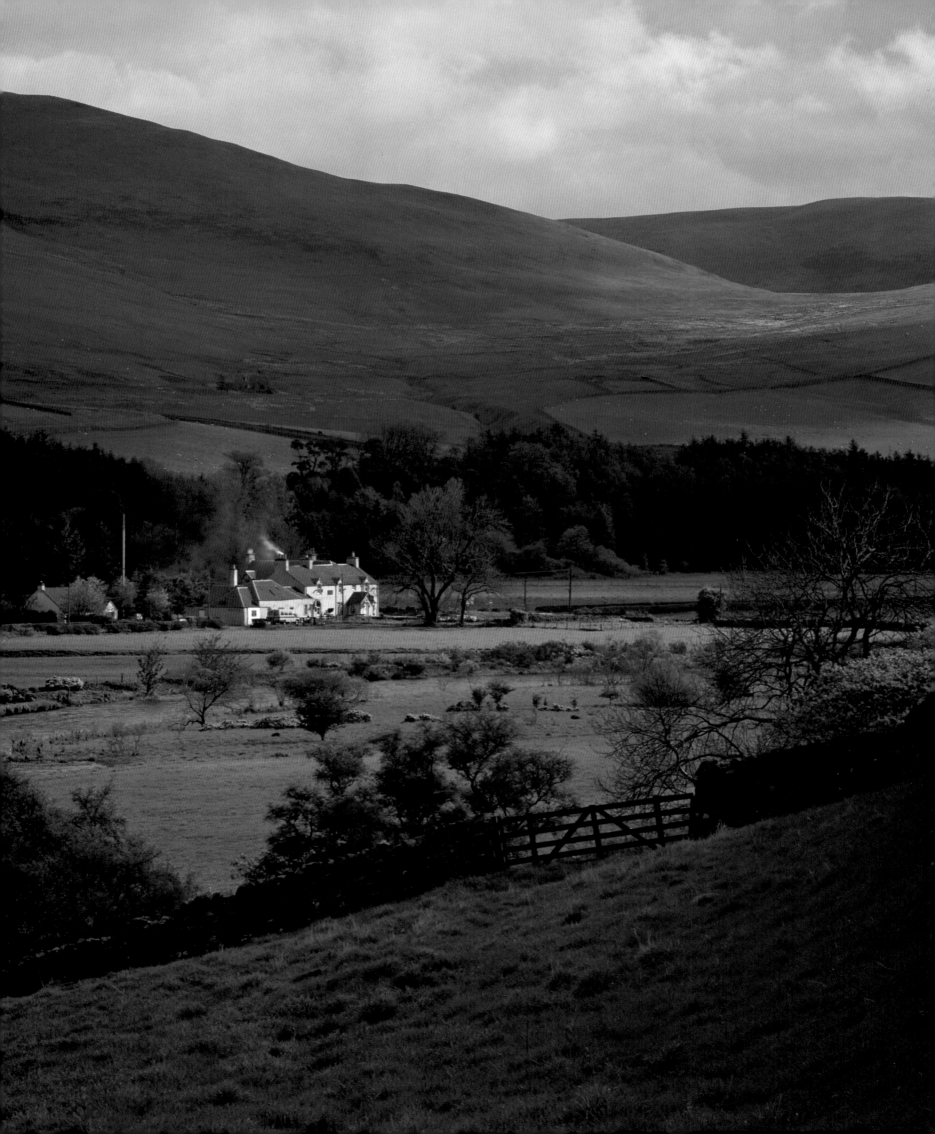

Yarrow SELKIRKSHIRE

*L*ying in the valley of the Yarrow
Water, the village is famous for
its association with Sir Walter Scott
and with James Hogg; the Gordon
Arms Inn (opposite), to the west, is
said to have been the scene of their
last meeting. The village itself
(below) consists mainly of venerable
stone cottages and, seen here, a
handsome village hall.

Over the years, William Wordsworth wrote no
fewer than three poems in praise of the Vale of Yarrow.
It was not by chance that the Lakeland poet first
wandered into this lonely stretch of the Border
uplands. The wooded valley, through which the
Yarrow Water winds from Selkirk towards St. Mary's
Loch, was also a great source of inspiration for his
friend and fellow poet, Walter Scott. The Edinburgh-
born lawyer's son had been sent to the Borders as a
child, to recover his strength after a serious illness.

In adult life, Scott was able to move back to the
Borders, where he was appointed Sheriff Deputy at
nearby Selkirk. His assiduous collecting of local folk-
songs had resulted in the publication of his first book,
the three-volume collection, *Minstrelsy of the Scottish
Borders*, which became an instant best-seller. Scott's
maternal great-grandfather had been pastor of the
church at Yarrow, and the poet went there often to
worship on a Sunday. The church still stands by the
Yarrow Water, at the centre of the far-flung parish.

On one of his explorations along Yarrow Vale he
met and befriended a fellow enthusiast of the place.
James Hogg had been born in the adjoining Ettrick
Valley into an impoverished farming family. After
a mere six months of schooling, he started work at
seven years of age as a cowherd. Having taught himself
to read and write, as well as to play the fiddle, he
graduated to shepherding, becoming known locally
for his verse and traditional songs. The two poets
met often to compare notes on the folk-songs they
had discovered, meeting for long sessions at the
Tibbie Shiels Inn at the western end of St. Mary's
Loch, where a statue now commemorates 'the
Ettrick Shepherd'.

The road by which today's visitor approaches
St. Mary's Loch runs from the church past the tiny
cluster of houses that surround the old school-house.
Above the nearby Gordon Arms Hotel, where Scott and
Hogg had their last meeting, stands the derelict form
of Dryhope, one of the many pele towers to be found

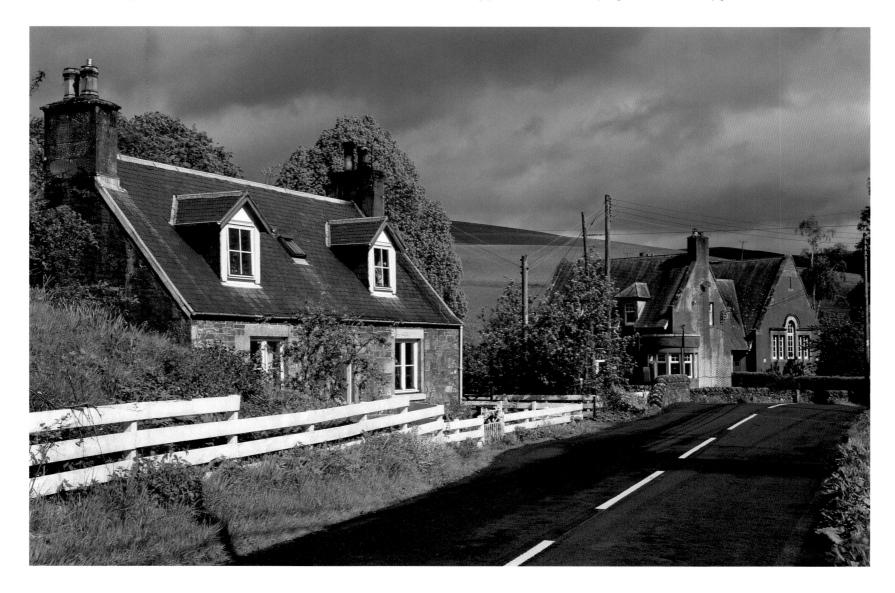

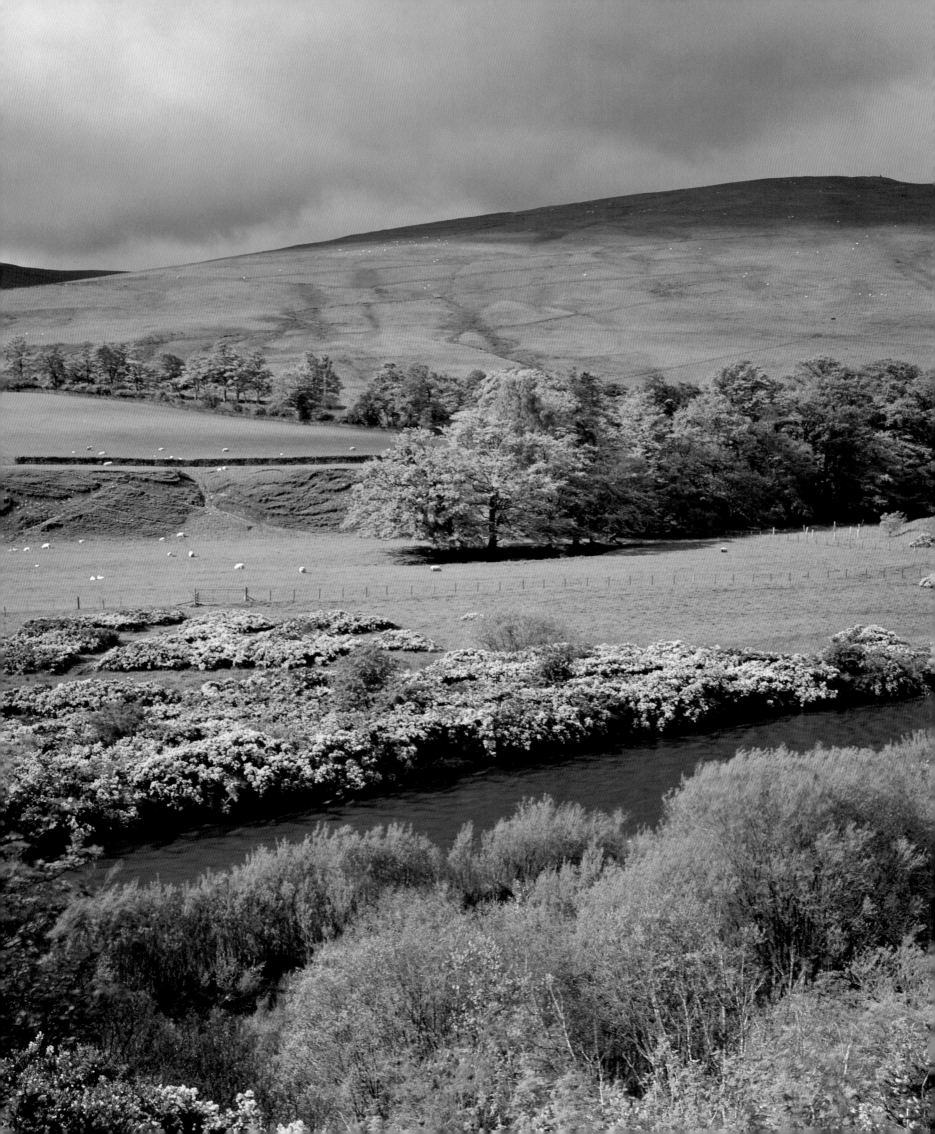

in the valley, which is to be restored. Appropriately, this is thought to be the former stronghold of the reiver Philip Scott, who forced his daughter to marry a local landowner instead of the ploughboy she loved, a story retold in one of Scott's poems.

*T*he peaceful Vale of Yarrow (opposite *and* above left) *was the inspiration for three poems by William Wordsworth. More literary associations are attached to the village church* (above right); *Sir Walter Scott's maternal great-grandfather was pastor there, and in later years it was a place of worship for the great author himself.*

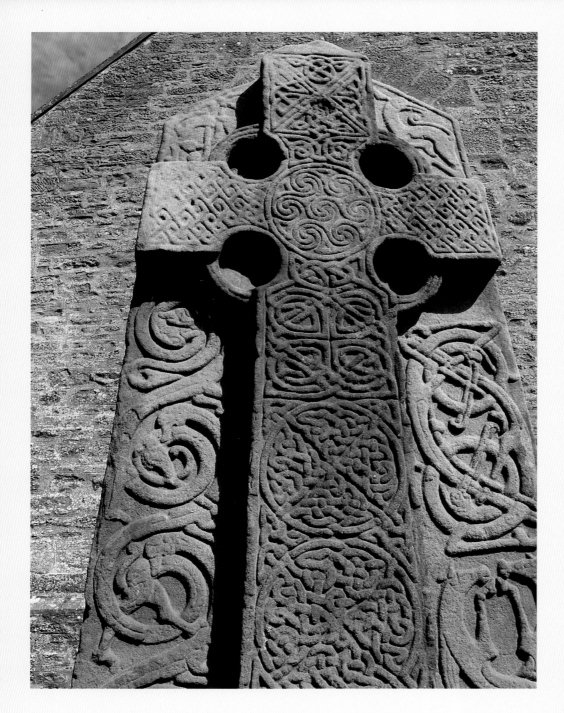

Ancient Scotland

The pre-history of Scotland is evoked, if not explained, by the powerful stone monuments raised by the country's early inhabitants. We know, from remains found on the Fife peninsula, of the presence of hunter-gatherers, who in all probability crossed from Germany or Scandinavia in primitive, coracle-like boats. These date from approximately eight-and-a-half thousand years ago. Further north, the mighty stone circles and alignments of standing stones, such as those found at Stenness and Brodgar on Orkney, are associated with later Bronze Age people, who lived a more settled, predominantly agrarian existence, building their arrangements of stone megaliths as a means of predicting the phases of the moon, as well as celebrating ritual observances.

History in its proper sense comes down to us first from a second-hand source, the historian Tacitus, writing in the first century A.D. He had a personal interest in the progress of the Roman Empire towards its most northerly boundaries; his father-in-law was Gnaeus Julius Agricola, commander of the Roman legion which invaded southern Scotland in A.D. 81. His decisive victory at Mons Graupius over the Celtic tribes marked the farthest point north of Roman territorial ambitions. Tacitus gives us a wonderful description of the tribesmen he calls the Picti ('painted ones') and even recounts a stirring pre-battle speech delivered by their leader, Galgacus. Tacitus, however, leaves us with few clues as to who the Picts actually were, and where they came from. Most historians agree that they had arrived from continental Europe during the first century B.C., as part of the successive waves of Celtic migration, although the mystery surrounding their origins, fuelled by the fantastic variety of their stone carvings, have led others to suggest that they might have first come from northern Spain, or even Scythia in Asia Minor.

The countryside of Angus is dotted with splendid sculpted artifacts of the Pictish era, such as the cross slab in the churchyard at Glamis (opposite). Another cross, in Aberlemno churchyard, has a Celtic cross on one side and a battle scene on the other (above left).

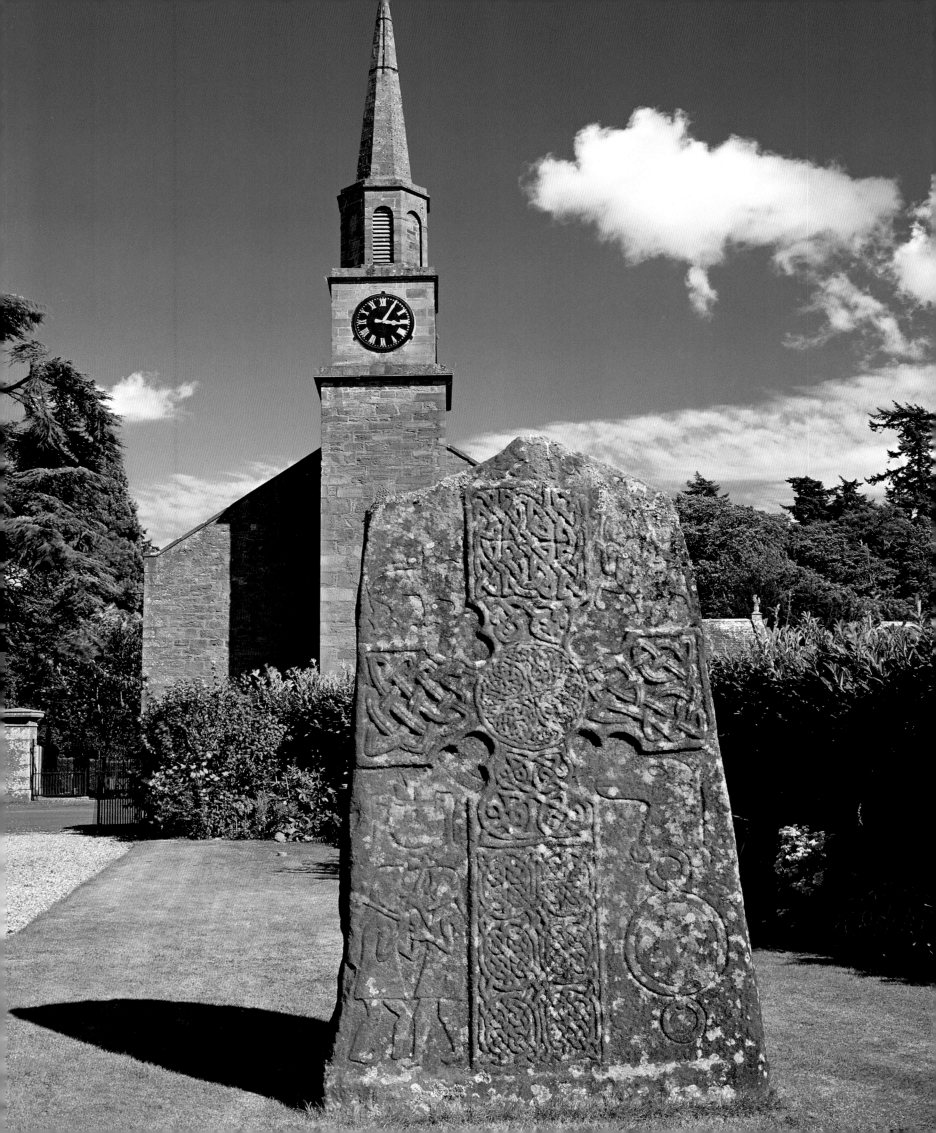

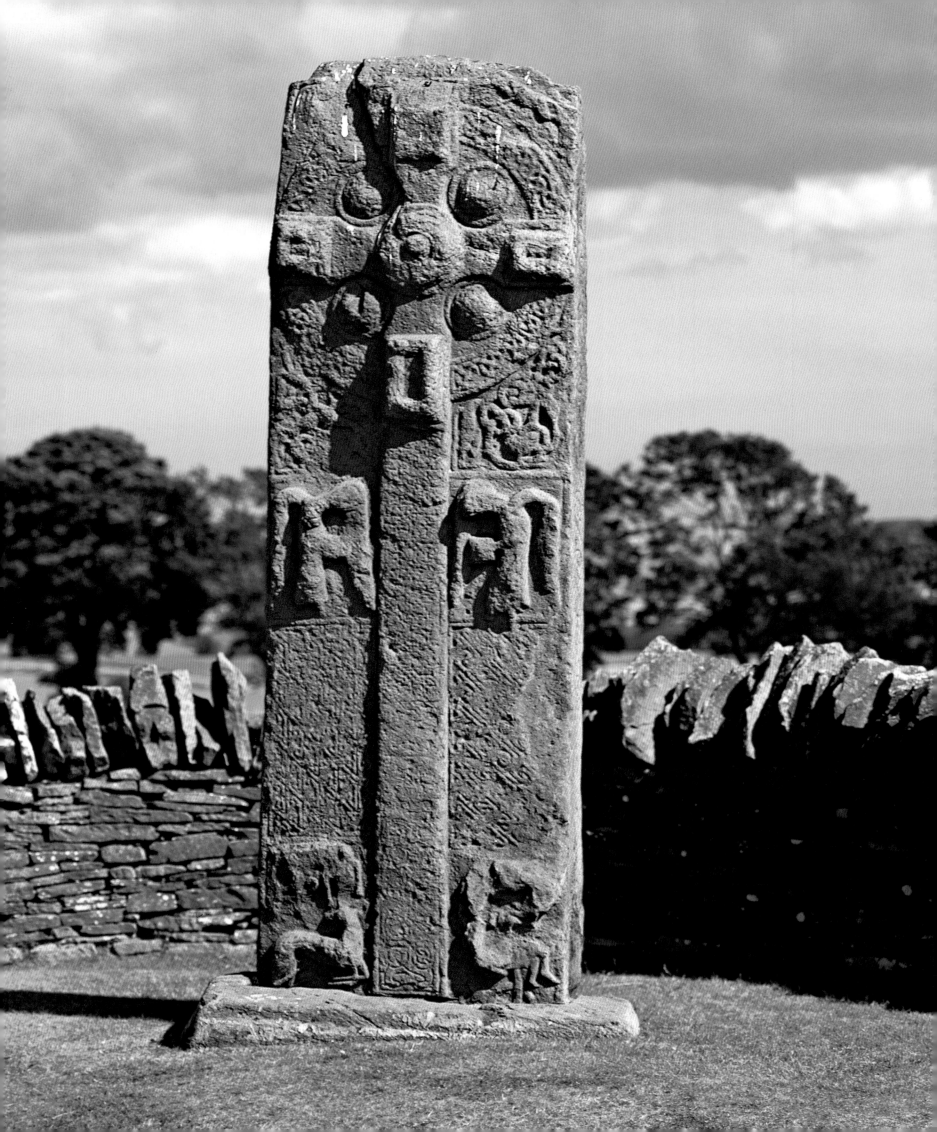

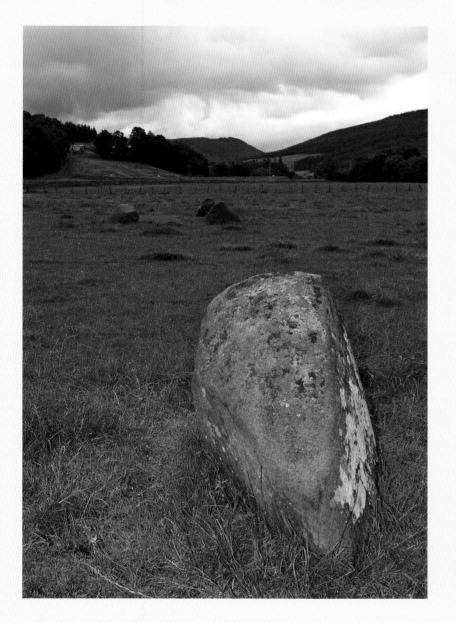

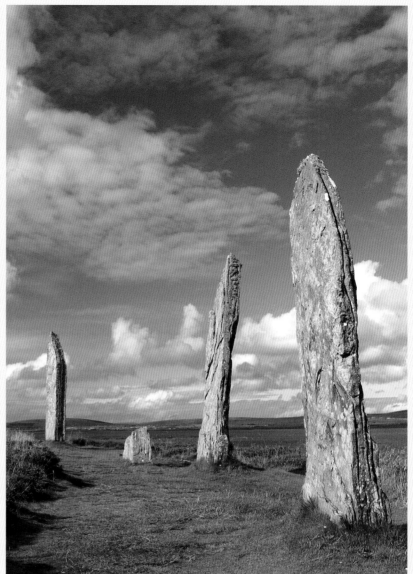

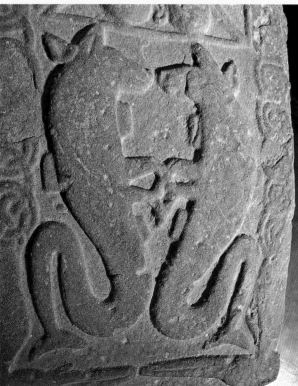

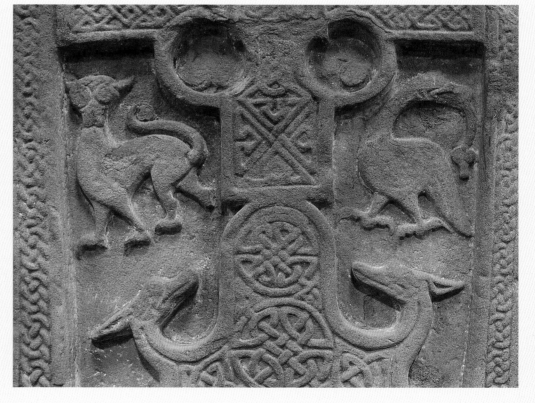

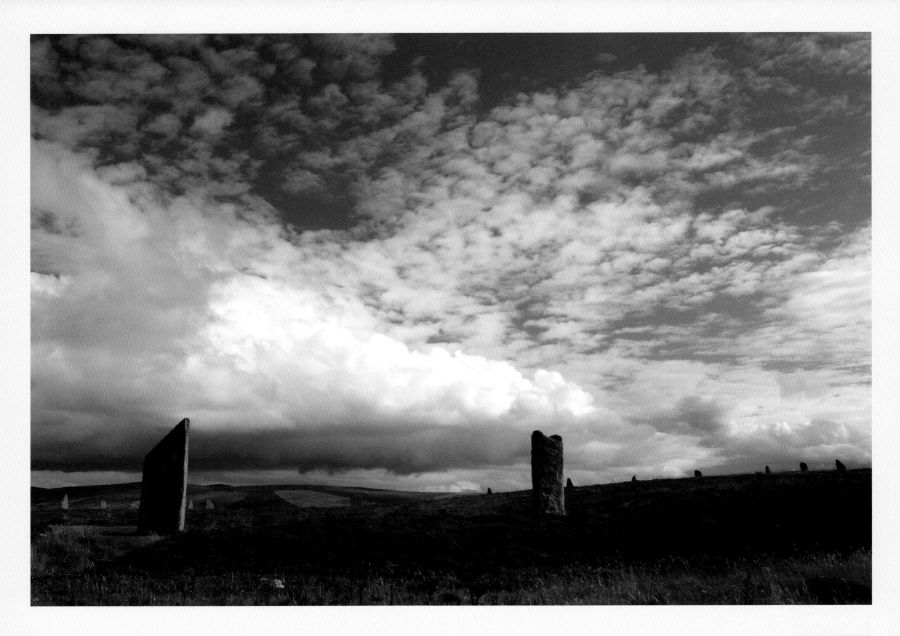

*T*he carved stones of the Pictish tribes (page 90 and page 91, below) *display a mixture of symbols which reflect the gradual conversion of the country to Christianity. There are, however, much earlier examples of standing stones, mainly in the form of ceremonial circles of the Neolithic period, near Fortingall in Perthshire (page 91, above left)* and, most notably, *at Brodgar on Orkney (page 91, above right).*

The Ring of Brodgar (above) *consists of a relatively wide circle of standing stones, of which twenty-seven survive out of an original sixty. More concentrated and in many ways more dramatic are the nearby Stones of Stenness (opposite), of which four remain from twelve, but the survivors do include a sixteen-foot giant. The stones of the Tomnaveric Circle, Aberdeenshire (right), have stood (and lain) in their present position since c. 1700 B.C.*

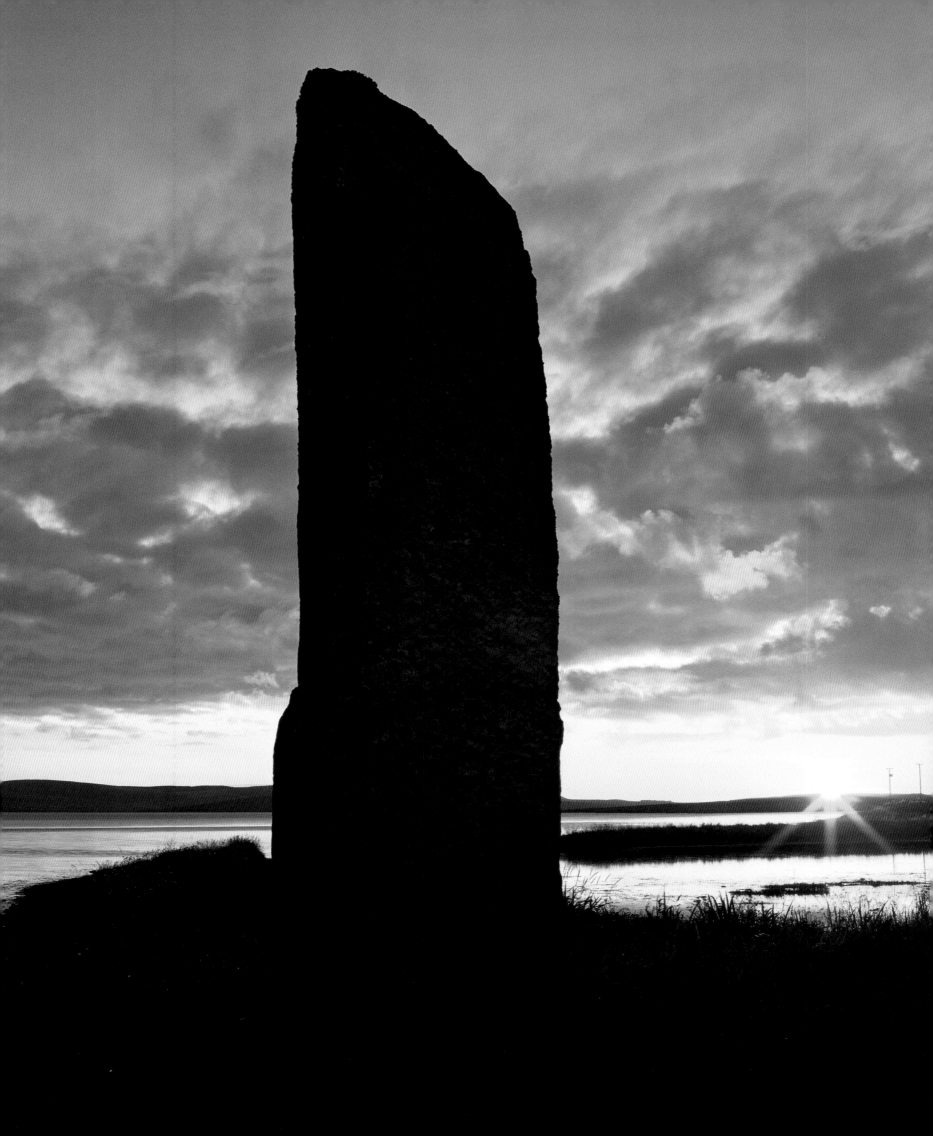

HIGHLANDS

*T*wo faces of the Highlands: originally a crofting community, Plockton has retained a number of traditional cottages, with their characteristic thatched roofs (above); other Highland villages, like Fortingall, have been subject to quite elaborate architectural attention (opposite). In this case, the designs of the hotel and the church were both inspired by the same man, James Marjoribanks MacLaren.

Visitors bound for the Scottish Highlands are treated to a suitably stirring overture, as they cross the mighty Firth of Forth by means of one of its famous bridges. These engineering marvels have been pointed out with pride to generations of schoolchildren. The first, a distinctive cantilevered railway bridge, was completed in 1890. Eight million rivets, fifty-five thousand tons of steel, and fifty-seven human lives were expended in this monumental undertaking; it also reduced the journey time for the Royal Train carrying Queen Victoria and her sizeable retinue on her increasingly frequent visits to her 'beloved Highlands'.

The monarch first came to the Dee valley in 1848, accompanied by her brightly-kilted consort, Prince Albert. She declared herself delighted with the scenery ('So gemütlich!' she wrote in her diary), and presumably with the reception committee of enthusiastic subjects who turned out to welcome her. Royal approval set the seal on a Romantic attachment to the Highlands which had begun with Wordsworth, Coleridge and Byron. Here, the gentle Lowlands have been quite left behind, and the often snow-encrusted peak of Lochnagar, celebrated by Byron, is only one of many substantial mountains that loom at the further end of the Dee valley. It is visible from the castellated home that Queen Victoria built here, at Balmoral, not far from the village of Ballater. Her successors have inherited her love of the place, returning annually for their summer holidays.

The vogue for the Highlands in Victorian times left its architectural mark on many of the smaller villages, among them Plockton, Tongue and Lochinver, which became destinations for the first generation of tourists in Scotland to go so far north. Busiest of all was Strathpeffer, which had a notable heyday up until the First World War, as a Highland variation on the spa craze at its height among the titled and wealthy of Europe.

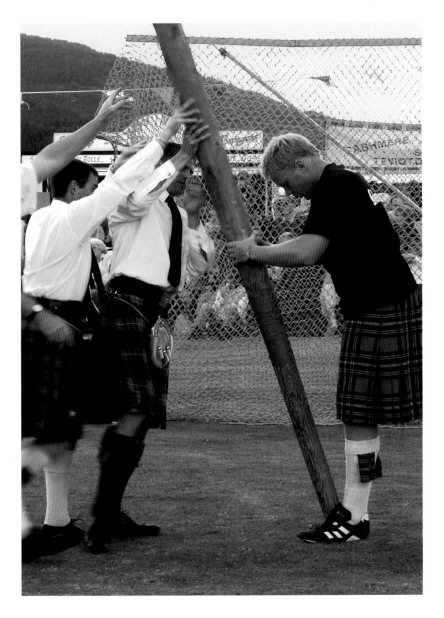

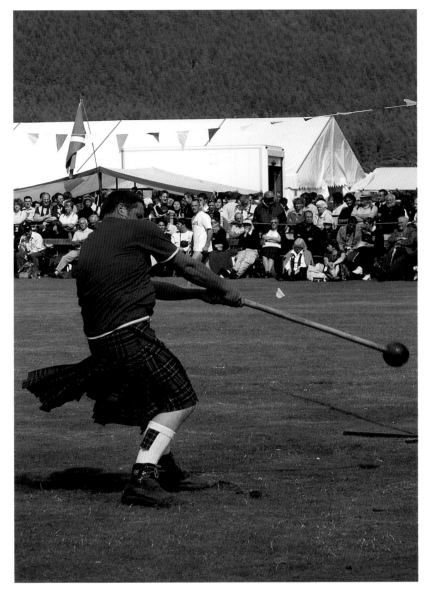

An essential part of Highland village life are the Games; activities vary from the 'heavies', such as tossing the caber (above left) or throwing the hammer (above right), to the lighter entertainments of piping and dancing (below right). Certainly, there is a renewed gaiety and pride in the Highlands, as here in the decoration of the streets of Victorian Edzell (opposite).

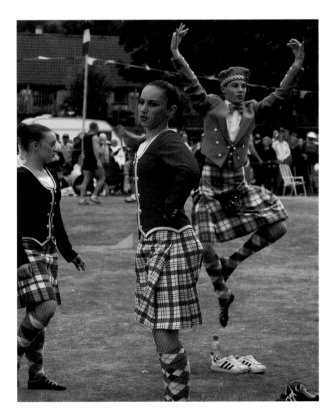

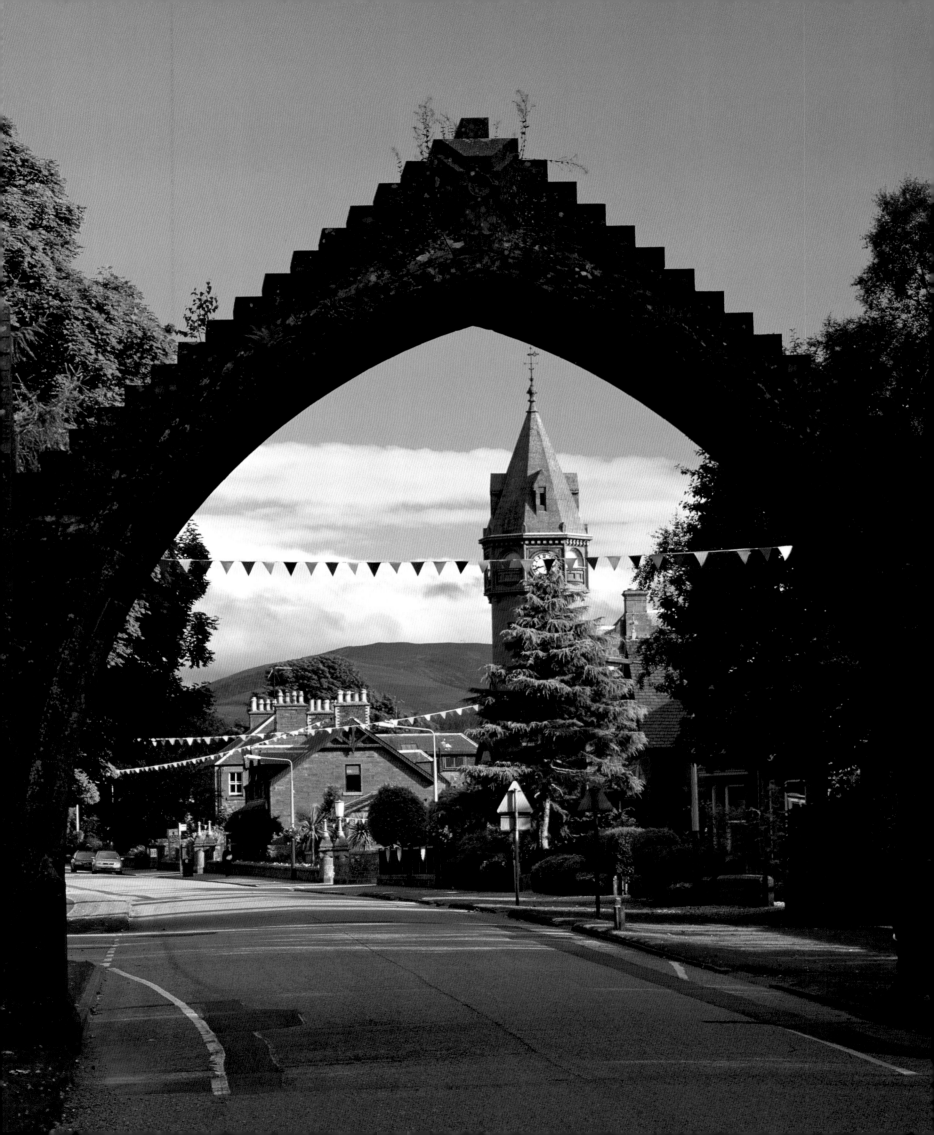

Auchmithie

ANGUS

WALTER SCOTT CHOSE THE DRAMATIC SHORELINE of Angus, where red sandstone cliffs rear up above an often stormy sea, for the setting of his third 'Waverley' novel, *The Antiquary*. He particularly admired the colourful lives of the local fisher-folk, who had eked out their precarious living here since Viking times. In Scott's day, the village had no proper harbour; the fishing craft were simply pulled up on the beach in the shelter of the rocks. The tenacity of the fishermen, setting off nightly in their small boats to arrive at the fishing grounds by dawn, was more than matched by that of their womenfolk. It was not only their job to haul the heavy creel baskets up the steep path to the cottages on the cliff top; they also regularly waded out to push the boats clear of the shore.

The main catch then was of haddock, which were in plenty all year round. However, for long periods in the winter, storms could prevent any attempt to go to sea and fish were often smoked to prolong their storage life. By 1890, the present harbour had been built, and no fewer than five hundred men worked in the village. But this level of activity started to decline when the

*T*he original home of the 'Smokie', Auchmithie is *a pleasant little fishing village, still with neat cottages on its cliff* (right), *but the harbour is now much quieter.*

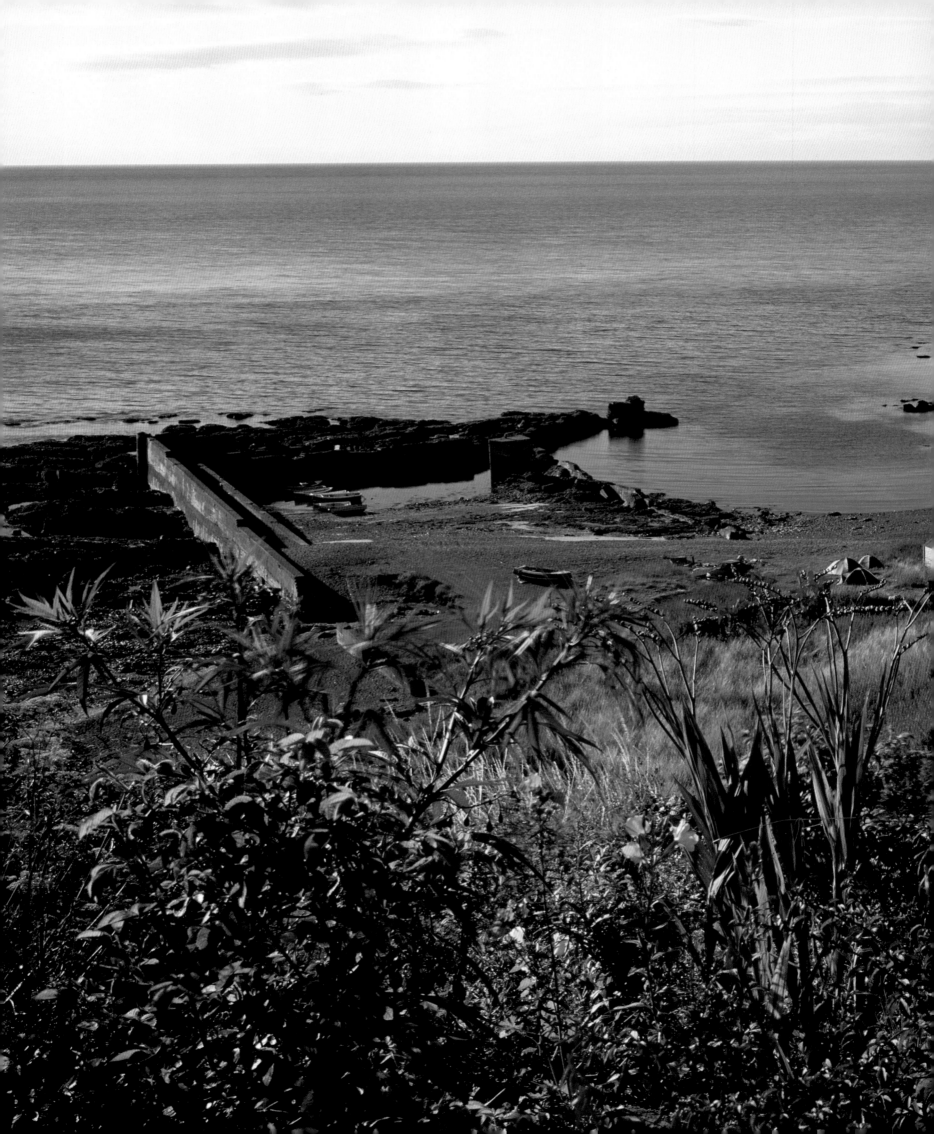

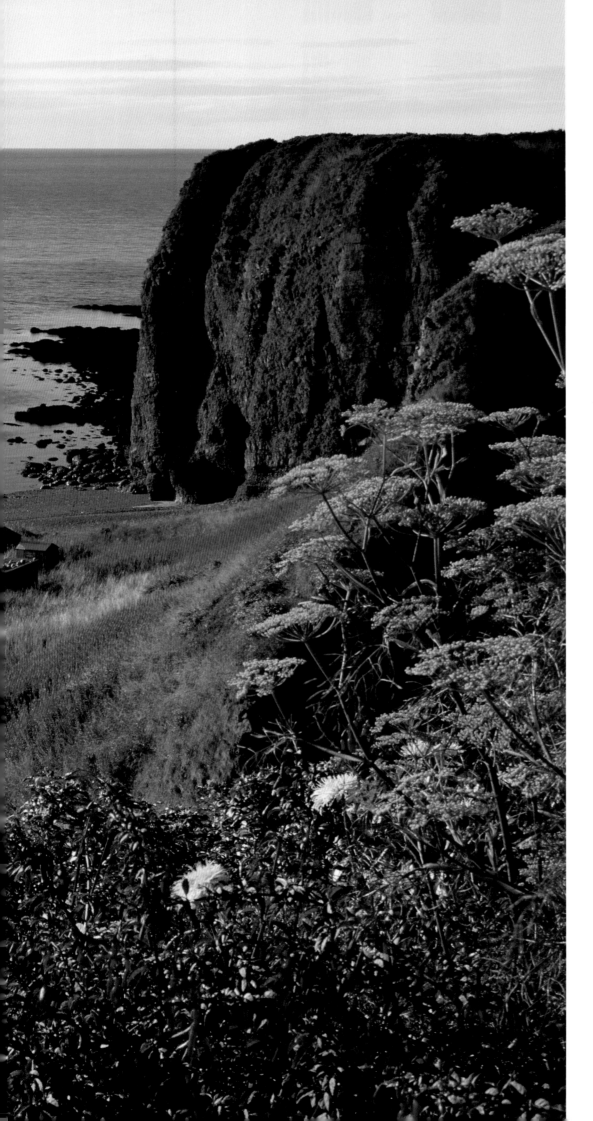

nearby town of Arbroath acquired a deep-water port after the First World War, and began to dominate the fishing in the area (as well as taking over the name of the famous 'Smokie').

These days, only a couple of boats use Auchmithie's harbour at the foot of the cliffs, fishing for lobster now, since the exhaustion of the haddock stocks. The diminutive cottages on the top of the cliff remain, though much tidied up since the days when Walter Scott could describe their fictional counterparts as having a 'squalid and uncomfortable appearance'. There is still only a single small lane to connect the village with the outside world; the resulting air of restful calm suits perfectly the mainly retired residents and charms the many visitors. The latter can take a quiet stroll down to the deserted beach, where the fishwives once argued over their prices.

There is a poignant beauty about the village harbour, lying beneath the brilliant hues of the cliff (left). *But the tiny community still maintains a pride in its appearance* (above).

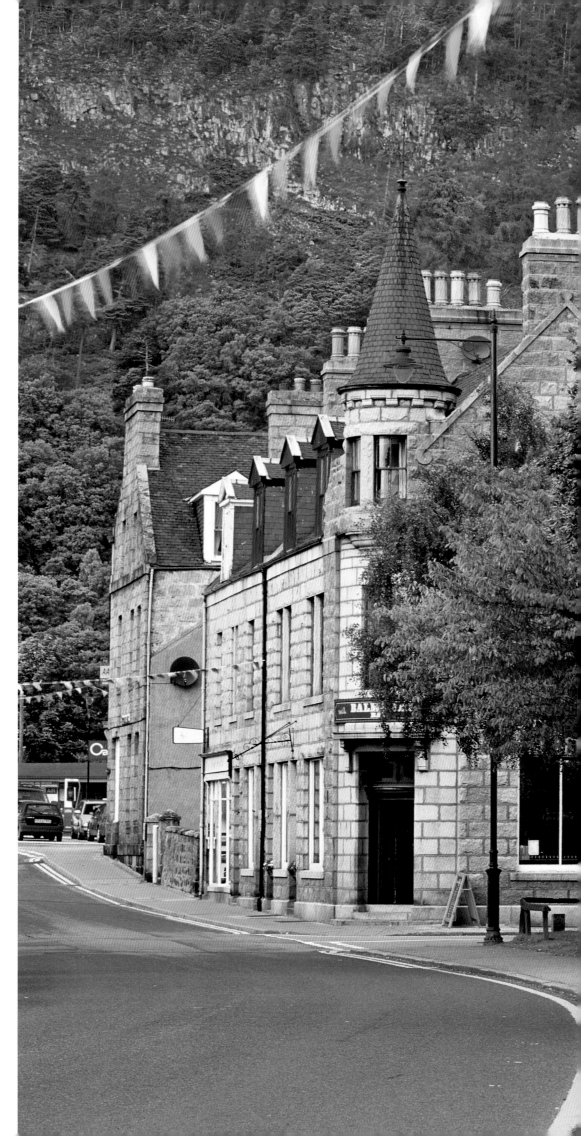

Ballater

ABERDEENSHIRE

THE LOVELIEST STRETCH OF THE VALLEY OF THE DEE, which sweeps down into the rich woodland around Aboyne from the wild and mountainous country to the west, will always be associated with Queen Victoria. The monarch gave 'Royal Deeside' her seal of approval when she established her summer home there in 1848. Chief beneficiary of royal patronage, then as now, was the village of Ballater, which had already seen a boom in its fortunes after nearby Pannanich Wells had gained a reputation for the curative powers of its waters. Prettily situated in a loop of the fast-flowing Dee, Ballater was the natural site for a resort, but had no connection, save by a risky ferry crossing, with the spa. A series of bridges were built, one by Thomas Telford himself, but none lasted many years before being swept away. Despite this, plenty of visitors flocked there to take the waters, among them a sickly youth who was later to grow into that robust swimmer of the Hellespont, the poet Byron. Indeed, the beauties of the Dee valley and the granite peaks that dominate it made a lasting impression on him, celebrated in the words of his *Lachin Y Gair*.

Ballater is still as popular a destination as ever, as Balmoral has been for succeeding generations of the Royal Family. The parade of little shops, some seemingly overburdened by the extravagantly proportioned Royal crests above their doors, continues to do a healthy trade. Bunting and bandstands abound, with trim parks and open spaces from which to admire the solidly baronial public buildings. These look as pristine as ever, built with no expense spared from the local granite. Equally solid is the latest bridge in the series, opened in 1885 by Queen Victoria; it has

Surrounded by tree-clad mountains, the prim and proper streets of Ballater exude an air of quiet prosperity, derived perhaps from years of Royal patronage and the presence of visitors (above and right).

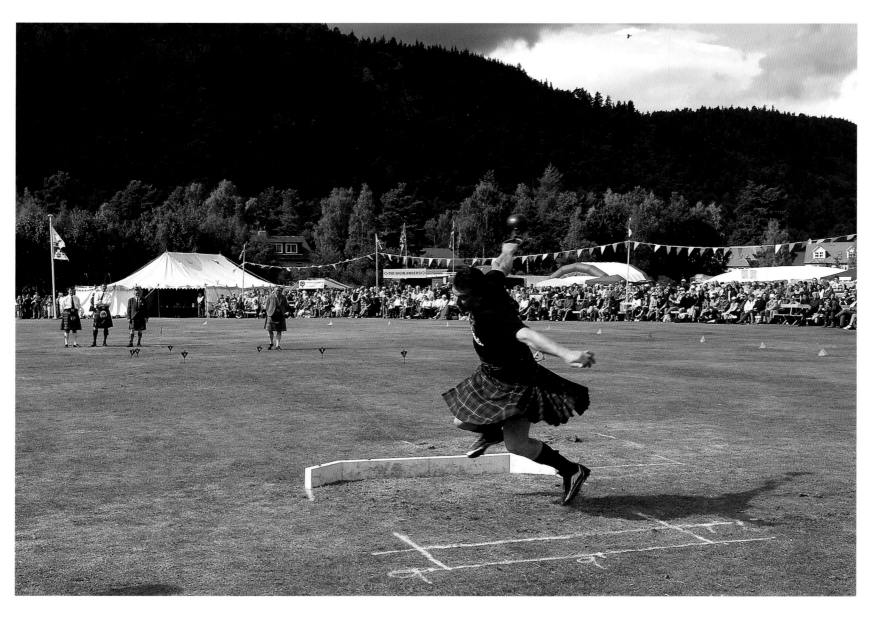

*B*unting, bands and open spaces for the Games (above and right) are obvious signs of the continuing vigour of village life in Ballater. The place remains as popular now as it was in the nineteenth century, when it was one of Queen Victoria's favourite destinations.

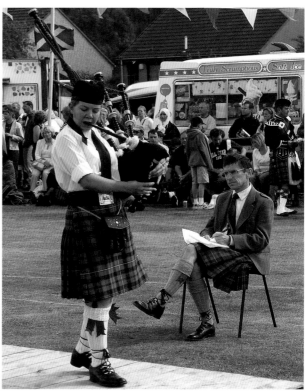

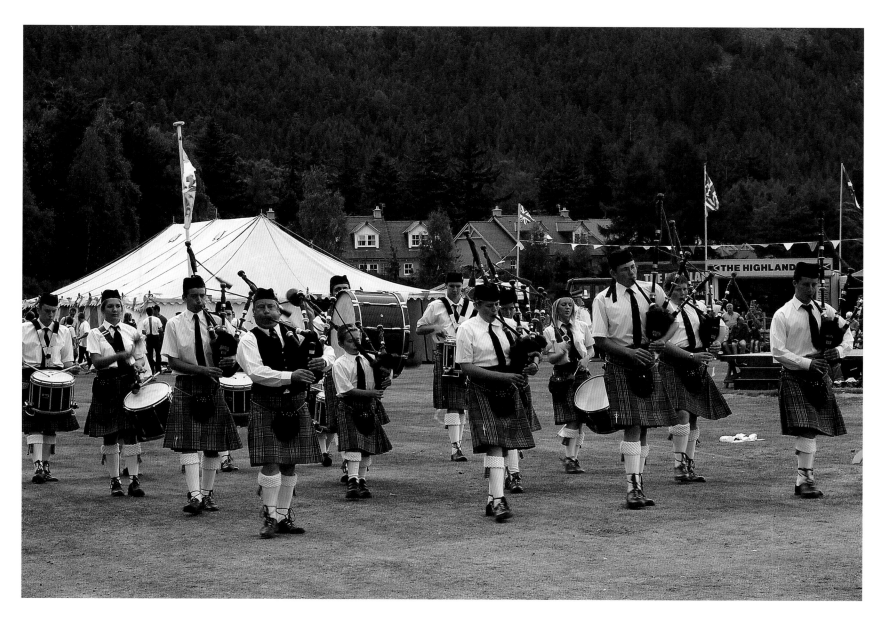

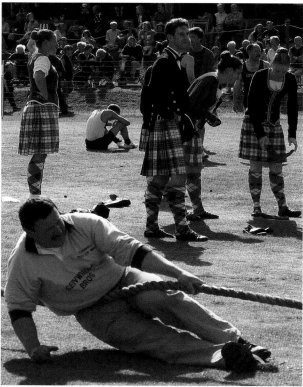

*T*he Games at Ballater have all the usual ingredients
of straining physical competition (left) *and dancing
and pipe bands, often from places far from the Highlands.
This group* (above) *is, in fact, from Bavaria.*

survived numerous winter floods and so far shows no signs of needing yet another replacement. The only casualty of history has been the railway line, built in 1866 to bring the Royal Trains, as well the countless trippers in their wake, as far as Ballater. The splendid station, furnished with an extra-long platform to accommodate the trains of state (a Shah and a Czar came to Ballater) has been restored as a Victorian Heritage Centre, complete with tableaux designed to give an idea of the pomp and circumstance of a Royal arrival. The tracks themselves have long since disappeared, leaving Victoria marooned in the plush comfort of her personal Waiting Room.

*O*ne of the casualties of the growth of motorized transport has been the elegant station at Ballater, now restored to life as a Victorian Heritage Centre (above). Originally opened in 1866, with a specially long platform to accommodate the Royal Train, the station was but one aspect of the regal presence here; shops display outsize crests, indicating Royal patronage (right), and inevitably there is a Victoria Road (opposite).

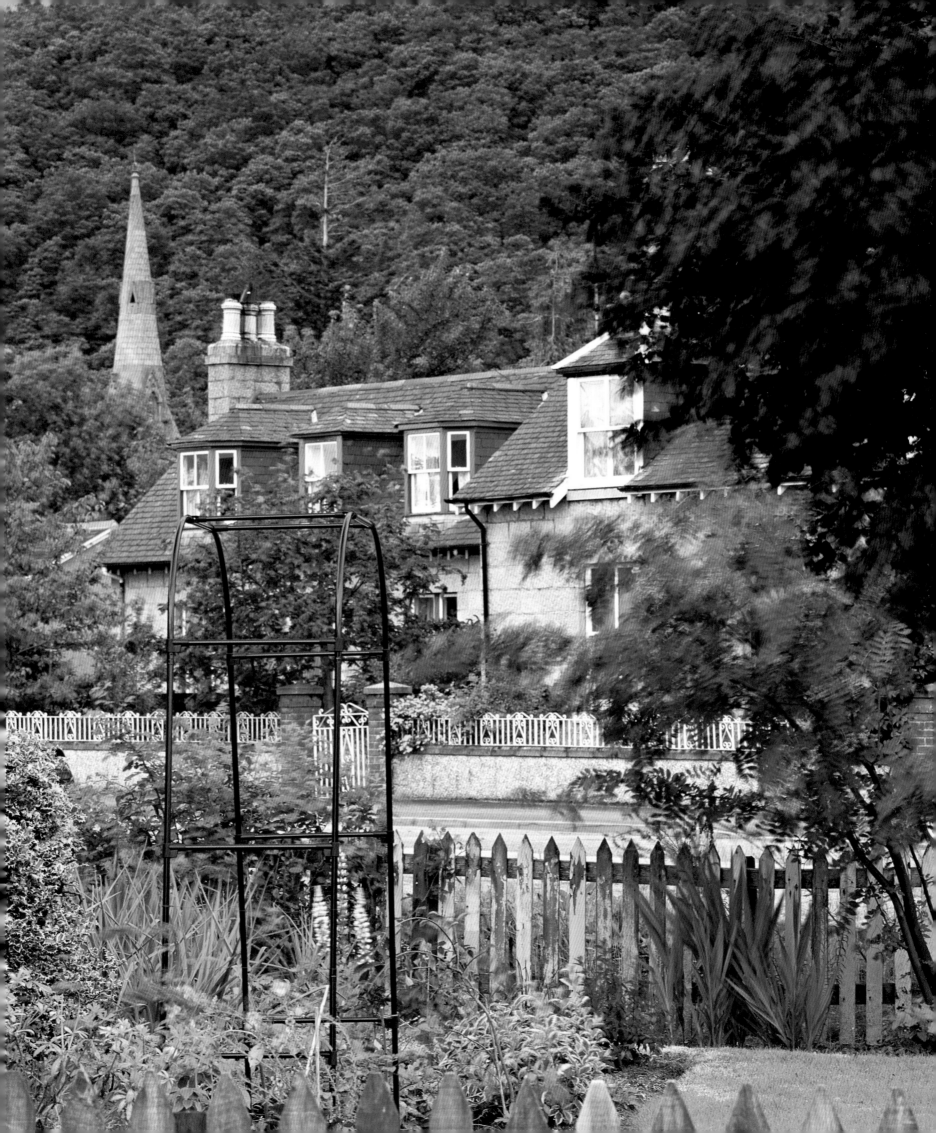

Crinan
ARGYLLSHIRE

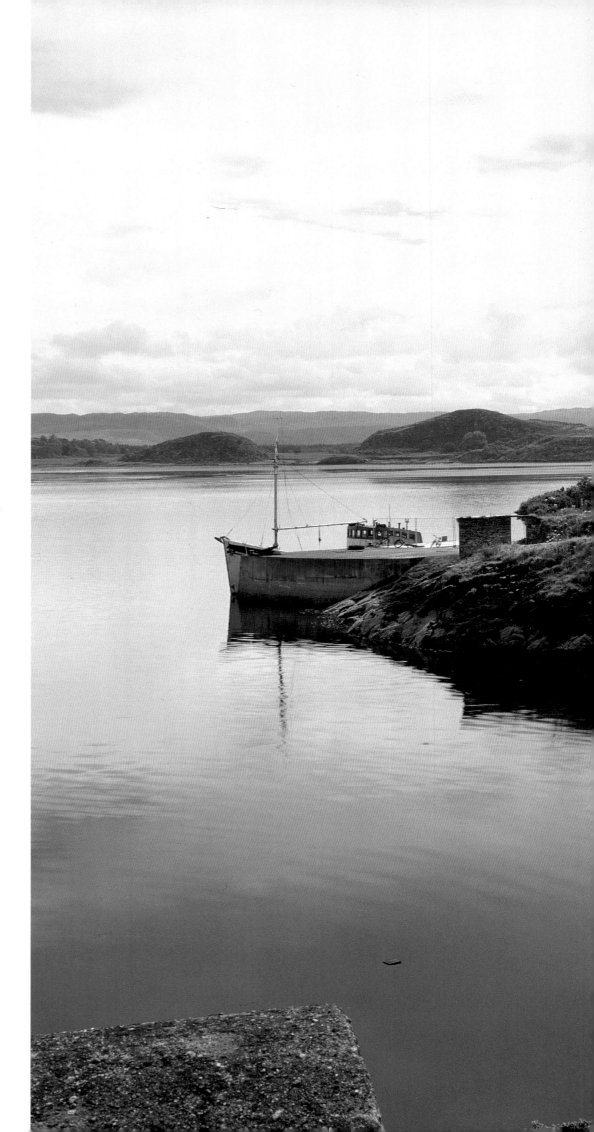

IN 1789 A GROUP OF SCOTTISH LANDOWNERS commissioned the engineer John Rennie to survey the narrowest point of the Kintyre peninsula. Their plan was to run a canal between Loch Fyne and the Sound of Jura, cutting out a 130-mile circumnavigation and thus avoiding the often stormy waters off the Mull of Kintyre. The north-west of Scotland and the Hebrides would then benefit from the shipping and industrial developments emerging around the Clyde. The survey was completed, the arguments made at Westminster, and in 1793 an Act of Parliament was passed authorizing the construction of the Crinan Canal, the money to be raised by its noble proprietors and the equity to remain in their hands. By 1801 the canal had been dug and opened, although not properly finished – its poor condition subsequently necessitated constant repairs and renewals.

The arrival of the railways put paid to the dream of a money-making canal system, and the newer freight-carrying ships were larger and too wide for the waterway. Passenger craft still continued to use the route, however, although it is recorded that passengers often walked along the towpath, easily keeping up with the slow progress of the steamers through the fifteen locks. Today's visitors are often tempted by the pleasant views to follow their example. The nine-mile walk, or cycle ride, is not unduly taxing, as the canal rises a gentle 65 feet to its highest point.

Journey's end is at Crinan, where the canal, having followed the shoreline of the sea loch for some miles, eventually connects with the Sound of Jura by means of its northernmost lock. A tiny village, presently home to less than sixty people, has grown up around the canal basin here. It is all very neat and shipshape, with moorings for passing yachts and the occasional antique vessel laid up for restoration. A handful of whitewashed cottages surround the little haven,

By the northernmost lock on the Crinan Canal, looking out to the Sound of Jura, a tiny fishing settlement has grown up, complete with a diminutive lighthouse (right).

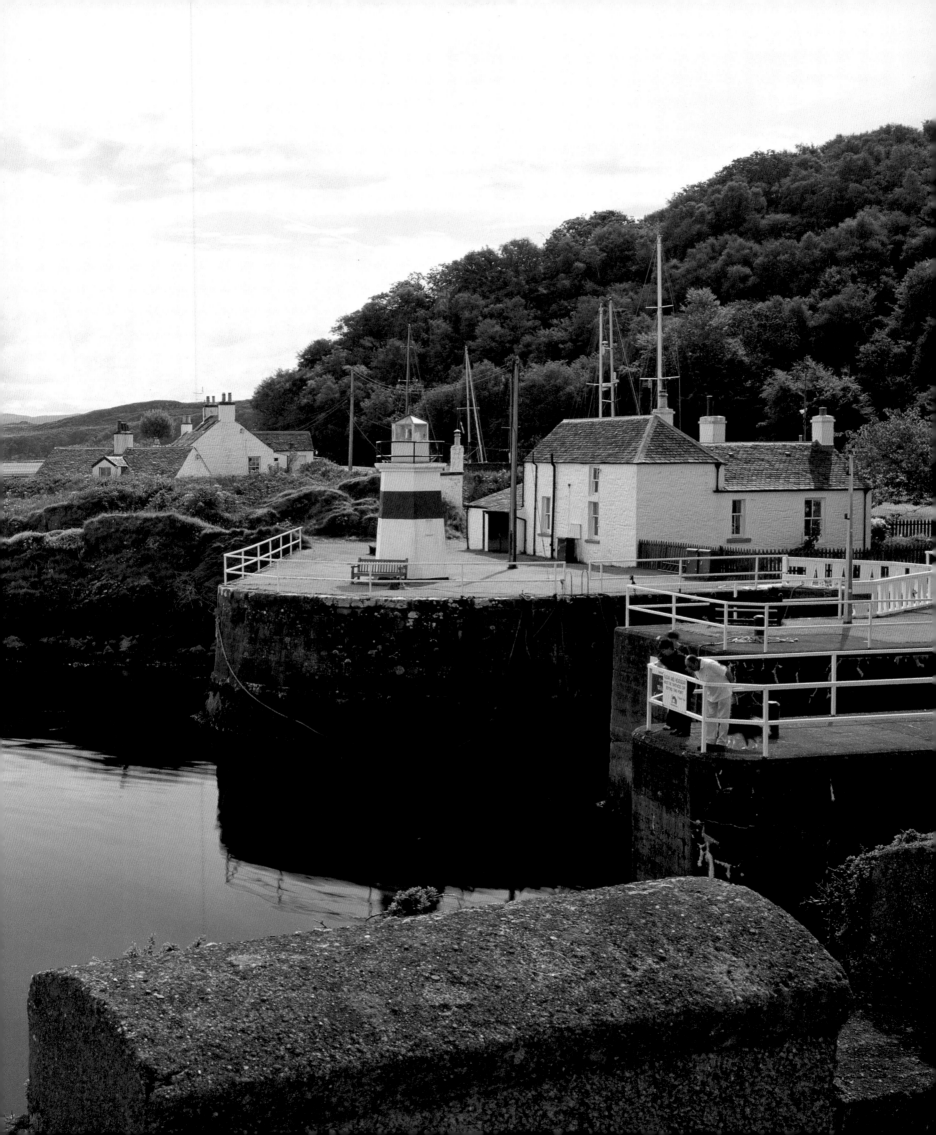

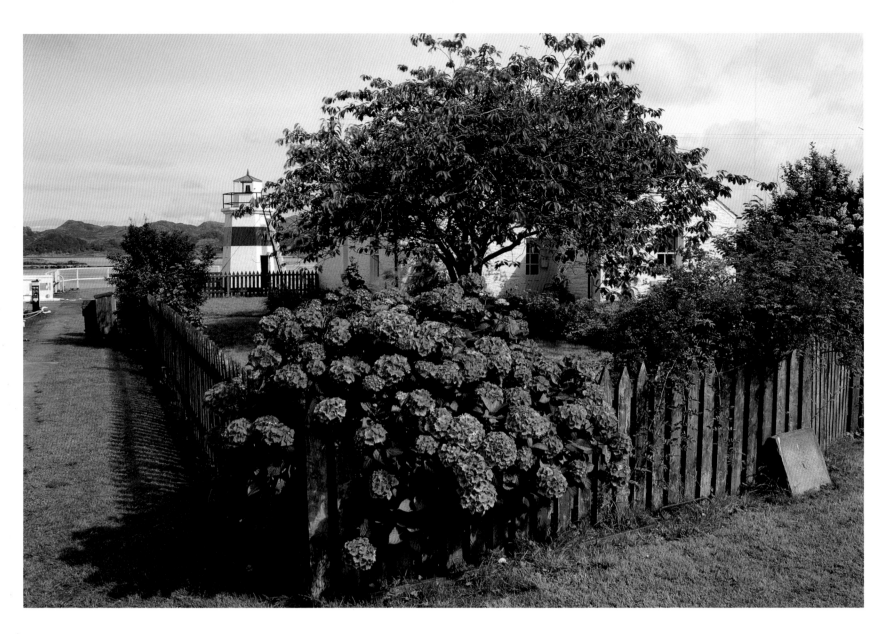

*T*his tiny community, characterized by stylish cottage architecture and well-kept gardens (above *and* right), *came into being entirely because of the canal and lock. More cottages, at Cairnbaan, extend down the banks of the canal* (opposite).

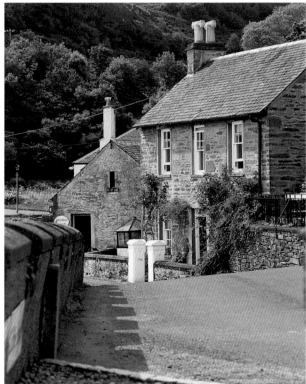

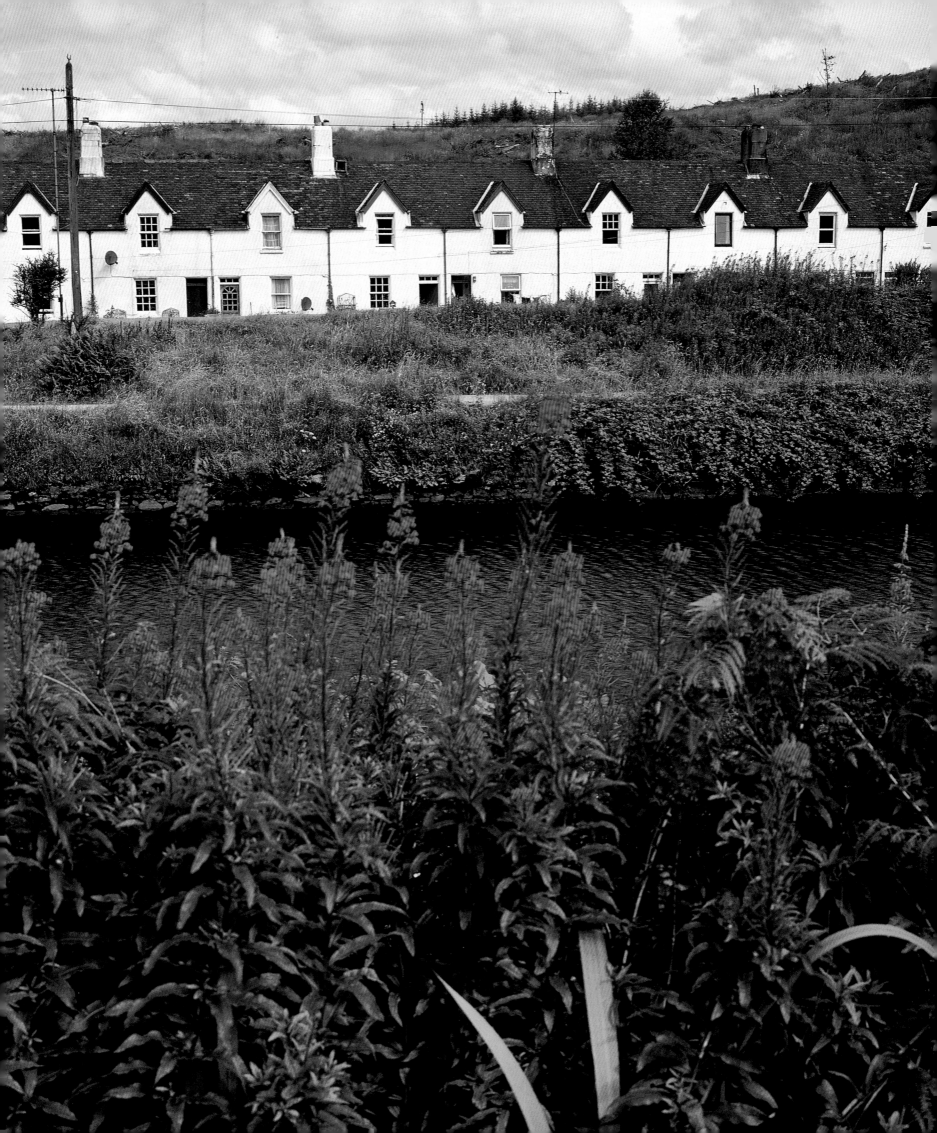

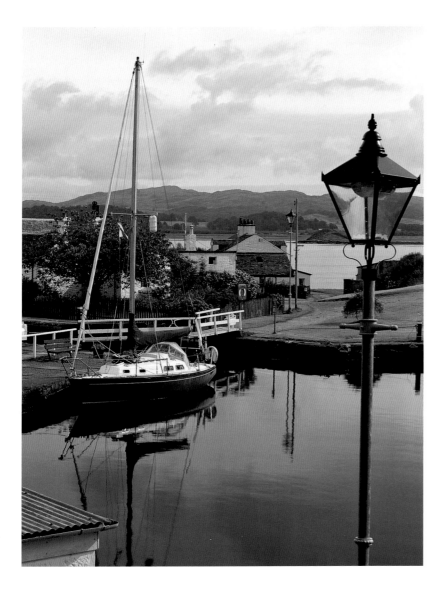

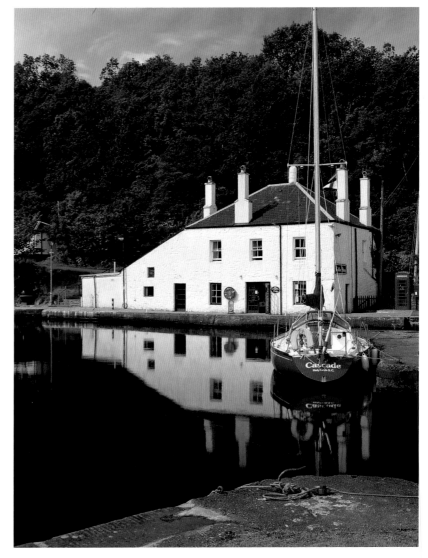

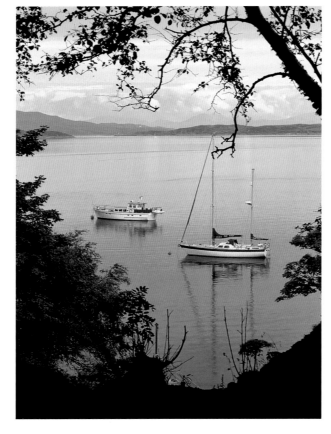

their mown lawns and picket fences giving the community a toy-town look. There is even a tiny lighthouse, which certainly looks no more than a toy on a clear bright day when not a ripple disturbs the glassy surface of the loch. Mariners making landfall after ocean crossings, cyclists and strollers along the canal towpath, and mere spectators of the gently paced goings-on in the basin, all enjoy repairing to the famous Crinan Hotel which faces north over the sound, where they can sample the excellent seafood landed daily beside the lock.

The canal basin itself (above left *and* above right) *forms the focal centre of the village. Looking outwards, though, there are splendid views to the north across Loch Crinan* (right *and* opposite) *from the yacht haven and from the famous Crinan Hotel.*

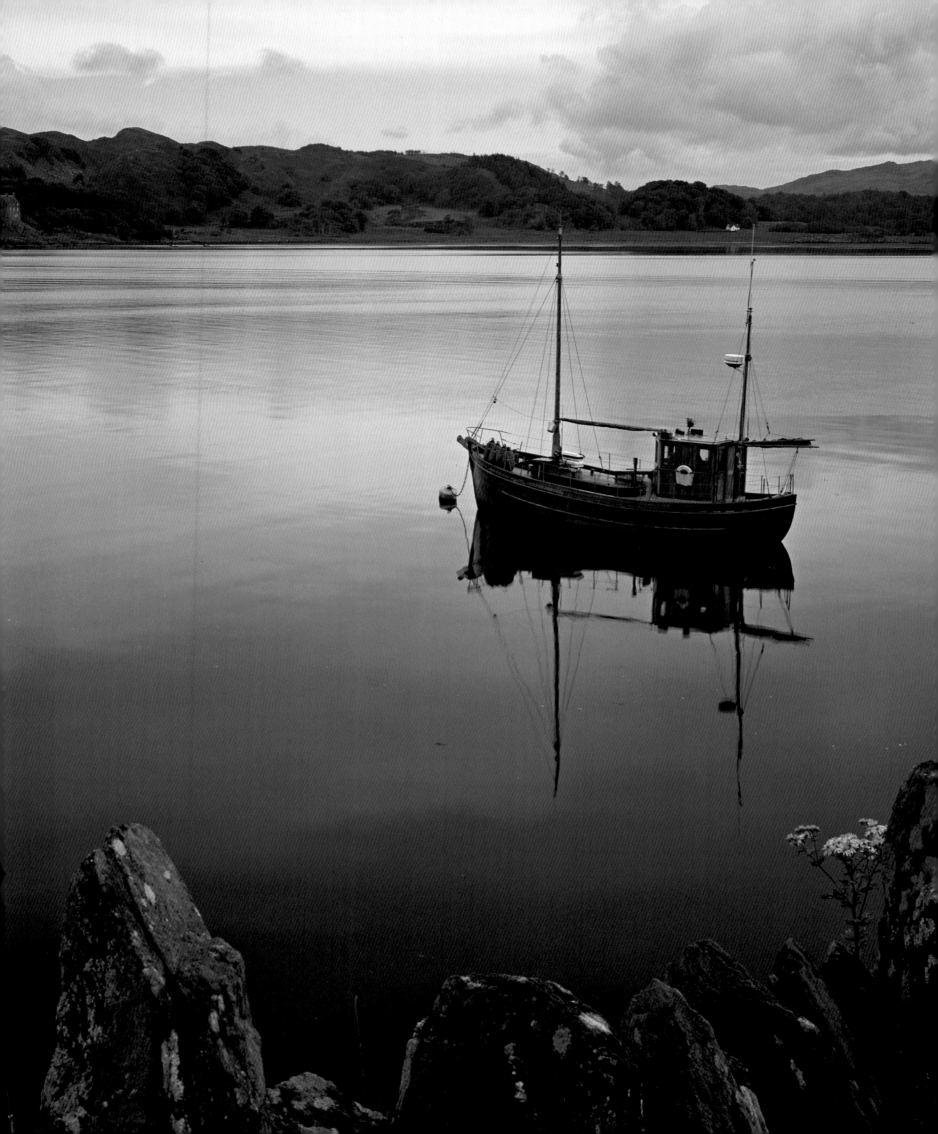

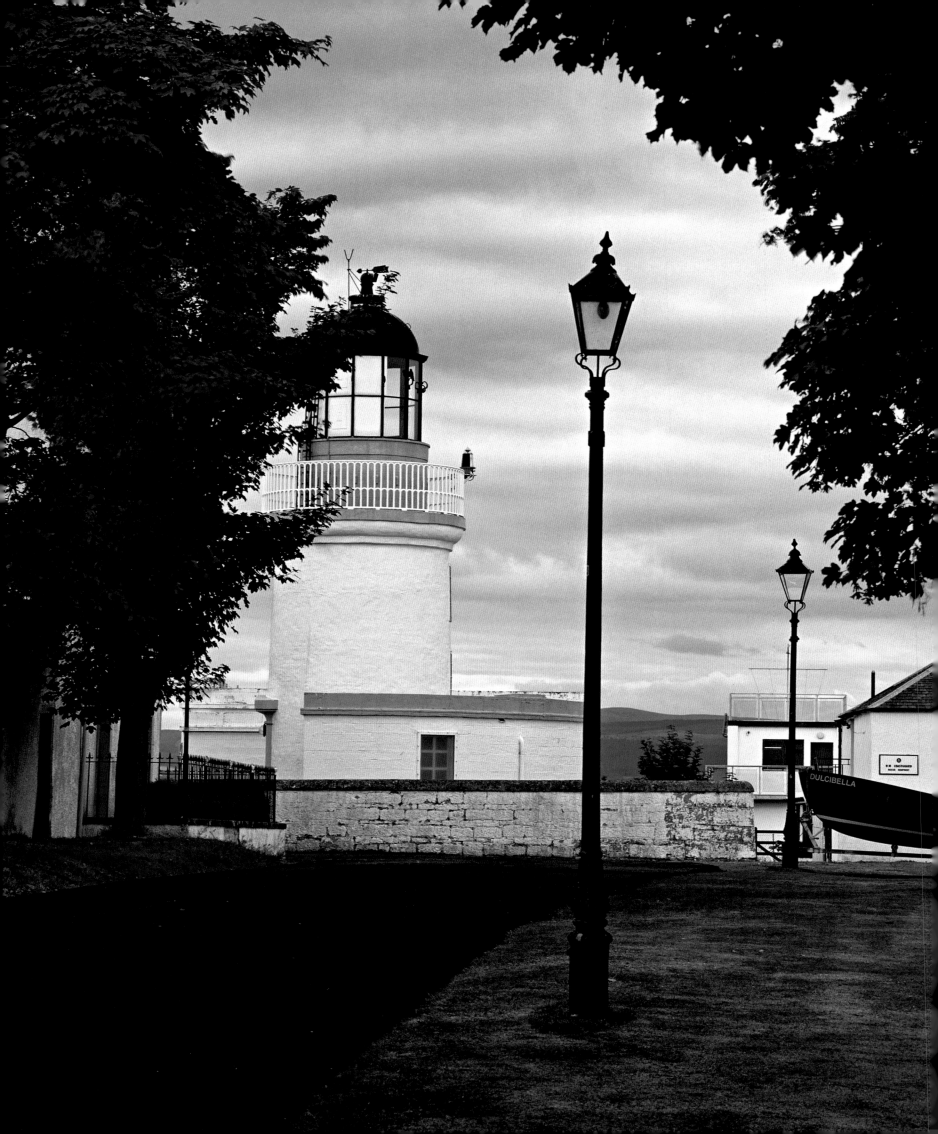

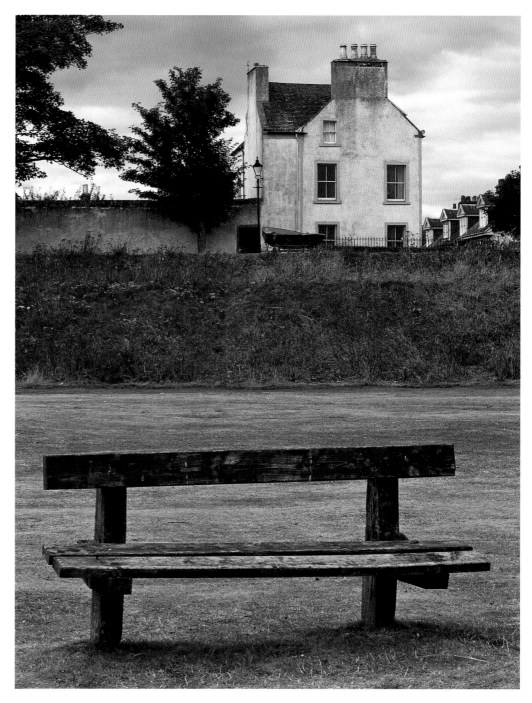

Cromarty
ROSS AND CROMARTY

ANYONE EXPECTING THE BLACK ISLE to live up to the rugged, piratical promise of its name will be pleasantly disappointed to find instead a low-lying plain of rich arable farmland. As well as failing to be at all black (except in the winter months when it often escapes the snowfall which covers the higher ground around), the Isle is not in fact an island, but rather a peninsula. And at its easternmost tip, the village of Cromarty perches at the edge of a huge sheltered bay. 'Ten thousand ships together may within it ride in the greatest tempest that is, as in a calm', in the words of Sir Thomas Urquhart, laird of Cromarty in the seventeenth century and first English translator of Rabelais. A prolific writer, he was much addicted to hyperbole, but in this claim he can be taken literally, as the bay has seen the largest naval fleets at anchor, right up to the Second World War. Cromarty House now stands on the spot from which Urquhart surveyed the bay from his castle.

Below the hill, in a tiny white-washed cottage on Church Street, another famous man of letters was born in 1802. Hugh Miller was orphaned at an early age when his sea-captain father failed to reach the shelter of the bay. He later became an eminent journalist in Edinburgh but expressed his love of Cromarty in many writings about the place. In these we learn that the massive cliffs that guard the entrance to the bay were named 'The Sutors', after a legend which cast them as two cobblers (*souters* in Gaelic) who hurled rocks at each other.

A wander through the trim streets that border the sea front leaves a strong impression of the long association of Cromarty and its people with the sea. From the back-to-back cottages of the Vennels, where the fishwives would sit outside baiting the endless fishing lines with mussels, to the fine merchants' houses along Church Street, little has changed. These latter date from the late eighteenth century, and testify to the success of the various schemes initiated by George Ross, who took over the Cromarty estate in 1772. He established factories in the village where rope was spun from the hemp arriving from the Baltic ports.

Despite good intentions and actual improvements, economic activity fell away during the nineteenth century, particularly after the building of the railway to Dingwall in the eighteen-sixties effectively bypassed

From diminutive white-washed cottages, like the birthplace of Hugh Miller (above left)*, to some of the finest Georgian architecture in Scotland, the streets of Cromarty present a picture of trim perfection* (opposite *and* above)*. Maritime associations are never far away; these include a fine nineteenth-century lighthouse and keeper's cottage* (opposite)*, designed by Alan Stevenson, a member of the family of the author of* Treasure Island.

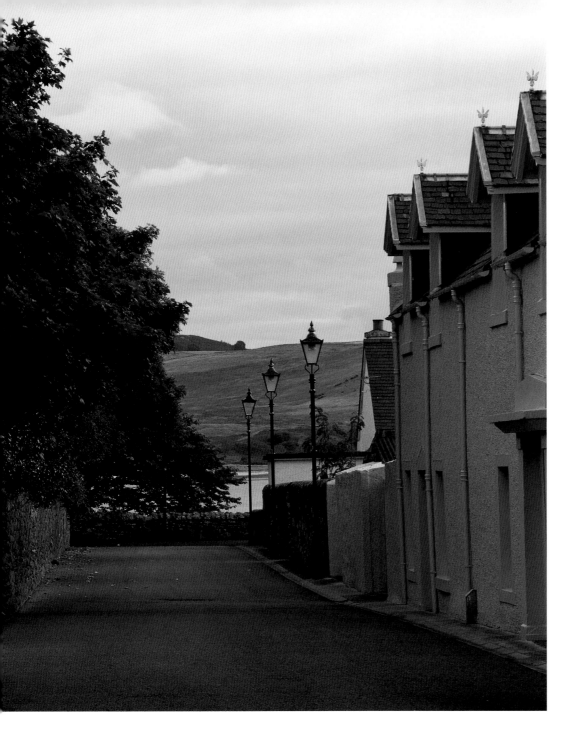

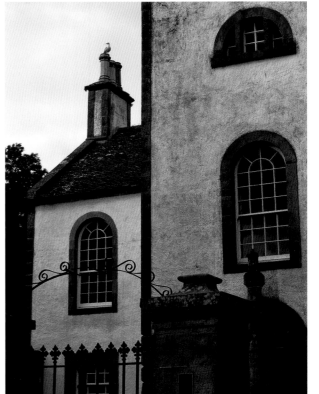

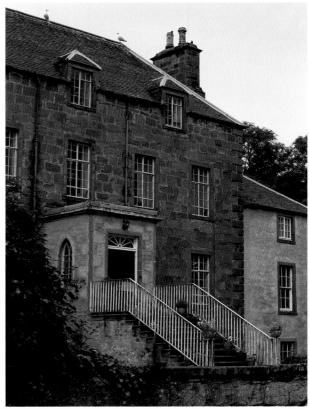

the Black Isle. Happily, the circle of the peninsula's fortunes has turned, and present-day visitors can experience the tranquillity that can only be envied by communities dominated by the roar of a nearby highway.

Among the splendid houses of the late eighteenth century is the Court House on Church Street (above right), built by George Ross, and now home to the local museum. 'Bellevue', also on Church Street (right), is a fine example of a rich merchant's house. More modest dwellings, still beautifully maintained, line Barkly Street (above left).

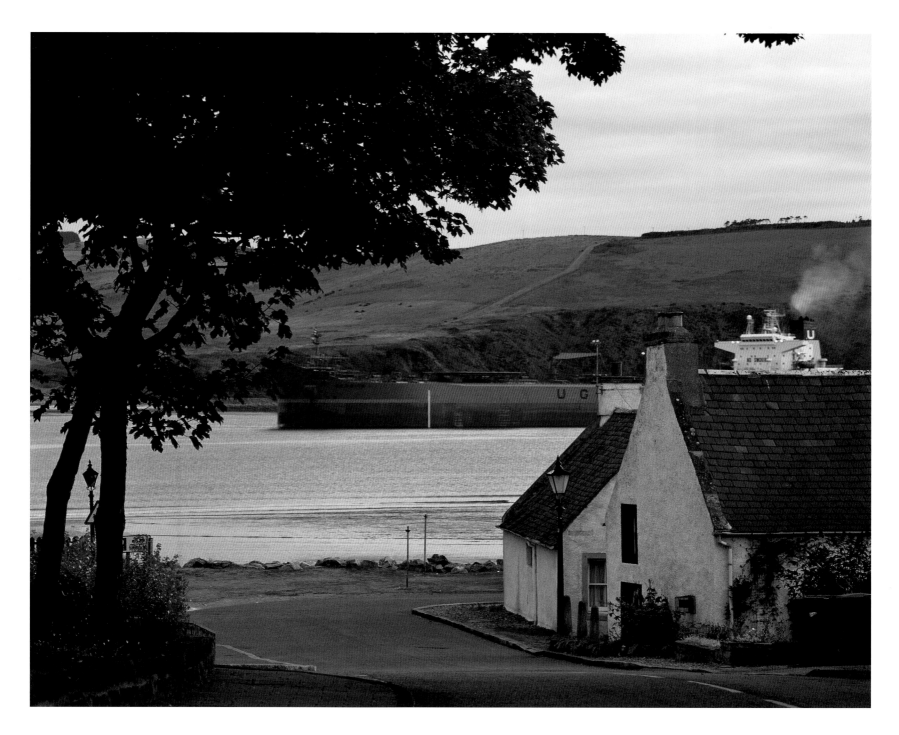

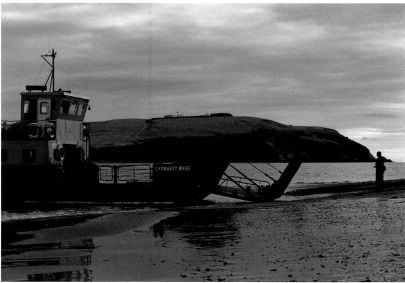

*T*hough no longer a thriving port itself, Cromarty still
sees a succession of ocean-going vessels passing close
to its intimate streets (above). More in keeping with the
village's present-day scale is the two-car ferry to Nigg (left).

Dornoch
SUTHERLAND

THE CHAMPIONSHIP GOLF COURSE at Dornoch is the most northerly in the world as well as the third oldest; a round played there must feel to many like a pilgrimage to one of the birthplaces of the sport, complete with all its vexatious technical challenges, made even more demanding by the easterly winds that bluster in unimpeded from the sea. The village itself, out on its low-lying headland, has always been somewhat cut off; those same winds have often prevented safe access to harbour, and many a vessel has fallen prey to shifting sandbanks. But the surrounding water also keeps the climate comparatively mild, which was perhaps one reason why the Bishop of Caithness moved his see here in 1222 from its former site at Halkirk near Thurso. This was Gilbert de Moravia, a member of the powerful Norman family which became the Murray clan. He founded the lovely cathedral that stands in the centre of Dornoch, and lived long enough to see the first service held there before he died in 1245. He was also buried there, and became the last Scotsman to be entered into the Calendar of Saints. It is partly the small scale of the building – a compact, cruciform shape – and partly the use throughout of locally quarried sandstone, pinkish-gold in colour, that gives it such an air of warmth and intimacy.

Many of Dornoch's buildings are of the same attractive material, and a balmy summer evening can create an impression reminiscent of that of a Cotswold village. But Dornoch's sleepy charm belies a wilder past of constant tribal feuding, especially between the Murrays and their northern neighbours, the MacKays of Strathnavar. In 1570, an army from that clan laid waste to the town, besieged the enemy in the bishop's palace and desecrated and burnt the cathedral. The building was left in ruins for many years, and final repairs to the damage were not completed until a programme of restoration in the eighteen-thirties.

Dornoch also had the unhappy distinction of witnessing the last burning of a witch in Scotland: in 1722, a local woman, Janet Horne, met her fate in a barrel of burning tar, for the alleged crime of having turned her daughter into a pony!

*I*mpressively endowed with fine architecture, yet curiously intimate in feeling, Dornoch enjoys mild summers, when the light illuminates walls of the local pinkish-gold sandstone (above). At the centre of the village lies the finest building in this material: the lovely thirteenth-century cathedral (opposite), small yet a commanding presence.

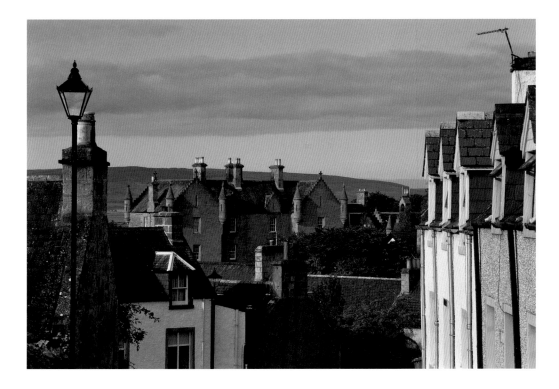

*W*herever the visitor turns in the centre of Dornoch, some building of interest presents itself, whether in the form of a fine private house (below) or in that of the Dornoch Castle Hotel (right *and* opposite), which still bears clear signs of its past as the fortified episcopal palace.

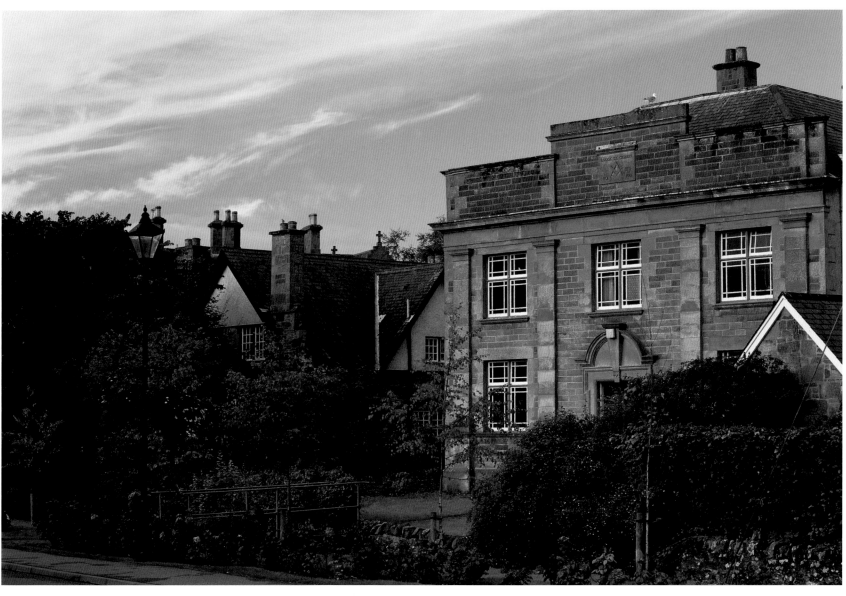

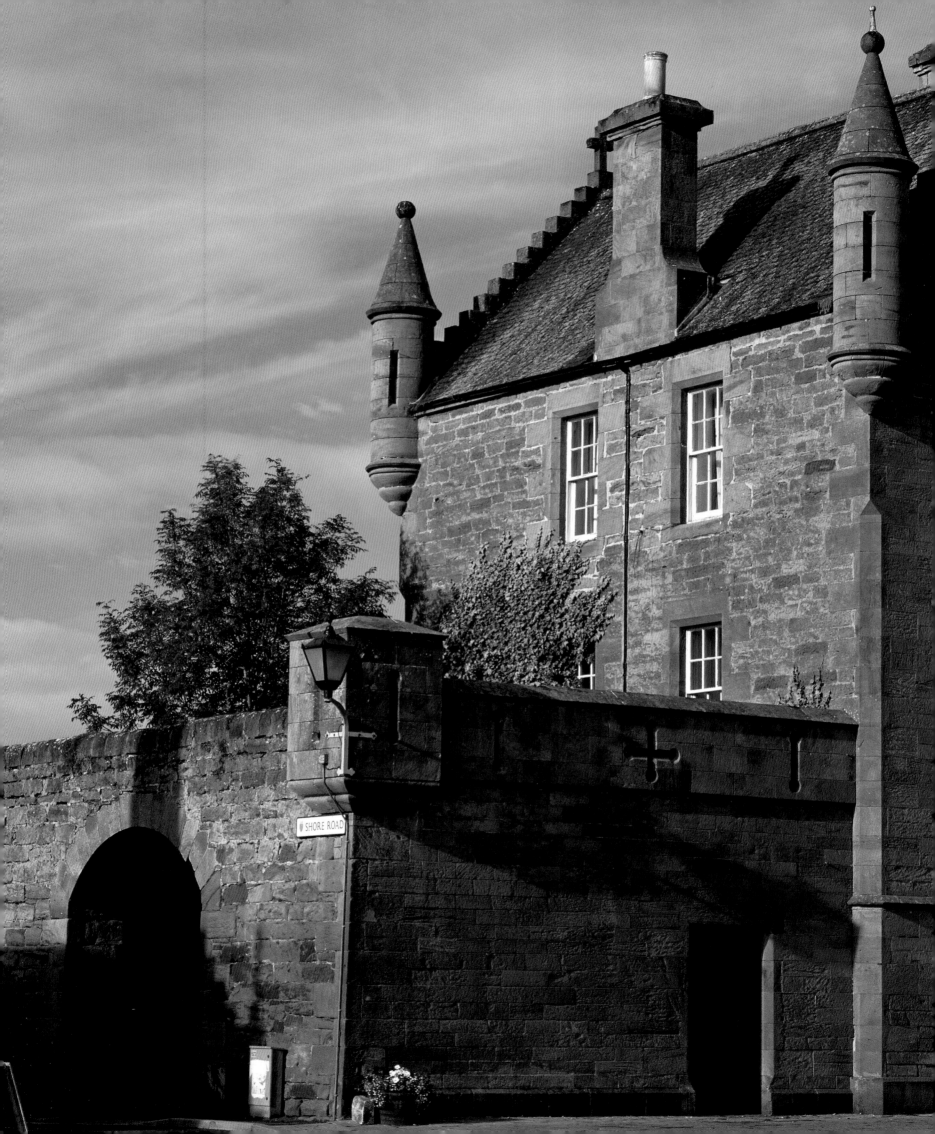

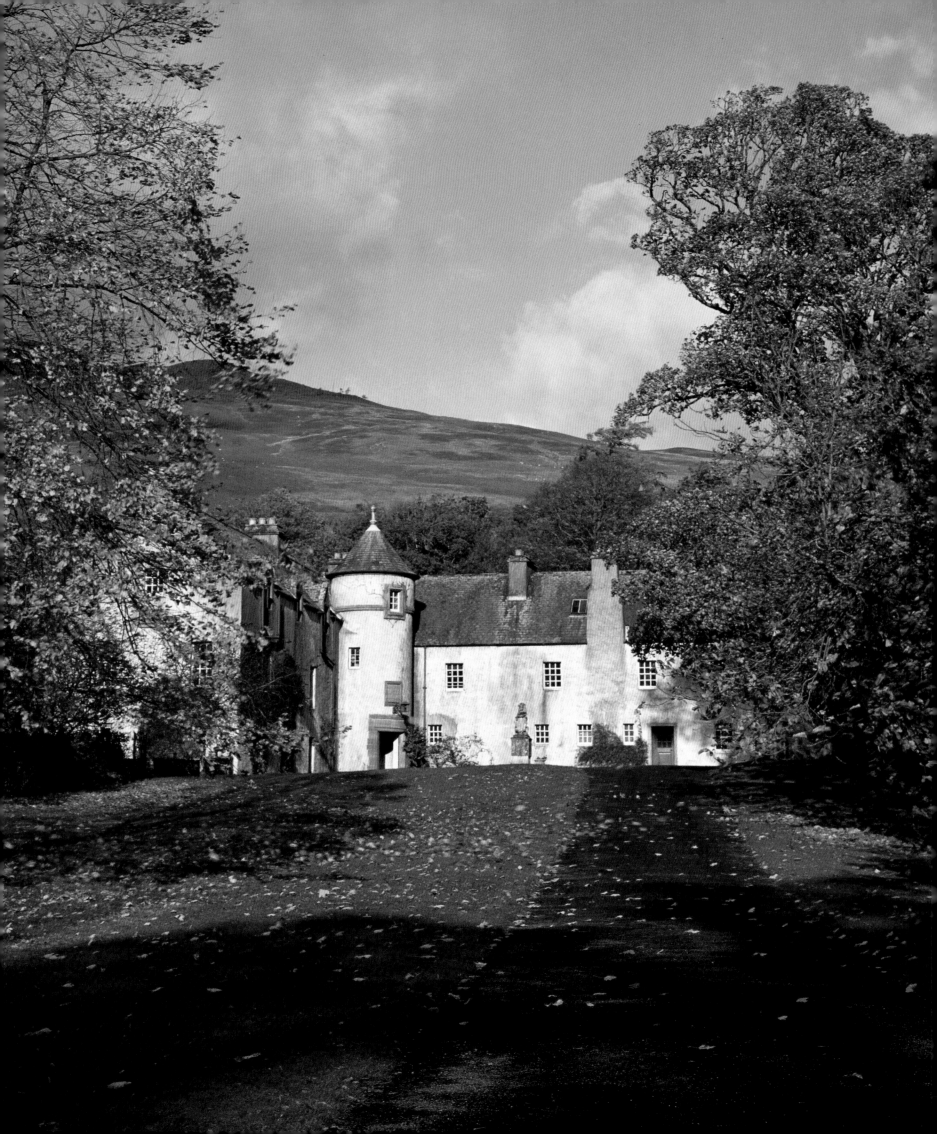

Fortingall PERTHSHIRE

Seventeenth-century Glen Lyon House (opposite) lies at one end of the village. Much modernized in the nineteenth century, it was the country home of Sir Donald Currie, founder of the Union Castle Line. Of much more recent construction is the handsome village hall (below) of 1936; the building still has a distinctly Arts and Crafts look about it, in keeping with the rest of the village.

THE LEGENDARY CELTIC HERO FINGAL is said to have built no fewer than twelve forts along Glen Lyon, which lies in the wildest part of Perthshire, close to the geographical heart of Scotland. If his intention was to deter unwelcome visitors, he would certainly have succeeded; even today, the glen is difficult of access. A single-track road, impassable in winter, winds thirty-four miles up to remote Loch Lyon, beyond which it goes no further. The other, eastern end of the glen, however, widens out into a flat and fertile valley, in which sits the village of Fortingall; looking the very opposite of wild, its thatched cottages give it an air of cosy domestication.

In the churchyard stands a remarkable survival, the much-visited Fortingall Yew, which enjoys the status of being 'Europe's Oldest Living Object'. The eighteenth-century diarist Thomas Pennant certainly believed it to be so when, during his visit of 1776, he recorded its girth at a mighty fifty-six feet. The decrepit remnants visible today certainly betray a loss of stature appropriate to extreme old age, but they do satisfy the archaeologists, who agree that this relic has indeed been standing for more than three thousand years. By contrast, the adjoining church could not be more youthful, having stood but a century. It was rebuilt in keeping with the architecture of the rest of the village, remodelled in the eighteen-eighties to the designs of James Marjoribanks MacLaren, a native Scot later transplanted with great success to London, where he became a fashionable architect. A walk along the single street of the village will serve as a delightful introduction to the style of the Arts and Crafts movement, which combined traditional building styles and a modernist aesthetic. The resulting groups of cottages, slate-roofed as well as thatched, form an attractive and harmonious grouping.

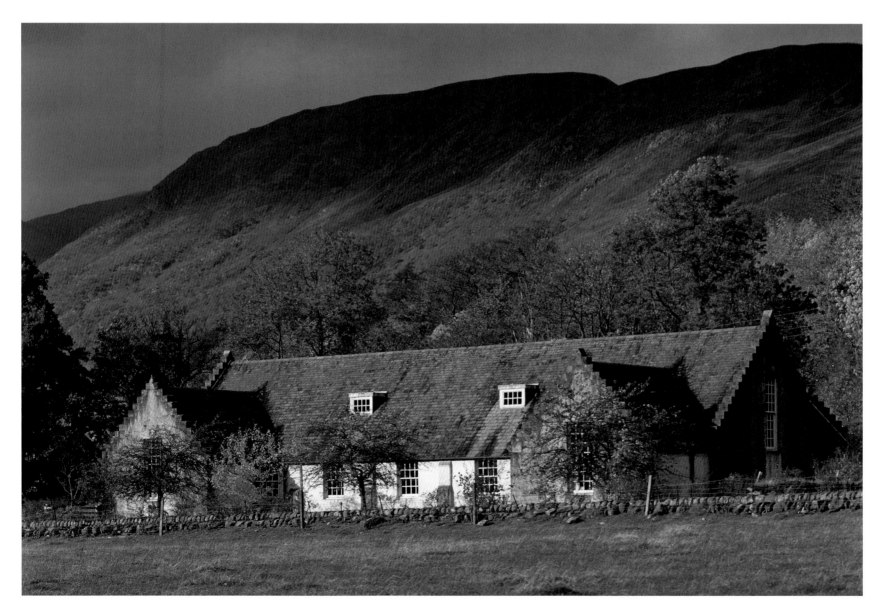

MacLaren's client was Sir Donald Currie, the local Member of Parliament, a spirited example of that type of self-made man formed in disproportionate numbers in Scotland during the Victorian age of imperial expansion. He started his working life as a shipping-clerk, foresaw the future of global shipping in the age of steam, and famously invited the derision of his traditionally minded competitors when he insisted on running his first small fleet of sailing ships to a set timetable, an unheard-of innovation. When steamships did arrive, his Castle Steamship Co. saw off most of the opposition and eventually became the renowned Union Castle Line. Glen Lyon House, at the end of the village, dates from the end of the seventeenth century, but was modernized by Sir Donald as his main country retreat. Not all the many modern conveniences were introduced in the name of luxury, however. The miniature hydro-electric plant he installed in the burn above his house has been, ever since, a supplier of electricity to the National Grid.

The traditional building materials and forms (above and right) of the village cottages lend an atmosphere of harmony and order to Fortingall. The thatched roofs of this row of cottages need replacing every ten years or so, and journeyman thatcher Graham Carter spends the whole summer here, up from his native Cambridgeshire.

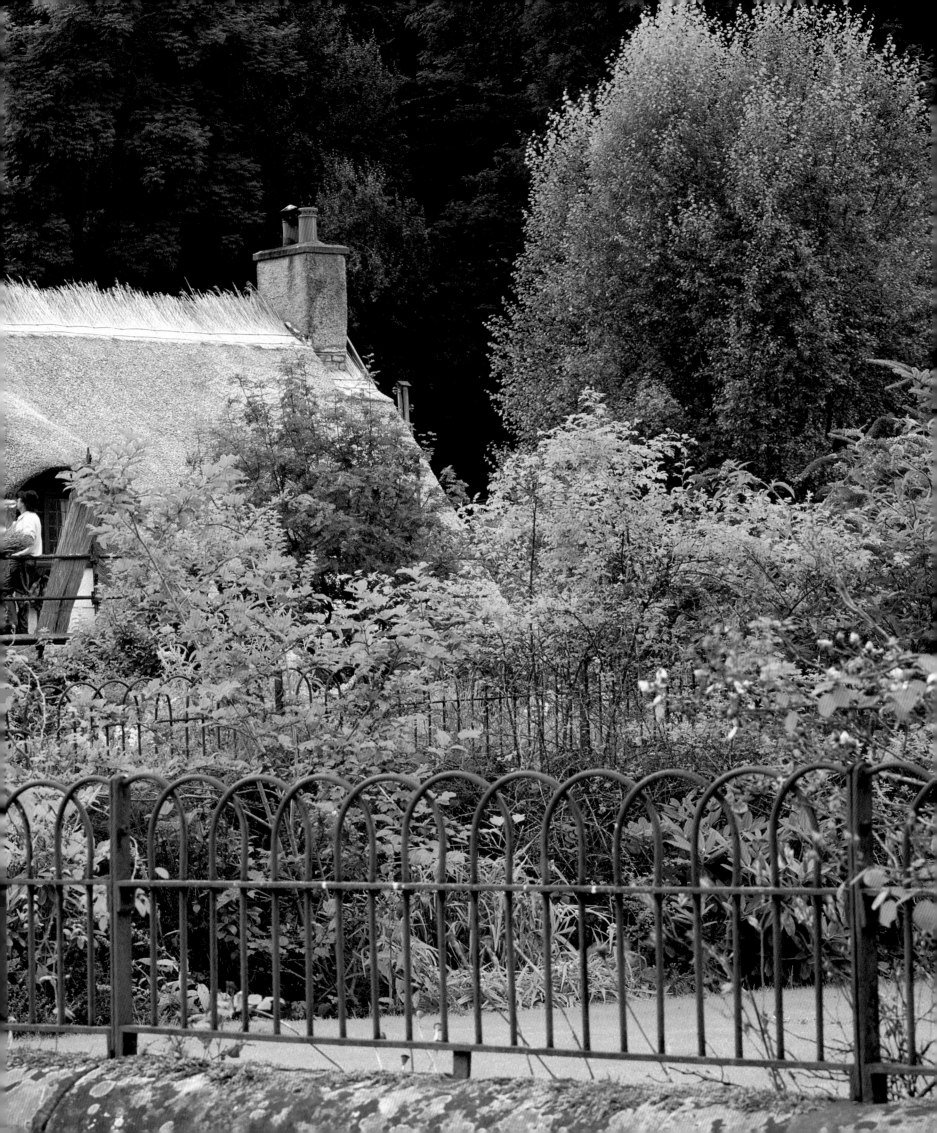

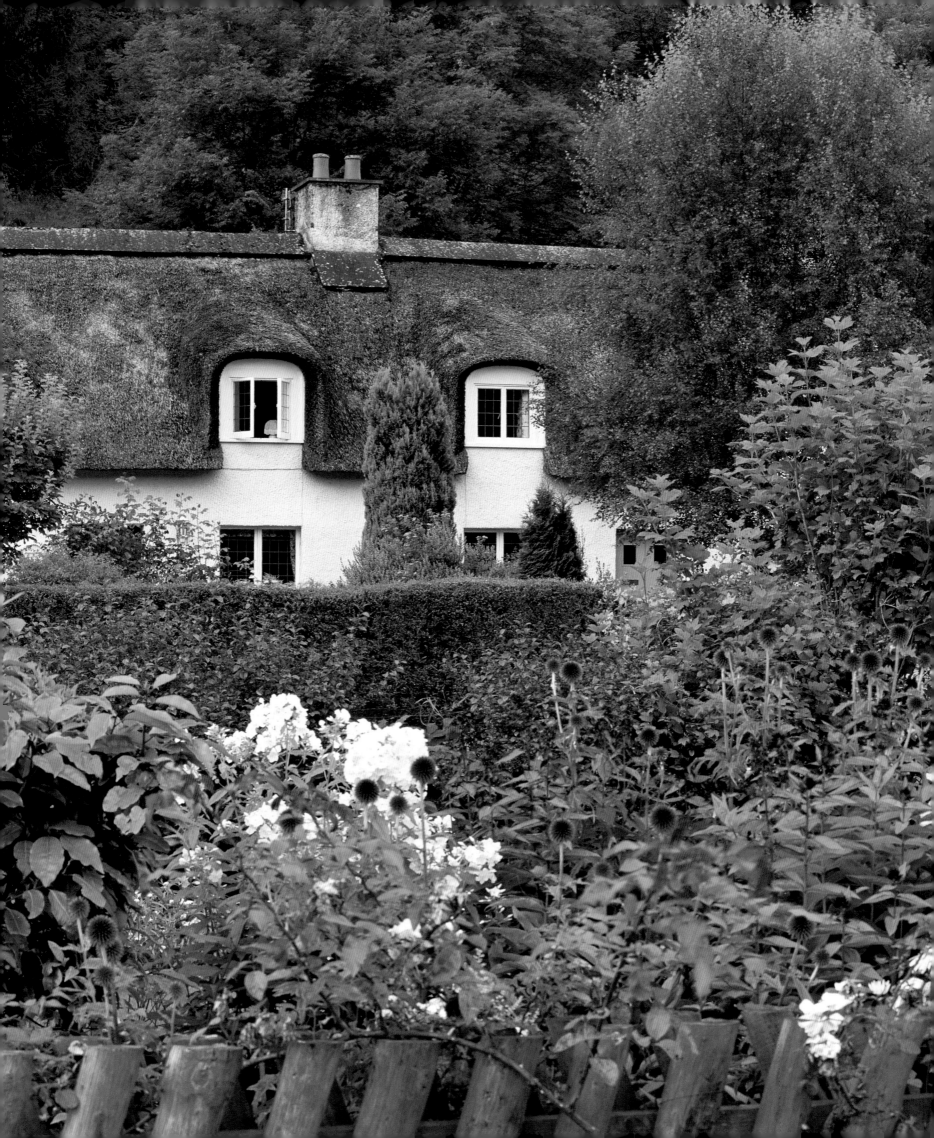

The Arts and Crafts movement of the late nineteenth century had a profound influence on Scottish architecture, deriving its strengths from vernacular cottage building (opposite) *for reinterpretation in such houses as 'Blanald' (above), designed by James MacLaren in 1887. Much more venerable is 'Europe's Oldest Living Object', Fortingall's three-thousand-year-old yew tree (left).*

Lochinver

SUTHERLAND

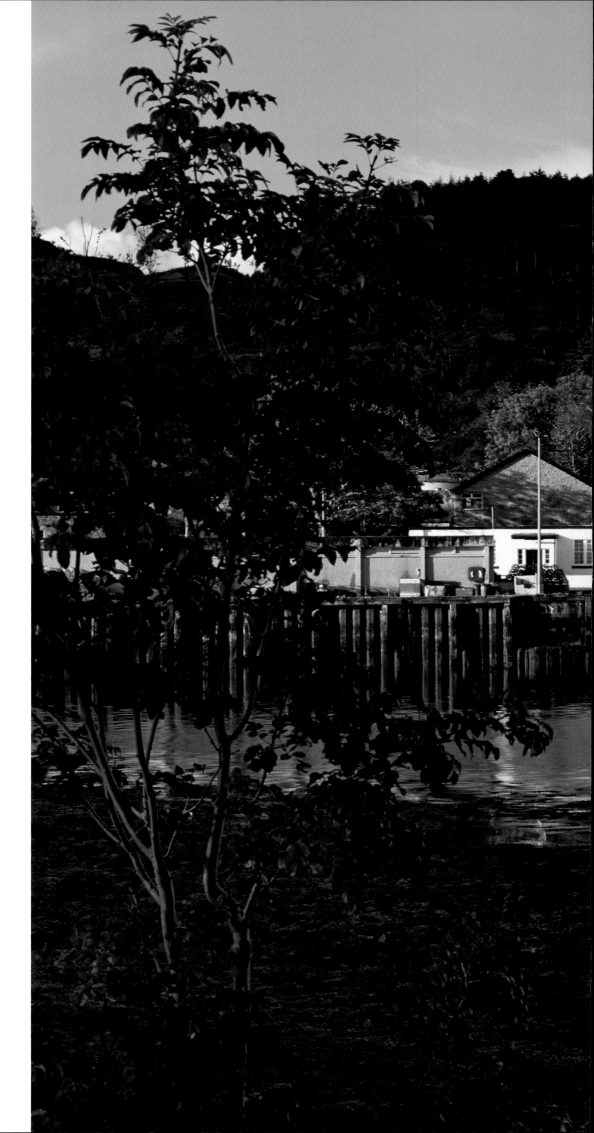

THERE'S AN ODD AFFLICTION that often affects those travelling to the further parts of Scotland's west coast, and it usually strikes after Ullapool has been passed. The illusion grows, as the undulating ribbon of road unwinds over the moorland, that even as the miles click by, the country ahead just keeps getting larger and larger. The moorland round about gets wilder, the mountain masses bigger, and it is easy to feel that your destination isn't getting any closer. Eventually, a twinkling light from a window is sighted (night has a tendency to fall during such protracted journeys); the rewards of an over-sized glass of whisky and the promise of slumber are at last in prospect. But the real treat arrives the next morning. Immediately after the 'where-am-I-how-did-I-get-here' sensation, the feeling dawns that you are indeed a wonderfully long way away from your starting-place.

A famous centre for the enjoyment of the most beautiful part of this coast is Lochinver. Not much more than a tiny cluster of whitewashed houses, it is nevertheless the first settlement of any size north of Ullapool, from where the determined seeker after the wild and scenic can approach the village along the tortuous coastal route via Achiltibuie and Inverkirkaig. Most visitors, however, will arrive after the easy six-mile drive from the main road, past the lovely, lonely expanse of Loch Assynt, with its rocky islets and the gaunt remains of Ardvreck Castle.

Lochinver has other reasons for being where it is, apart from the scenic beauty of its location, as is apparent from the purposeful fishery buildings on its pier, now rather dwarfing what would be otherwise an imposing Victorian hotel. This is an important fishing centre, and into its sheltered bay comes over half of all the fish landed on the Highland region's west coast. But because of its delightful coastline, dominated by the distinctive shapes of the giant limestone outcrops of Suilven and Canisp, Lochinver is also a huge draw for visitors. The recently instituted Assynt Visitor Centre is kept busy through the season directing folk up mountains, along the coast, or out to sea in boats to enjoy the company of the large population of grey seals who live within easy reach of the fishery.

This village is remarkable both for its gathering of pretty houses – and an imposing Victorian hotel – and as home to a sizeable fishing fleet, which lands over half the total catch of the west coast of the Highlands.

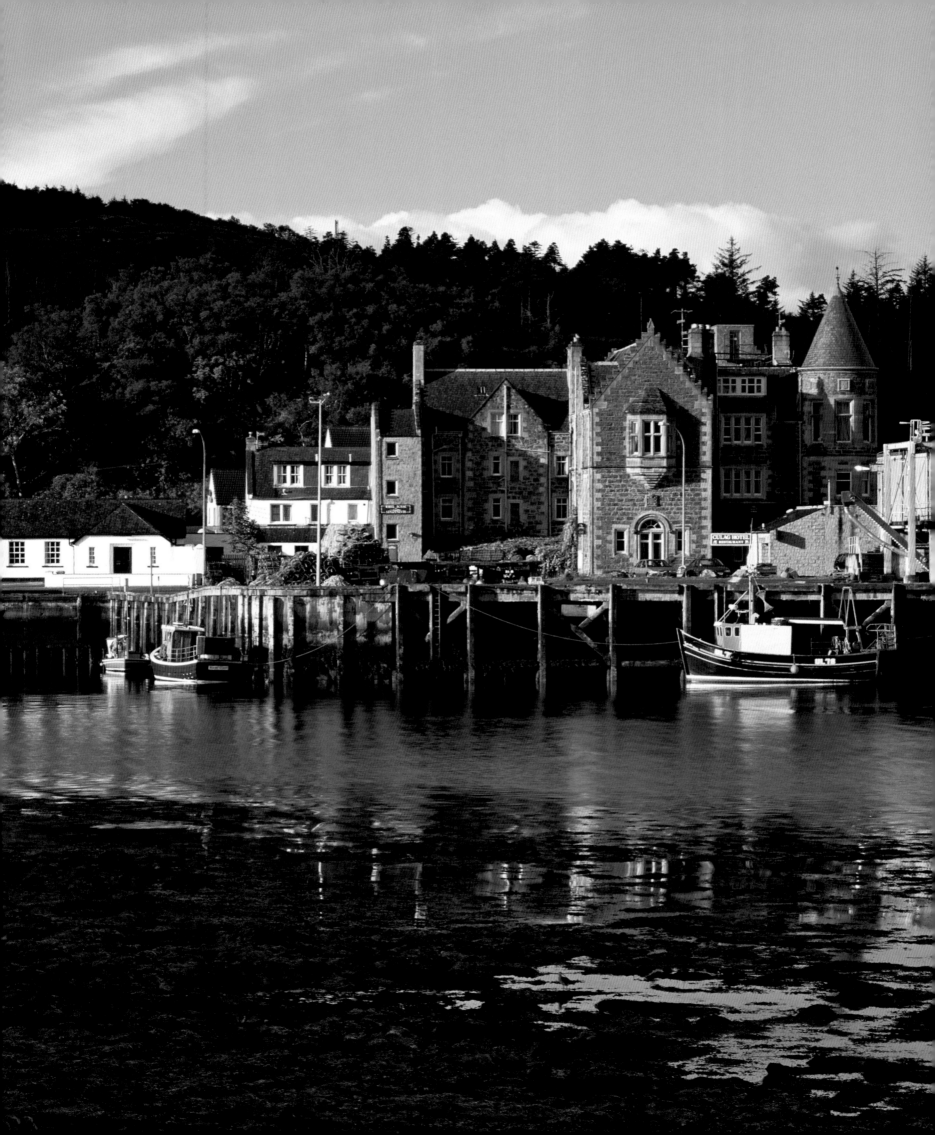

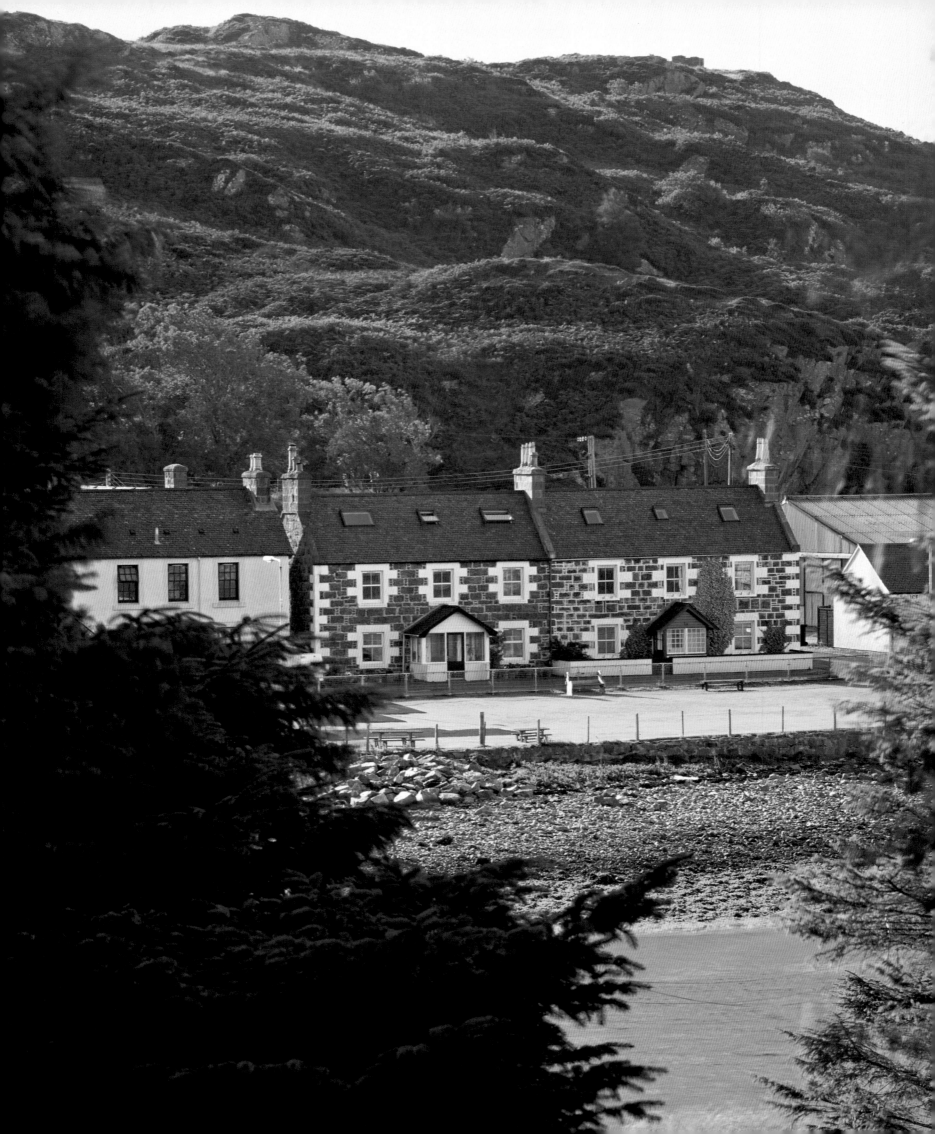

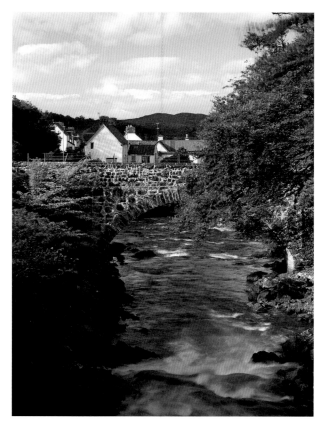

*W*ild moorland rises immediately beyond the streets *of Lochinver* (opposite), *though the village itself has a protected feel as it looks out over its sheltered loch* (above left). *This is fed by vigorous mountain streams* (left *and* above) *which flow down from the high masses of the Glencanisp Forest.*

*A*round Lochinver lies a remarkable wilderness;
the hauntingly beautiful Loch Assynt and its shores
(above *and* right) *is a favourite spot for serious anglers.
The fells beyond are popular walking country.*

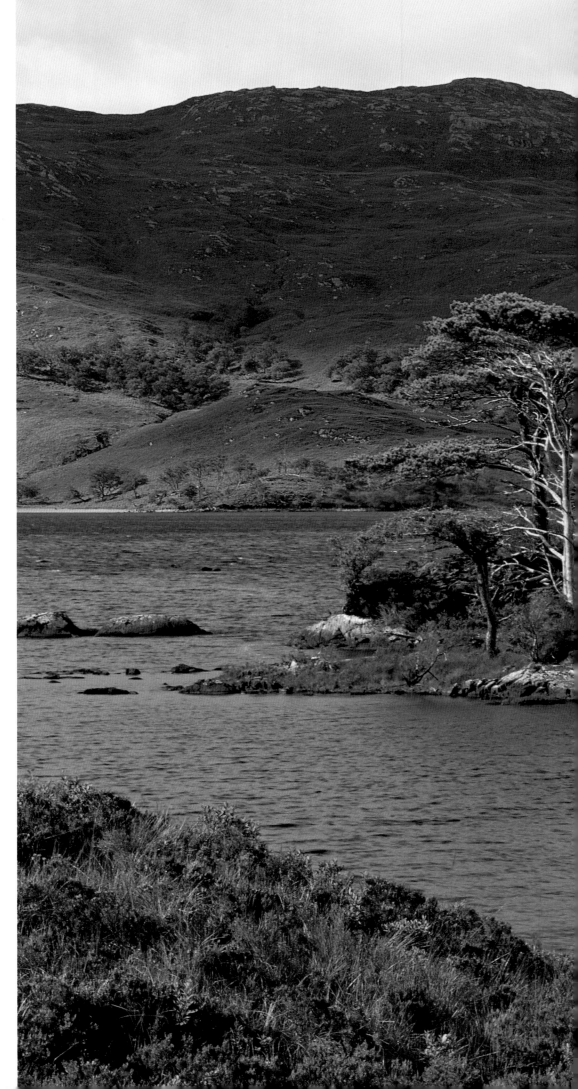

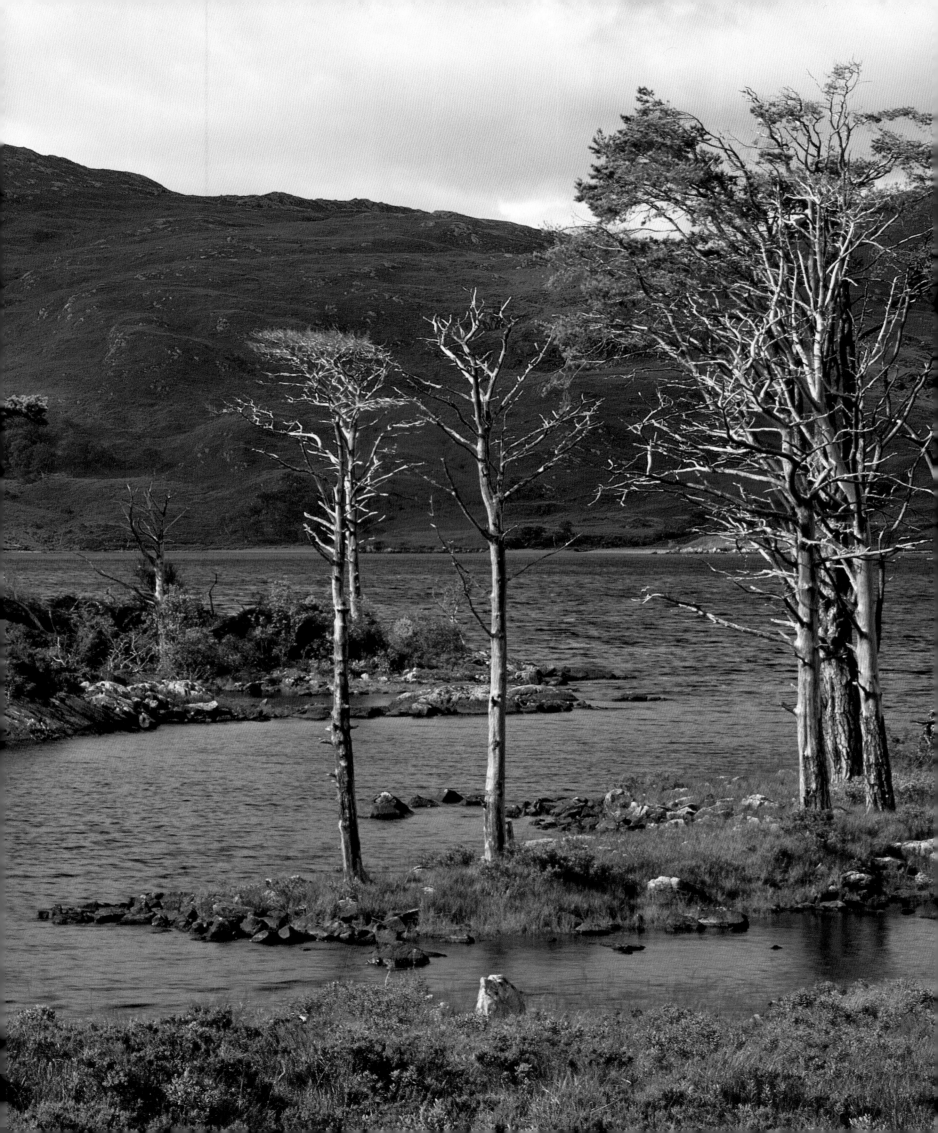

Luss

DUNBARTONSHIRE

'WHAT SAY YOU TO A NATURAL BASIN OF PURE WATER,
nearly thirty miles long, and in some places seven miles
broad, and in many above an hundred fathoms deep,
having four and twenty habitable islands, some of
them stocked with deer and all of them covered with
wood; containing immense quantities of delicious
fish…?' Thus the eighteenth-century novelist Tobias
Smollett rhapsodized about Loch Lomond – the
'Arcadia of Scotland', as he called it. Smollett was
no tourist; he was born nearby, at Dalquhurn House,
his family seat on the banks of the river Leven. But
his enthusiasm for Britain's largest expanse of fresh
water has been echoed since by countless visitors.
The Wordsworths and Coleridge, as well as Queen
Victoria, marvelled at the alpine character of the
landscape. She did the sensible thing and explored
the loch on a steamer; even in 1869 the large numbers
of coach-borne tourists drew royal comment.

Loch Lomond has always had a magnetic attraction
for the passing sightseer, especially since the through
road to the Highlands closely skirts its western shore.
Today's motorist, seeking relief from the strains of

*The stone cottages and gardens of the main street
(above and right) owe their neat appearance partly
to the Victorian landowners who laid out the village as
a model community to house their workers.*

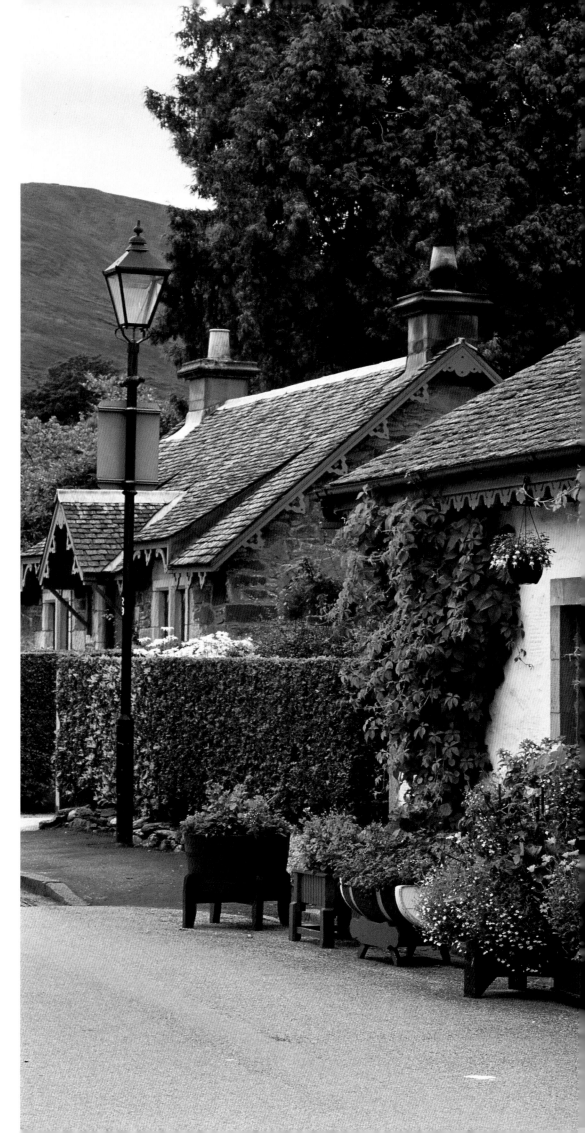

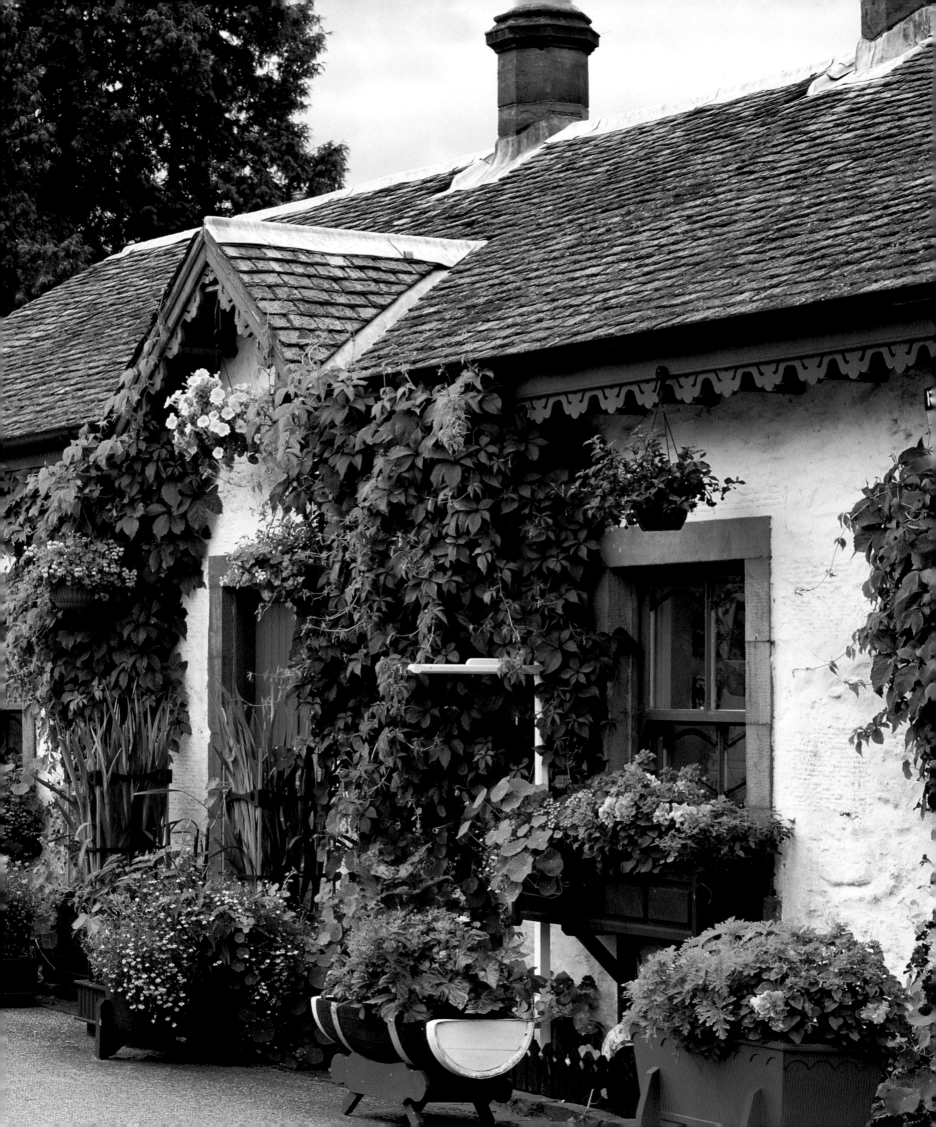

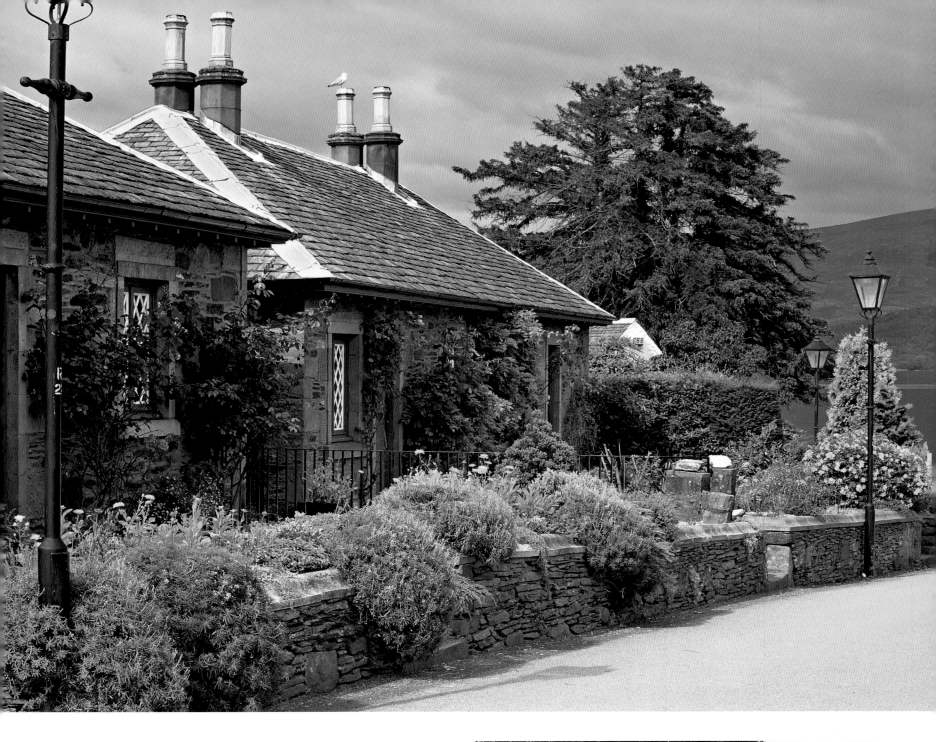

*M*ost visitors to Luss will eventually be tempted to
stroll down to the bewitching promenade (above
and right) which yields superb views of one of Scotland's
most dramatic sights, Loch Lomond.

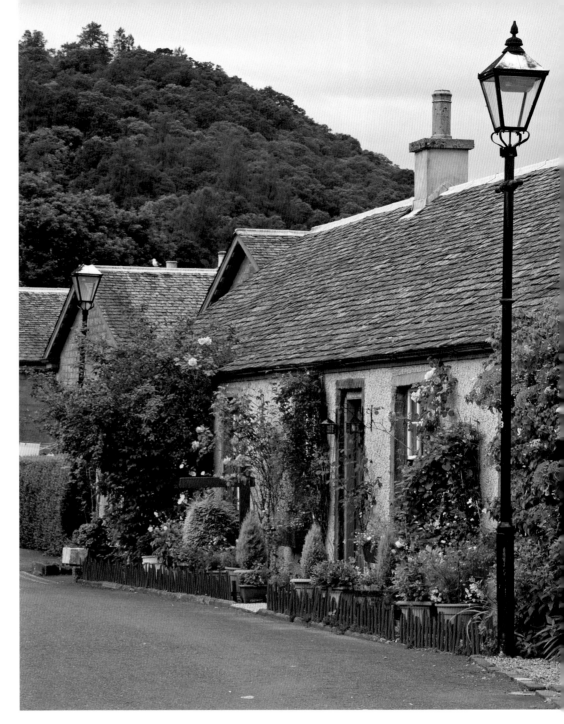

convoy travel (one eye on the glinting water tantalizingly glimpsed through trees, the other on the rear of the inevitable caravan in front) will gratefully turn off at Luss and take the opportunity to stroll down to the small promenade which has the most enchanting view of the loch at its prettiest reach. The present appearance of the streets, with their immaculately restored rows of stone cottages and fantastic profusion of hanging baskets, would have delighted the Victorian landlords, the Colquhouns of nearby Rossdhu. They philanthropically demolished what had been known as Clachan Dubh – 'Dark Village' – and laid out this model community to house workers employed in their slate quarries and cotton mills. The steamer pier is still there, for those who wish to follow Queen Victoria's example. Otherwise, seekers after tranquillity are advised to get up early

to take in the sight of the 'bonnie banks' of Loch Lomond. The famous ballad dates from 1746, when the hapless Highland soldier who wrote it was awaiting his fate at Carlisle in the dispiriting aftermath of the Jacobite defeat at Culloden.

*E*verywhere one looks in Luss, both on the promenade *and on the main street* (left *and* above), *the eye is met by a profusion of blooms in flower-beds and in a variety of containers. Behind the houses and in front, the inhabitants have united to create a sparkling and vibrant horticultural paradise.*

Plockton
ROSS AND CROMARTY

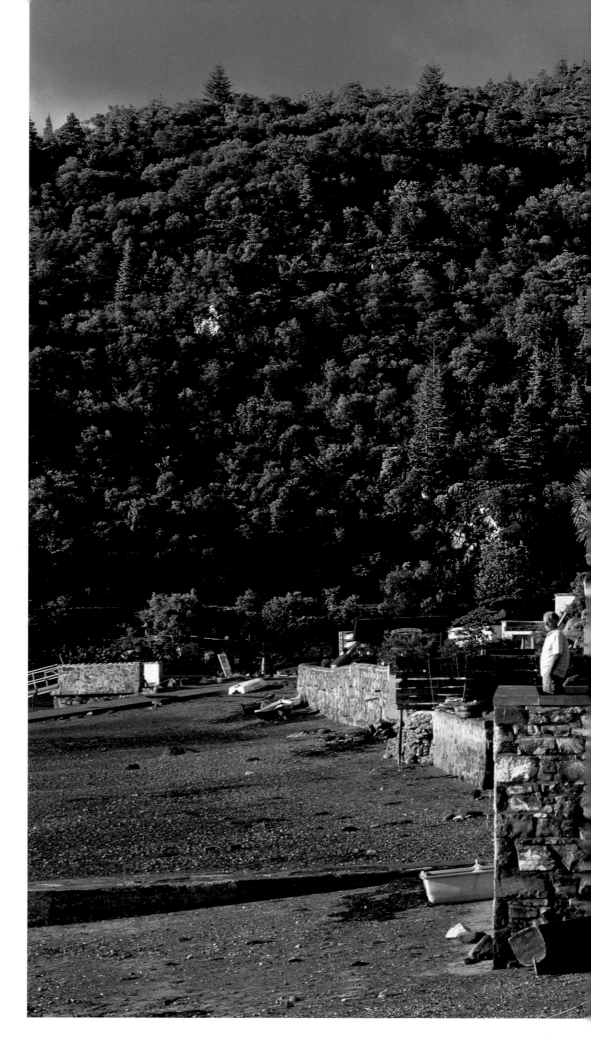

ONE OF THE BEST WAYS to experience the Highlands is to take a train from Inverness and watch the dramatic scenery unfold across the wild hinterland, as the line runs by remote lochs and rugged mountains, before descending to the mildness of the west coast. Trains used to stop at Stromeferry, where the sea-bound Loch Carron gathers to a narrow strait, but in 1897 the line was extended to the Kyle of Lochalsh. The building of these ten-and-a-half miles of track was considered a great engineering feat in its day: it took four years and cost a quarter of a million pounds. After the train has wound along the southern shores of the loch and skirted the wooded hill on which Duncraig Castle stands silhouetted, it plunges through deep cuttings blasted from the rock, and pops out to reveal a tableau that seems worth every penny spent on the line's construction. In a rich jewel-box setting, between the peat-coloured inlet and the heather-clad mass of An Criathrach behind, lies a string of neatly painted cottages among palms, curving around the sheltered harbour of Plockton.

Until the end of the eighteenth century, there would have been little to see on this promontory (*ploc* in Gaelic) on which a handful of crofting families made their living. The progressive ideas of a new landlord, the local Member of Parliament Sir Hugh Innes, inspired the founding of a model fishing village, which he named Plocktown. By the time of the census of 1841, the community was thriving; its population had grown to 550 and would continue to remain stable through harsh years of famine and emigration. Although the little harbour saw many departures to Canada and New Zealand, enough of those who were leaving the land came to the village and stayed. There was plenty of fishing activity; huge shoals of herring regularly came right up the loch in season.

Plockton even supported a number of schooners, which could take the salted catch to Greenock and Glasgow, where they could trade at better terms than the smaller communities who were at the mercy of the take-it-or-leave-it prices offered by merchants visiting in their own vessels. Although the last schooner plying out of Plockton was decommissioned in the nineteen-fifties, the harbour here – its rocky bottom offering excellent anchorage – has remained a busy place.

*H*ills of pine and heather surround the pretty houses of Plockton (right), neatly arranged around the small harbour, busy now with pleasure craft, and basking in one of the west coast's balmiest climates.

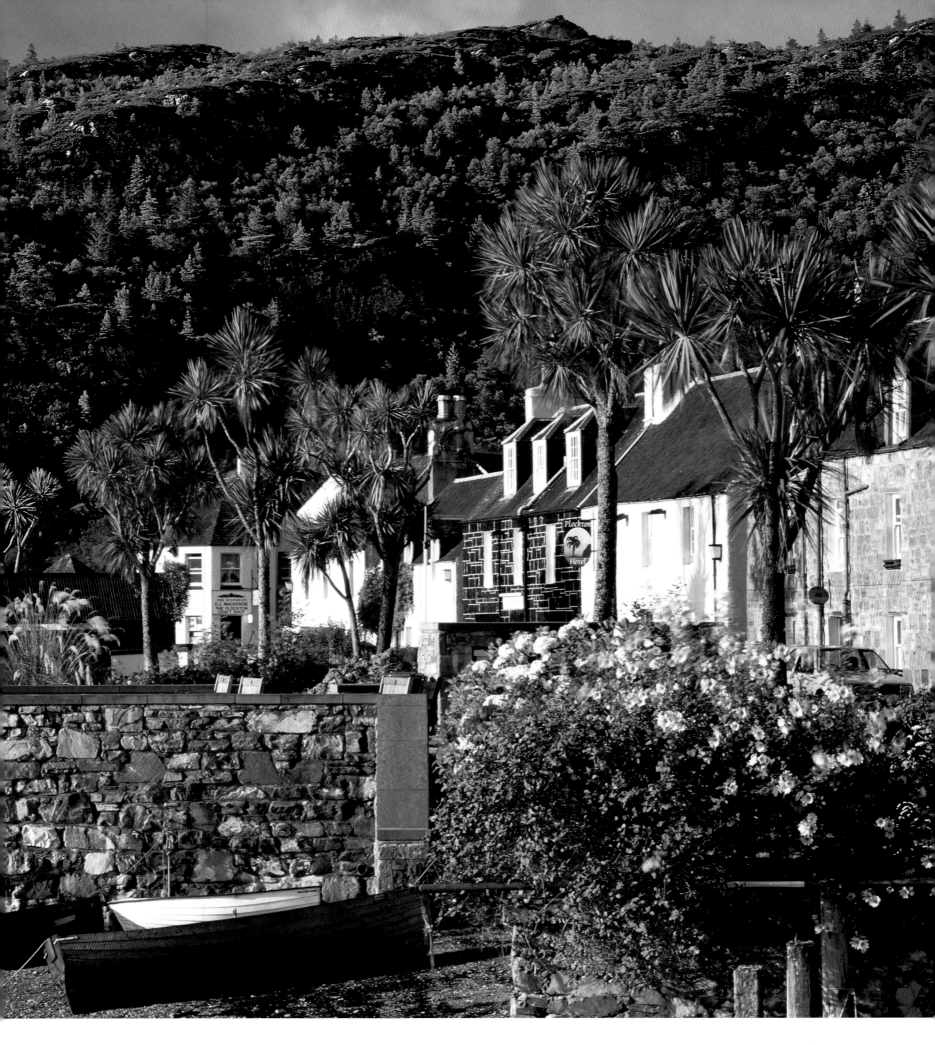

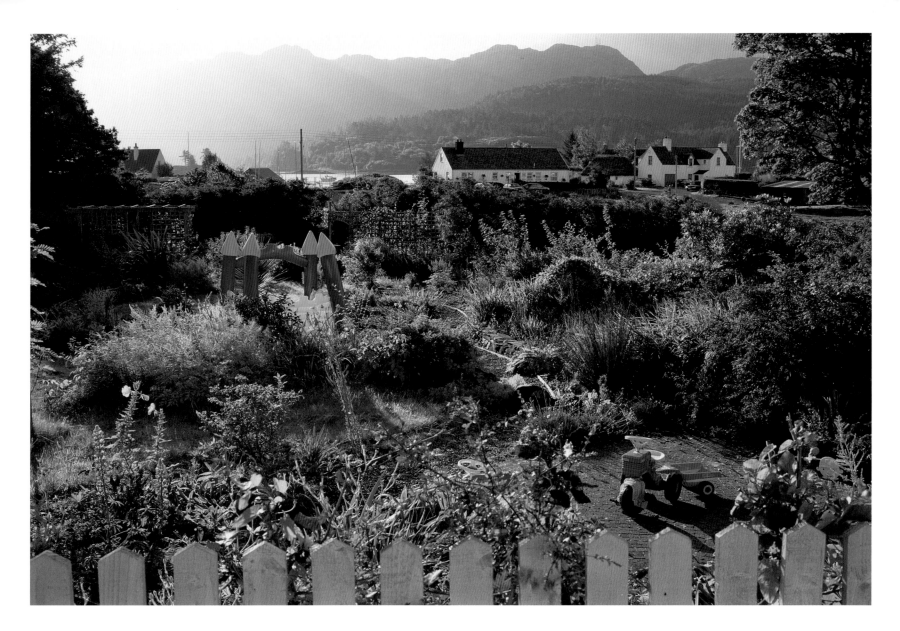

*T*he mild weather and special quality of light have clearly inspired the village's gardeners (these pages); they have also attracted a population of amateur painters, sailors and second-home owners.

The pubs along Harbour Street are full of sailing folk regaling each other with tales of the deep sea. Smaller boats abound too, and the residents support a lively sailing club. When not in preparation for the annual regatta, their dinghies dispose themselves prettily, either bobbing on the tide or reclining at picturesque angles among the weedy rocks.

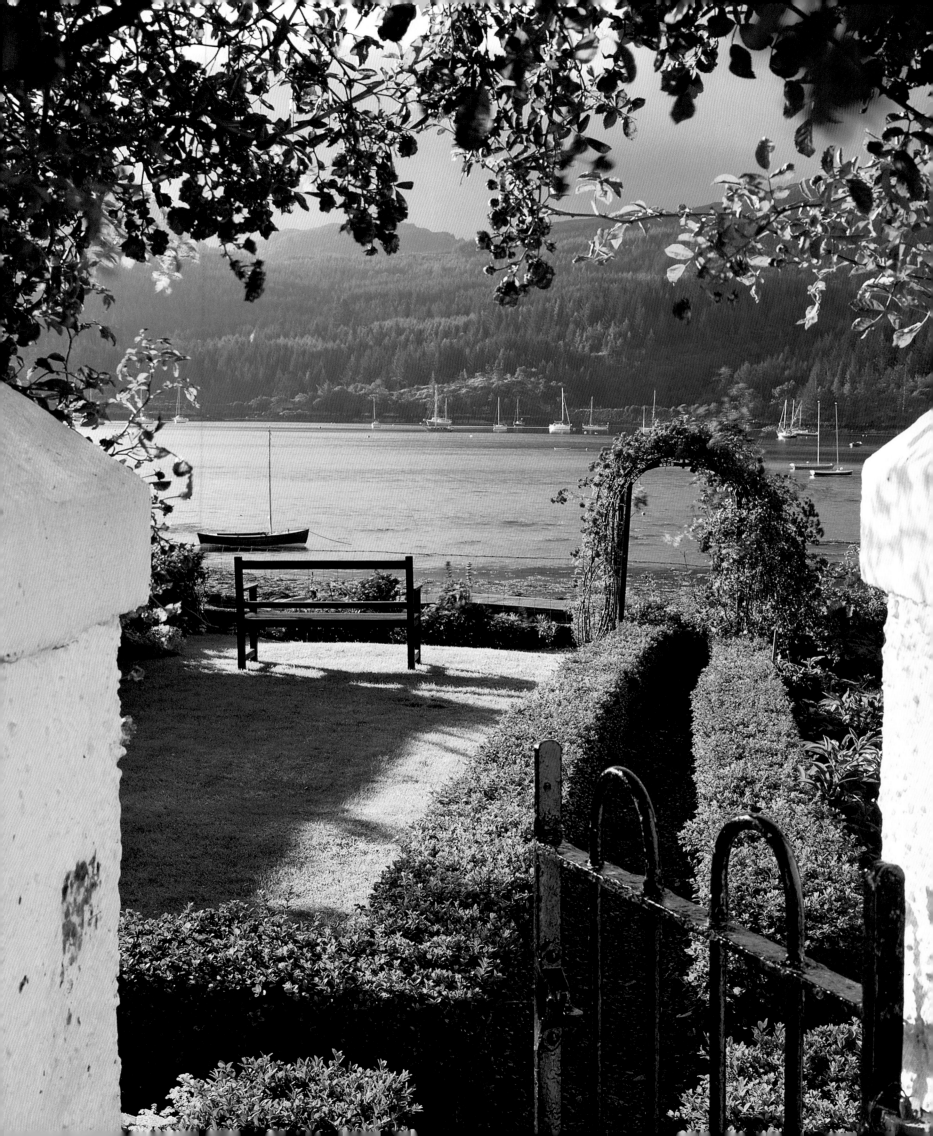

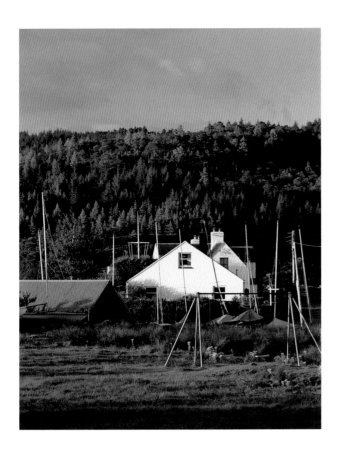

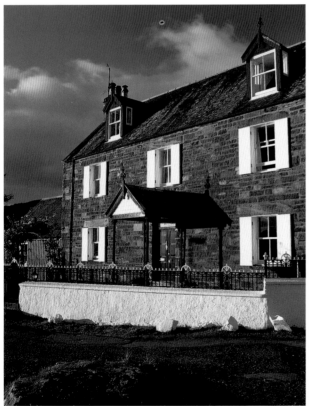

*A*round the harbour (these pages), *looking out on to beautiful Loch Carron, the village is especially busy in summer, with numbers of dinghies bobbing prettily on the swell.*

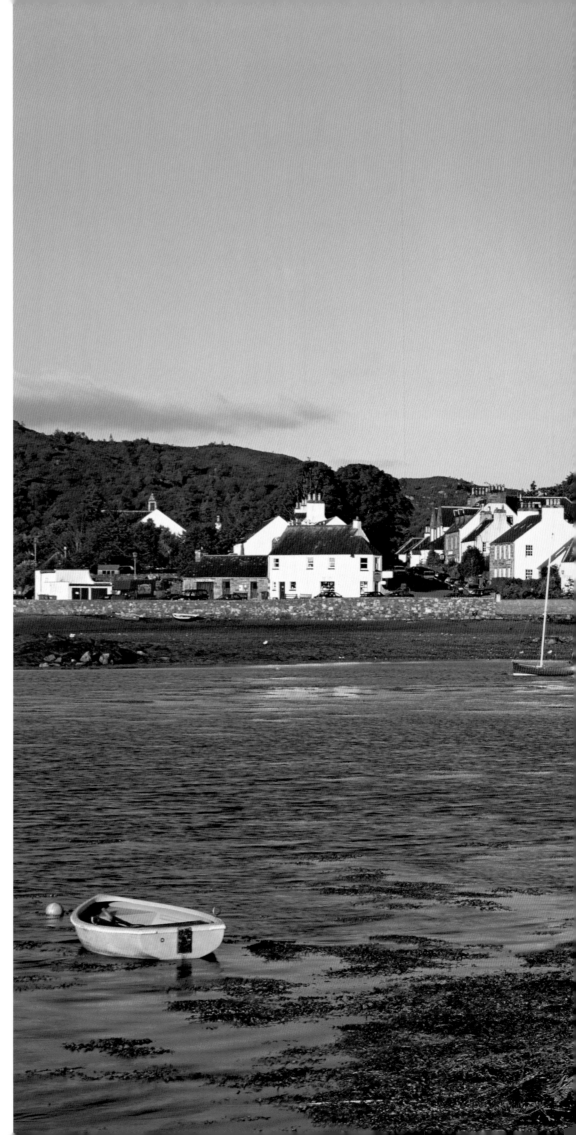

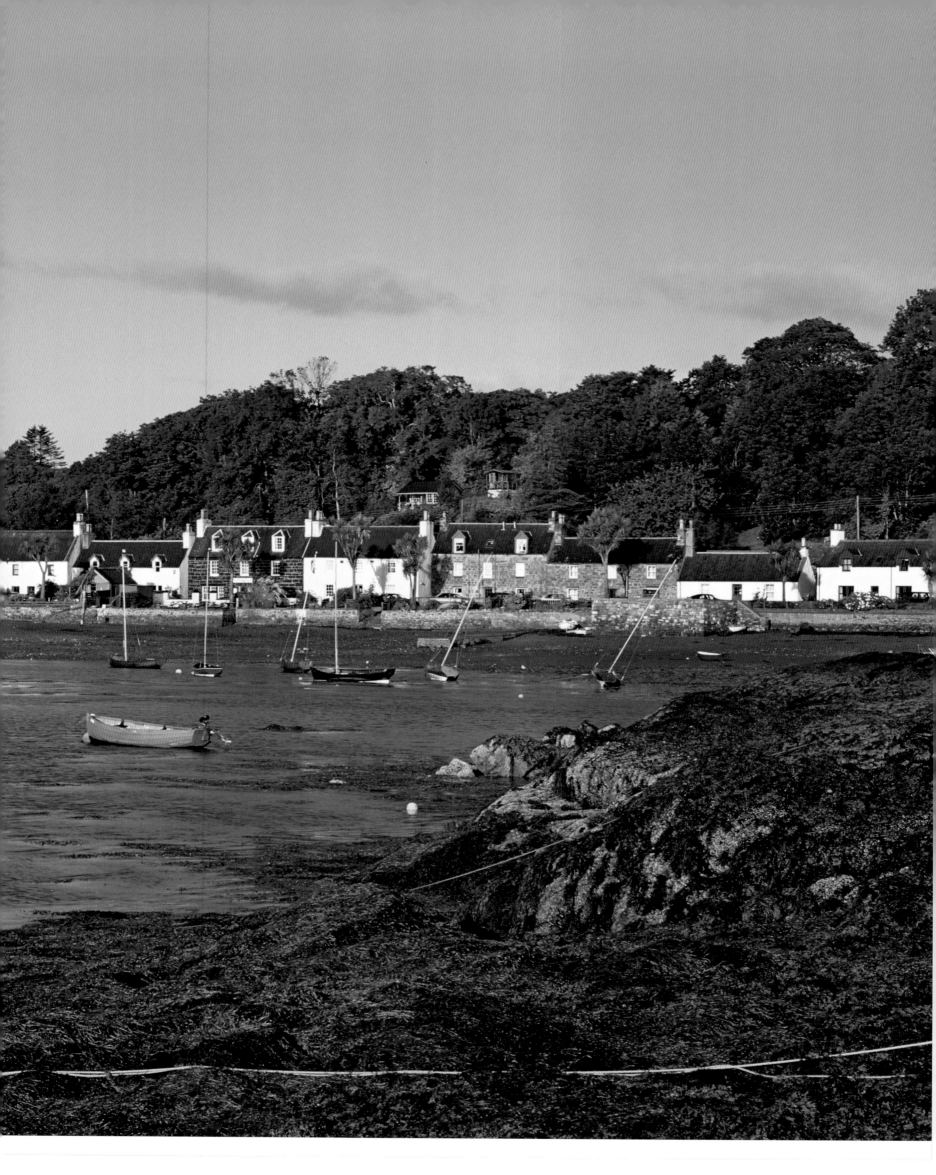

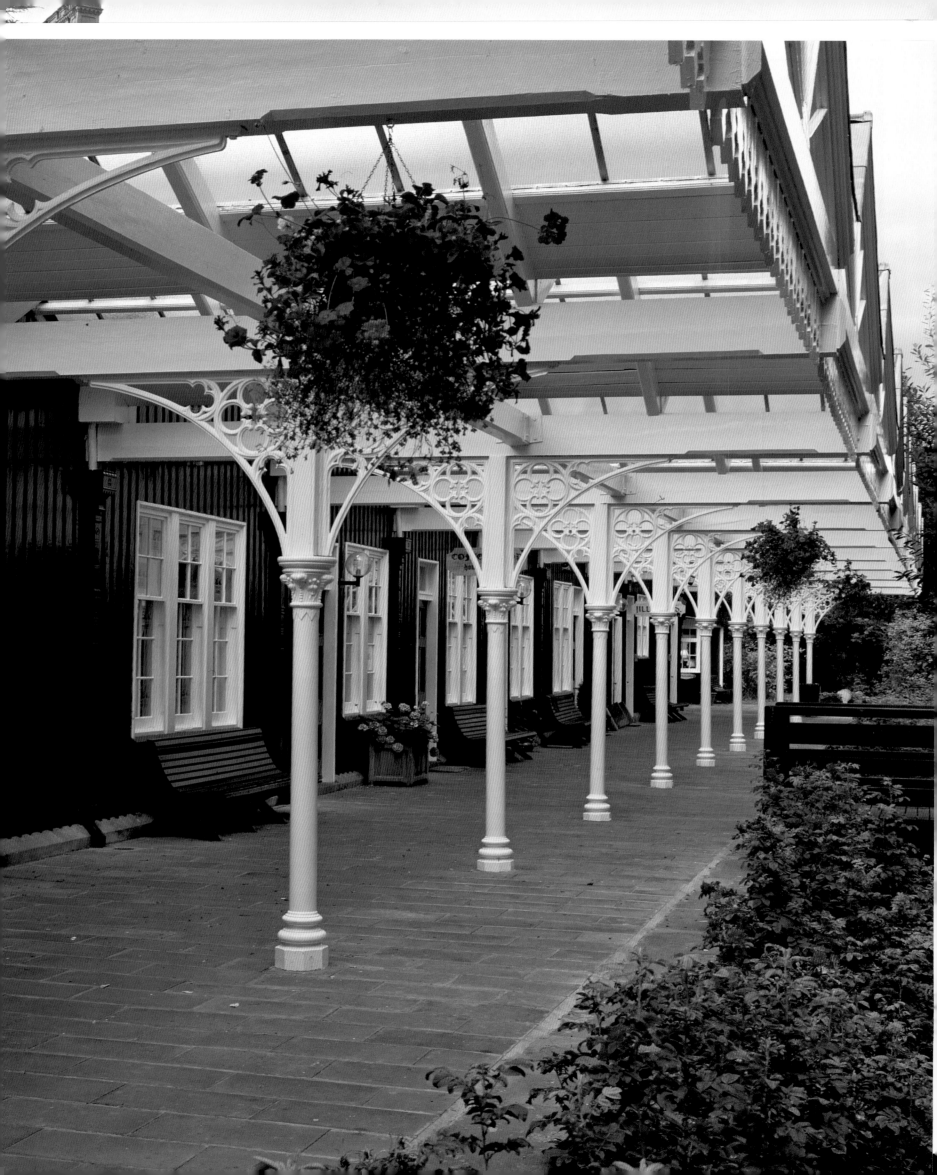

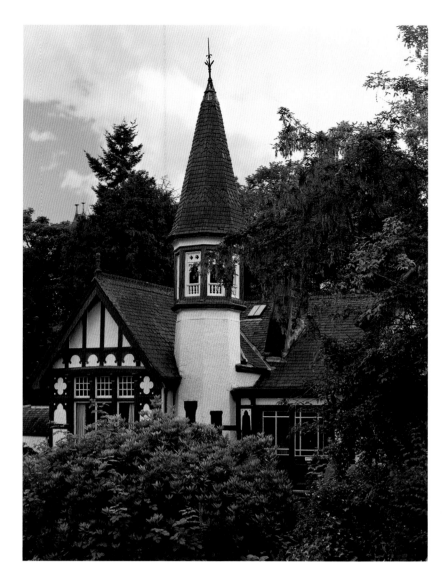

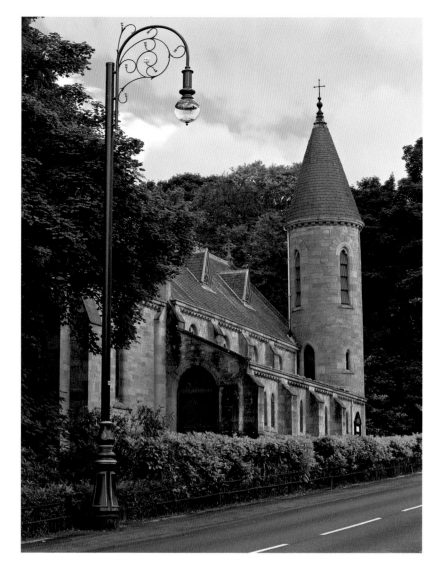

*T*he railway tracks have long since been removed
from Strathpeffer's magnificently ornate station
(opposite), *but it has found a new lease of life as the
Highland Museum of Childhood. Most of the important
village buildings, private and public, have now been
restored to their former pride and glory; even the church
(above right) seems to share the slightly middle-European
look of more secular establishments* (left *and* above left).

Tongue
SUTHERLAND

SUTHERLAND SEEMS A STRANGE NAME for the northern extremity of Britain, but it was so called by a people whose lands lay still further to the north: the Norsemen of Orkney, from whose *jarldom* this nearest part of the mainland was indeed the 'Land to the South'. Thus, the little village of Tongue, which sits on a long and sandy inlet along the north coast from Cape Wrath, started life as a Viking outpost, with the name 'Tunga', or 'spit of land' in Norse. It is thought that the defensible spit which projects here into the Kyle of Tongue may have been where the Vikings first settled, and that Varick Castle, whose ruins overlook the present village (*see* p. 157), was built on the site of the dwelling of a Norse king of the eleventh century. The single tower that still stands is at the end of a pleasant walk from the village, while the views north up the broad, shallow inlet are wonderful. Behind the inlet is the distinctive jagged profile of one of the highest mountains in the north, the 2509-foot Ben Loyal.

Certainly this easily defensible spot was an early stronghold of the increasingly powerful MacKay clan. This family were no friends to the Jacobite cause, and in the second uprising gave an unsympathetic welcome to the luckless sailors of the sloop *Hazard* which ran aground on the sandbanks of the Kyle of Tongue, while attempting to evade its pursuers aboard the government frigate *Sheerness*. The *Hazard* had been headed for Inverness, carrying £13,000 in French gold to support Bonnie Prince Charlie's faltering campaign. MacKay's men caught up with the fleeing mariners, who tried to scupper their treasure in the Lochan Haken nearby. Most of it was recovered, but stories of gold coins turning up and more yet to be unearthed have inevitably found their way into local folklore.

The MacKays continued to dominate the north-western part of the Highlands for six hundred years, engaged in constant struggle with the neighbouring house of Sutherland; eventually the clan sold the last of its lands to its wealthier rivals in the nineteenth century. The village and land around remain part of the Sutherland estates to this day; the grand Tongue Hotel, one of the fine stone houses in the village, was built by the fourth Duke as a hunting lodge, a character it still preserves, much frequented by fishermen and lined with trophies from loch and moor.

Viewed from the ruins of Varick Castle (right), *the dominant landmark of the area, the village appears distributed prettily along the eastern shores of the Kyle of Tongue.*

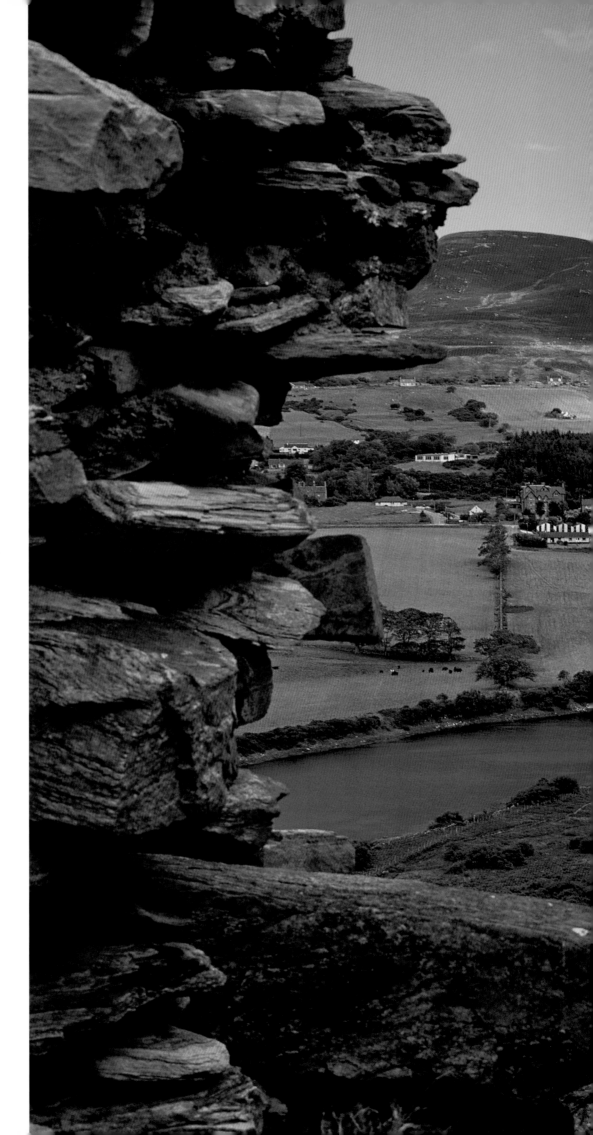

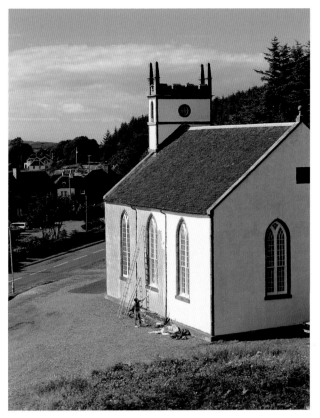

Dunvegan
SKYE

ONE OF THE MOST FEARED CLANS of the north-west
was that of MacLeod, whose castle at Dunvegan has
been the stronghold of its chieftains for almost eight
hundred years, creating something of a record for
continuous habitation by one family. The castle sits
on a rocky outcrop (*see* p. 159) and for most of its
history was accessible only from the sea through a
water-gate in the rocks, perilous for the inhabitants
and for anyone attempting to gain entry by force.
One of the clan's most celebrated chiefs, Alasdair
Crotach MacLeod, was also responsible for building
the church of St. Clement at Rodel on the island of
Harris, when that island was in the control of the clan.

More peaceful centuries have seen the castle
expand comfortably across its rock, Victorian
chieftains being more interested in raising clan
prestige by entertaining rather than by force of arms.
When the main rebuilding took place in the eighteen-
forties, however, a large and purposeful set of
battlements was the architectural feature of choice.
Today's visitors enter by means of a drawbridge,
having made their way unmenaced through some
luxuriantly planted pleasure gardens.

*Sheltered by the hills of the Duirinish peninsula,
the pleasantly down-sized church and houses of
Dunvegan straggle around the sea loch of the same name
(left and above).*

*T*he corrugated gable ends of the general store bring
an almost adventurous architectural aspect to the
main street (above). More in keeping with the traditions
of the place is the thatched roof of a restored smithy, now
home to the Giant Angus MacAskill Museum (right).

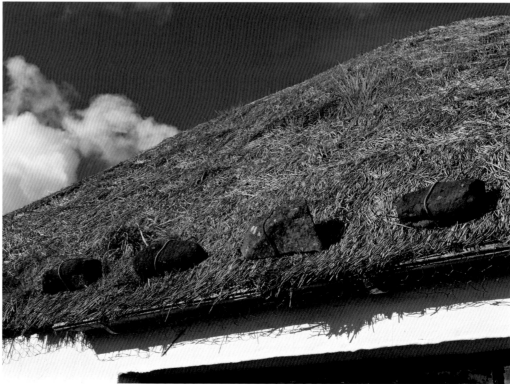

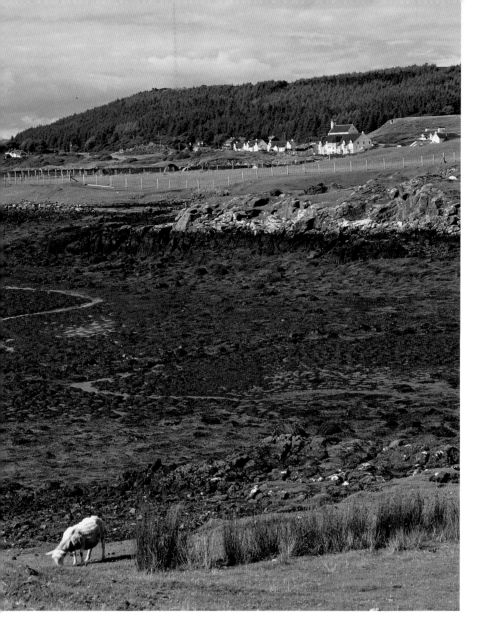

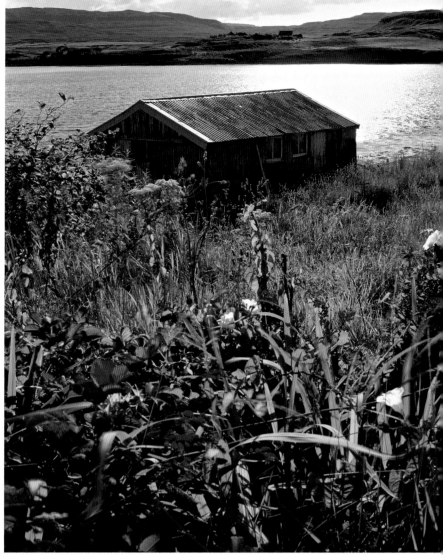

The village itself is the social centre of this north-western corner of Skye, and is sustained now by the large numbers of visitors who stop on their way round the island. They can also visit the former smithy, with its shaggy thatched roof, and marvel at the exploits of local giant MacAskill, who toured his 7'9" frame around the United States in the company of General Tom Thumb, before retiring here. Perhaps because of its proximity to the outer islands of Harris and Lewis, Dunvegan was noted for the fervour of its Calvinist observances; fiery sermons from the pulpit condemned outside influences (including tourism) and a strange variant of the neighbourhood watch operated on the Sabbath, when the long hours of compulsory inactivity after church were enlivened by training high-powered binoculars on neighbours across the glen to see if any signs of movement qualified as breach of the Sabbath laws.

Dunvegan's location at the end of its sheltered loch (above left *and* above right) *makes it a popular destination for yachtsmen; it is also a convenient departure point for small-boat trips to the outlying islands.*

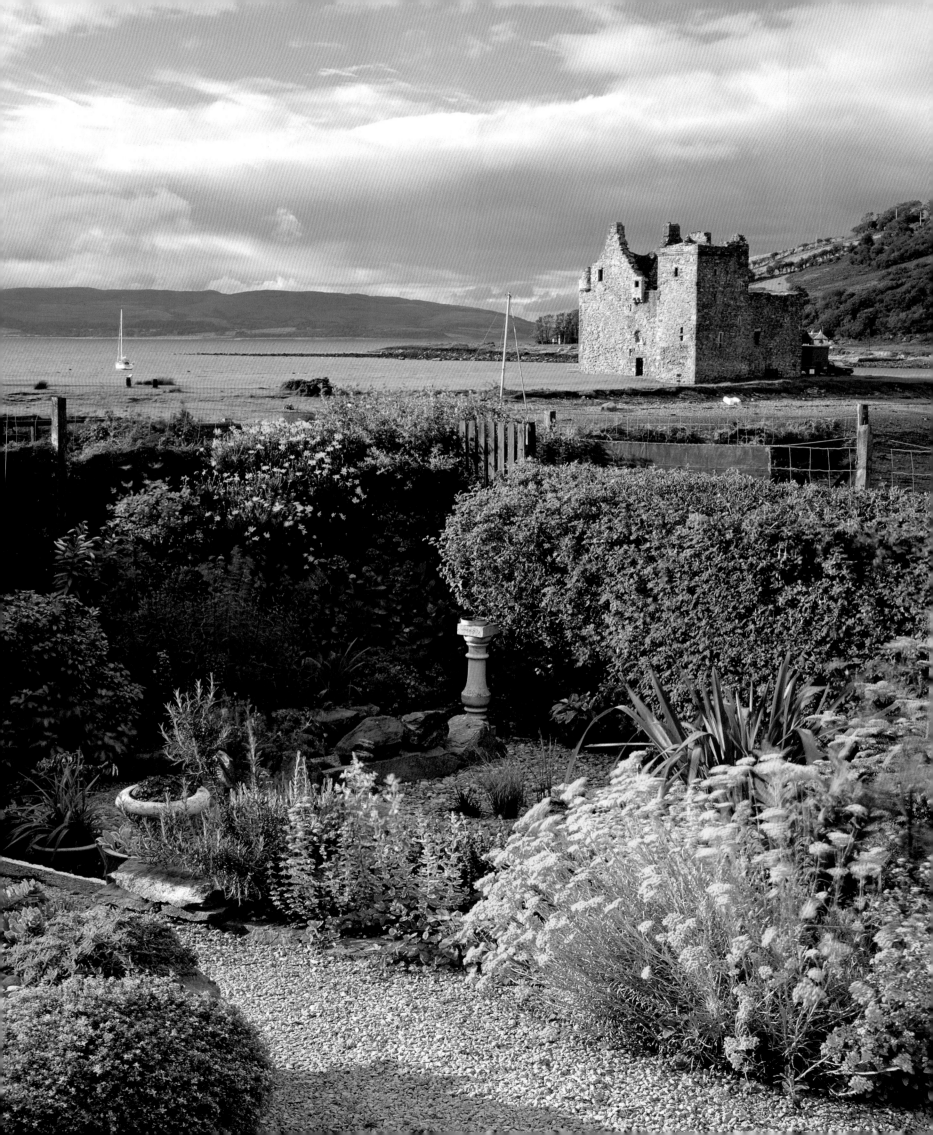

Lochranza
ARRAN

THE SHORT FERRY-RIDE FROM AYRSHIRE'S COAST has made Arran a popular day-trip from nearby Glasgow, and increasingly a stopping-off point for visitors from the south. But accessibility is by no means its only attraction. The tourist authorities' branding of the island as 'Scotland in Miniature' is not as fanciful as it sounds. A drive around the coast will clock up just 56 miles, but the range of scenery is extraordinary. Across the centre of the island runs the Highland Boundary Fault, a geological division that cuts it neatly into Lowlands and Highlands. Around Brodick, the main port of entry and chief town, the land is a broad plain, flat and fertile. Here, the balmy climate has lured settlers from the south, many of whom have set up businesses to take advantage of the tourist trade.

The north of the island is more sparsely populated. The road up from Brodick follows the east coast for some miles, then cuts across below the northerly tip of the island, the Cock of Arran. Here the scenery is as dramatic as anything to be found in the 'real' Highlands – the proximity of the craggy peaks to the road emphasizing their grandeur, with golden eagles often to be spotted soaring high above. It is a pleasant contrast to return to sea-level and enter the shelter of Loch Ranza.

By the time of Sir Walter Scott, Lochranza's castle, sitting on a shingle spit, would already have been a romantic ruin. The Clearances, which devastated the Highlands of the mainland, were no less cruel to Arran's crofters. Of those forced by the sheep enclosures to leave their farming life inland and try to make a go of it on the shores, few prospered and many headed for the New World. Now, 150 years since the last (legal) distillery functioned on Arran, a new one has opened in Lochranza. The product, benefiting from the purity of the air and water, has already attracted the attention of single-malt enthusiasts, and the distillery is conveniently sited on the route of round-the-island tours.

Round the headland, past the little ferry-port that connects with Claonaig on the Kintyre peninsula, there is a wonderful stretch of coast running southwards around the wide bay of Catacol. Here, a dainty row of identical black-and-white cottages, known popularly as the Twelve Apostles (*see* pp. 2–3), looks out over Kilbrannan Sound.

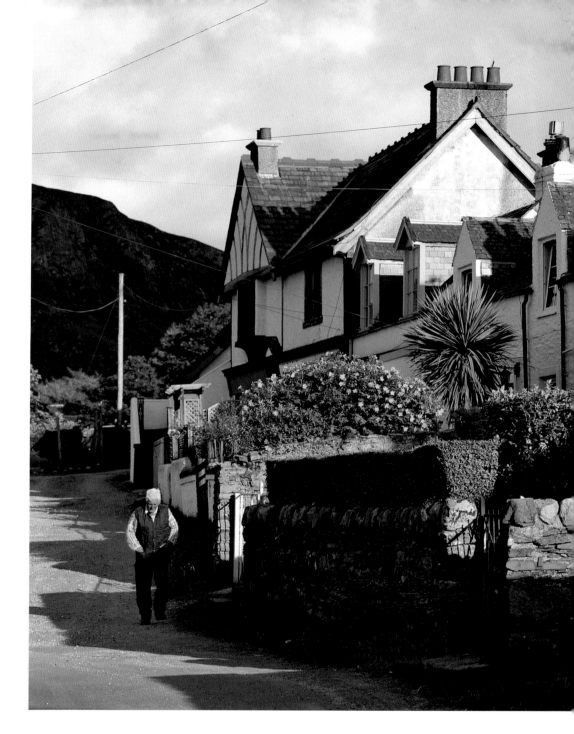

Although situated in one of Arran's most spectacular settings – a ruined castle on the shores of a bay, against a mountain backdrop – Lochranza somehow manages to escape the intense tourist attention which focuses on the southern part of the island (opposite). *Behind the shoreline, the village has its homely side in the solid dwellings on its main street* (above).

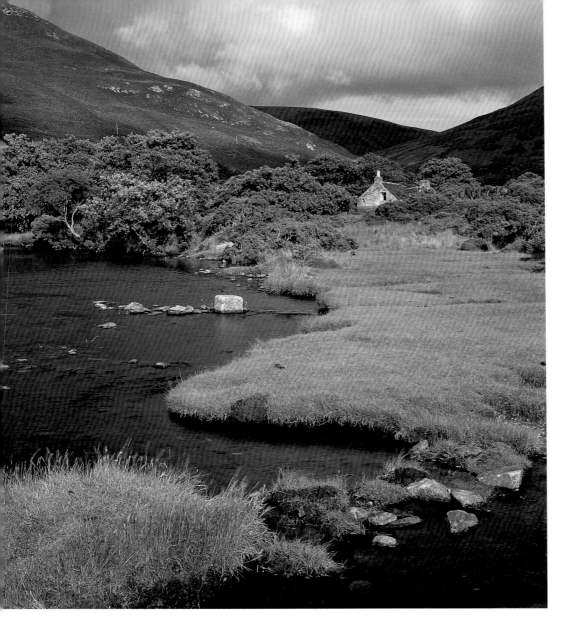

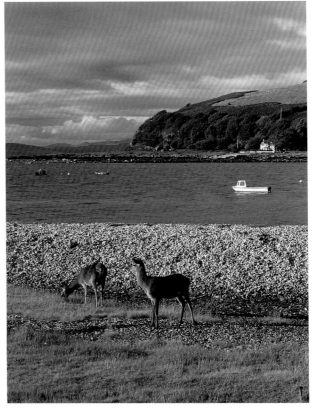

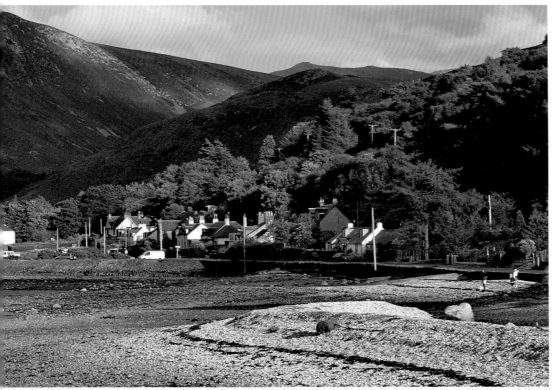

*S*ir Walter Scott noted that the mountains which
encircle Lochranza seem to separate it from the rest
of the world (this page). And, indeed, the village does
seem to look away from the land and out across its loch.

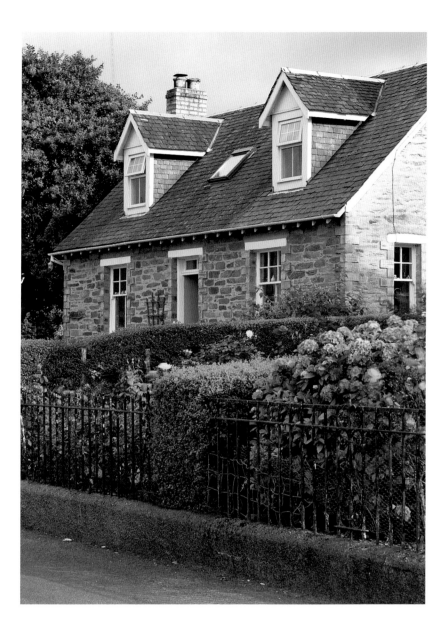

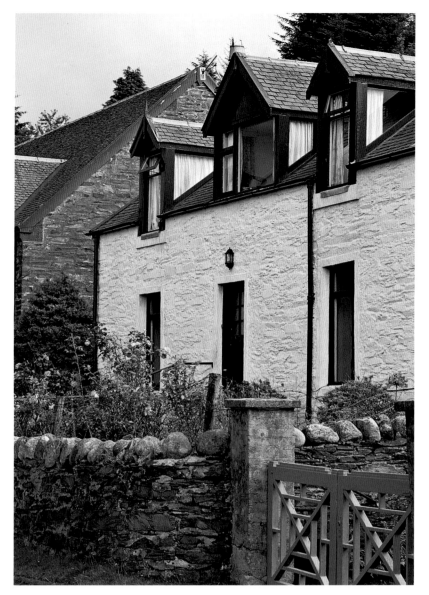

Within this enclosed community, the very sturdiness of the houses (this page) seems to bespeak a robust independence, born of the rigours of island living and separation from the more populous south.

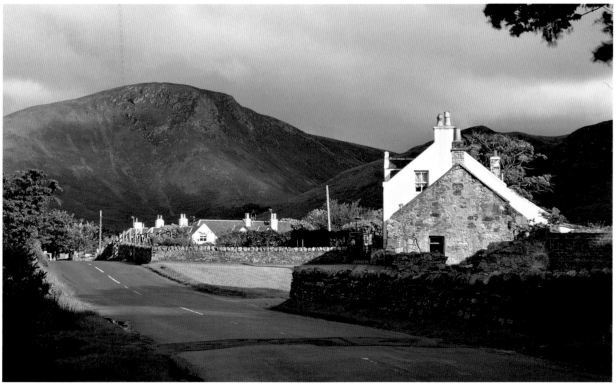

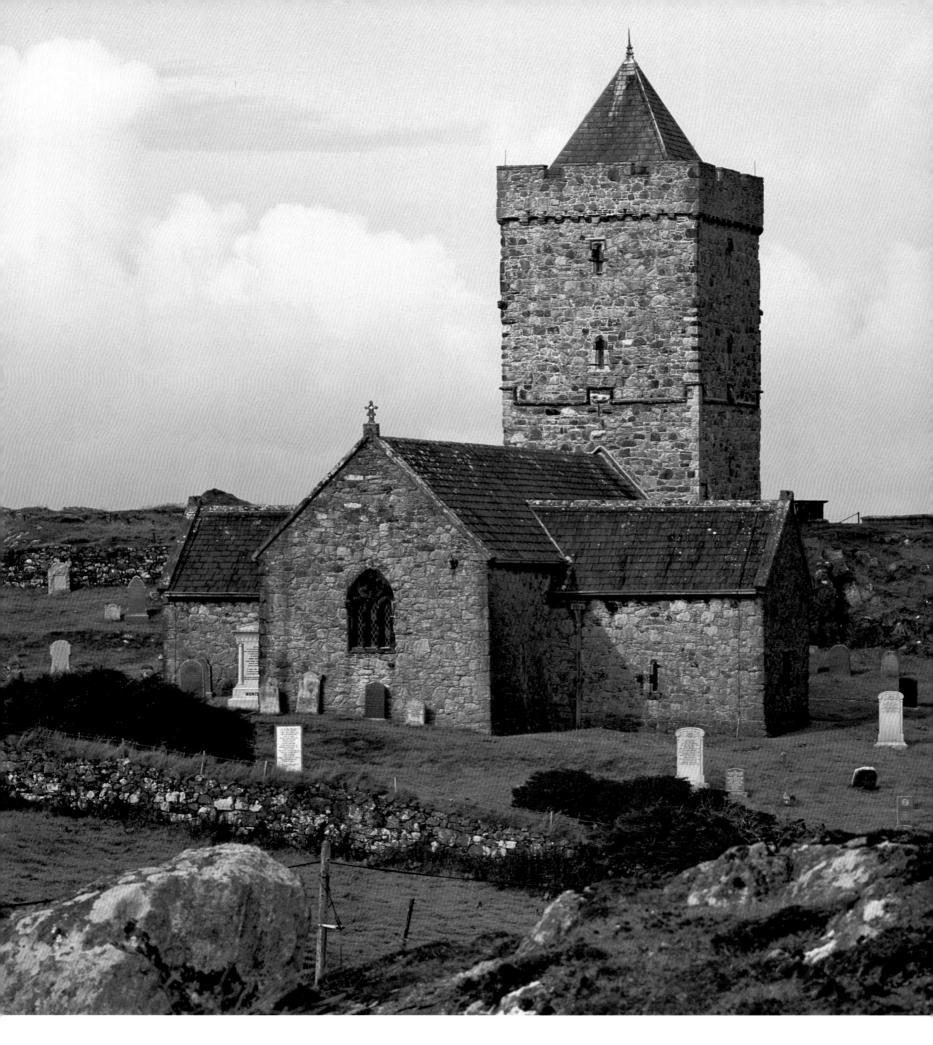

Rodel HARRIS

HARRIS IS INDEED PART OF THE WESTERN ISLES, but is not completely an island. Rather, it shares the main island of the chain with its northern neighbour Lewis. To confuse matters further, Harris is itself divided by a narrow isthmus on which the village port of Tarbert sits and south of which lies the most dramatic scenery of the whole of the Outer Hebrides. Following the east coast, the 'Golden Road' (so named because of the huge cost of its construction) weaves in and out of countless narrow sea lochs over a rockscape of bare gneiss, only occasionally relieved by moody patches of peat or the gleam of an inland 'lochan'.

On the opposite shore, the picture is quite different. Below the fringe of rich 'machair' (the fertile heather- and grass-land above the dunes) spread dreamlike, empty beaches, which look west to islands inhabited only by sheep and to the Atlantic beyond. It is a surprise to find so few signs of habitation on the lush pastureland, compared with the number of crofts tucked into the dips and hollows of the barren 'Bays' to the east. This was not a matter of choice, however, but a harsh illustration of the fate of the crofters who were removed from their grazing grounds during the Clearances.

A centre of Harris Tweed production (above)*, Rodel boasts one of the finest monuments of the Western Isles – the cruciform pre-Reformation church dedicated to St. Clement* (left)*.

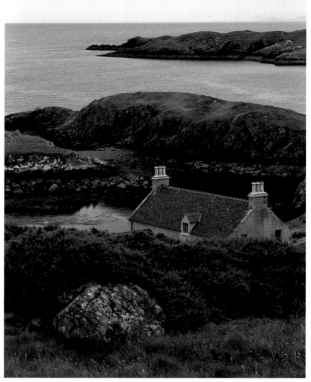

at the extreme tip of Harris in the tiny settlement of Rodel (Roghadal). It still contains the splendid recessed tomb of Alasdair Crotach MacLeod, who had it built for himself some years before he was laid there in 1547.

Rodel was once a port and the crossing-place for boats to North Uist, where the chain of the Western Isles continues. Now it is in a romantic state of disuse, the quaysides grassy and only a couple of fishing boats tied up there. Happily, the mansion by the former port, which was built in some style by the last-but-one of the MacLeod landlords, has been saved from dilapidation and collapse and reopened as a luxury hotel.

A deserted small loch, inland of Rodel, sums up the retiring nature of the place (left). No longer the ferry port for Skye, Rodel's harbour is now very quiet, though new life has been introduced by the restoration of the Rodel Hotel (above).

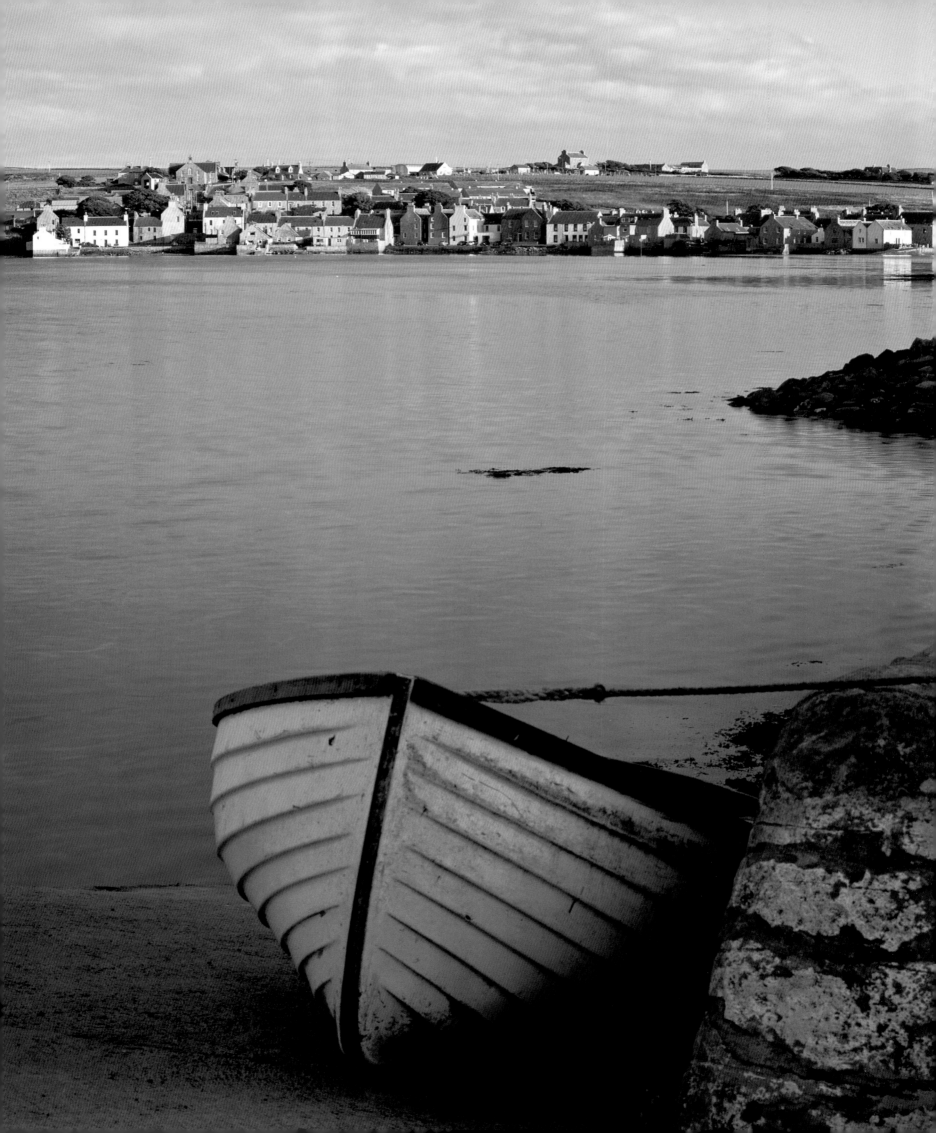

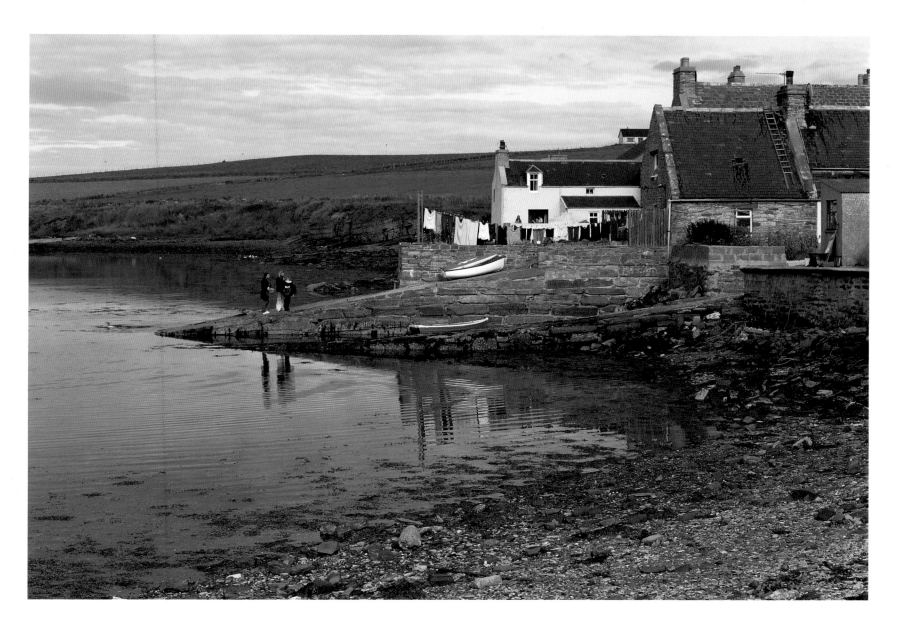

St. Margaret's Hope ORKNEY

*O*nce a thriving port,
*St. Margaret's Hope is now
a pleasantly peaceful assembly of
attractive houses around a quiet
harbour* (opposite), *although
there is now a ferry to the Caithness
coast. The houses reach down to
the quayside* (above), *built end-on,
presumably as protection from the
wind blowing in across the water.*

THE LARGE BAY OF ST. MARGARET'S has traditionally
provided a safe and welcome haven to local fishermen,
especially during the heyday of the herring fleets in
the early nineteenth century. Front Street, which
faces the tiny quay, is formed of a single row of
sizeable seventeenth-century houses which come
down to the water; here, with limited room, they
were built narrow end-on – at right angles to the
water. This arrangement also provides more shelter
when the weather turns bad. The main street of the
village, the only one of any consequence, is called,
appropriately, Back Street. Despite its small size,
this is still the third largest settlement of the Orkneys.
South Ronaldsay, of which it is the *de facto* capital,
is the southernmost of the islands, placid and remote
from the relative bustle of the Mainland, as the
largest island is named. Since the Second World War,
the two have been connected by a road over a series
of causeways built to protect the naval fleets at
anchor in Scapa Flow. In the last few years, a

smart red-funnelled car-ferry has also started a service
to Gills Bay on the north coast of Caithness.

It is not disputed that the name of St. Margaret's
Hope comes from that of a former Queen of Scotland,
but opinions are divided as to which one. The first
Margaret, chronologically speaking, started life as
a Saxon princess, who fled to Scotland after the
Norman Conquest of England, and was married to
Malcolm III. Her exceptional piety was recognized
in her lifetime, as well as after her death, when she
was canonized following a series of miracles at her
tomb in Dunfermline Abbey. The later of the two
Margarets might have had an even greater influence
on Scottish history than her predecessor. The
granddaughter of Alexander III of Scotland, she
was raised in Norway as her mother was married to
the king, Eric. At the age of three, Margaret became
the titular Queen of Scotland, after Alexander was
killed without producing a male heir. A marriage
was arranged between the infant queen and the young

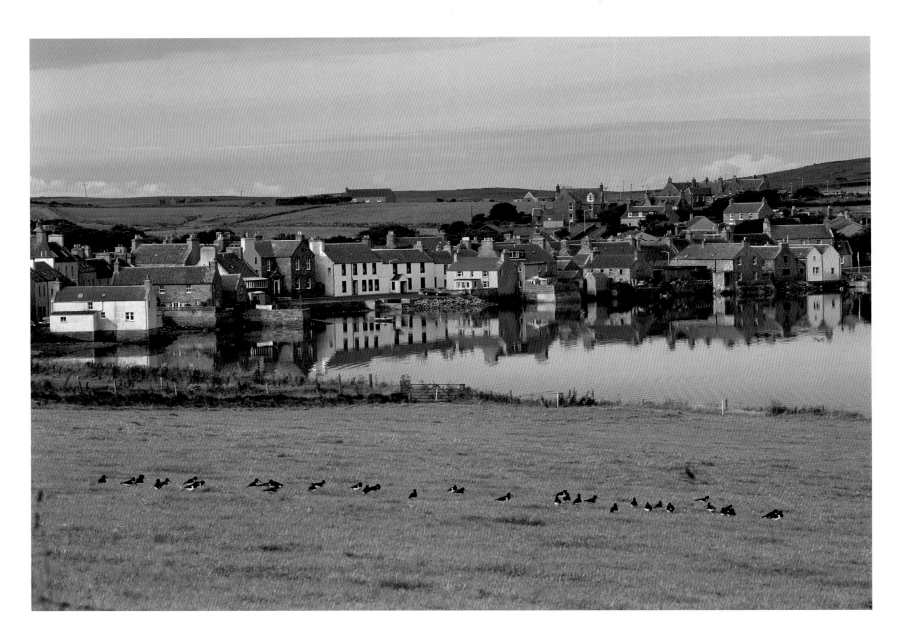

*M*irrored in the waters of its little bay, St. Margaret's appears as the very epitome of the small maritime village (above). A well-disciplined line of lapwings in the foreground completes the composition.

son of Edward I of England, who was to become Edward II. This union, which might have rewritten some of the bloodiest chapters in the turbulent history of the two countries, was destined never to take place. The bride-to-be set sail to meet her betrothed, but never arrived in England; caught in a storm, her ship made for the shelter of Orkney, where the seven-year-old princess died from an illness contracted during the voyage at the end of September 1290.

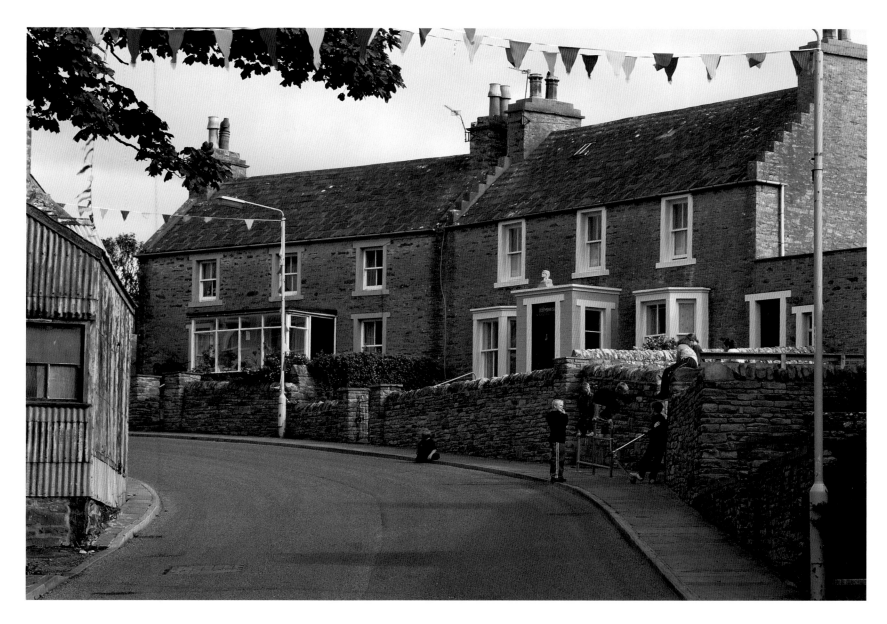

*B*ehind the sea-front, the main street meanders
(above) – *a series of honourable, sturdy dwellings
and, inevitably, the shop which has everything* (left).

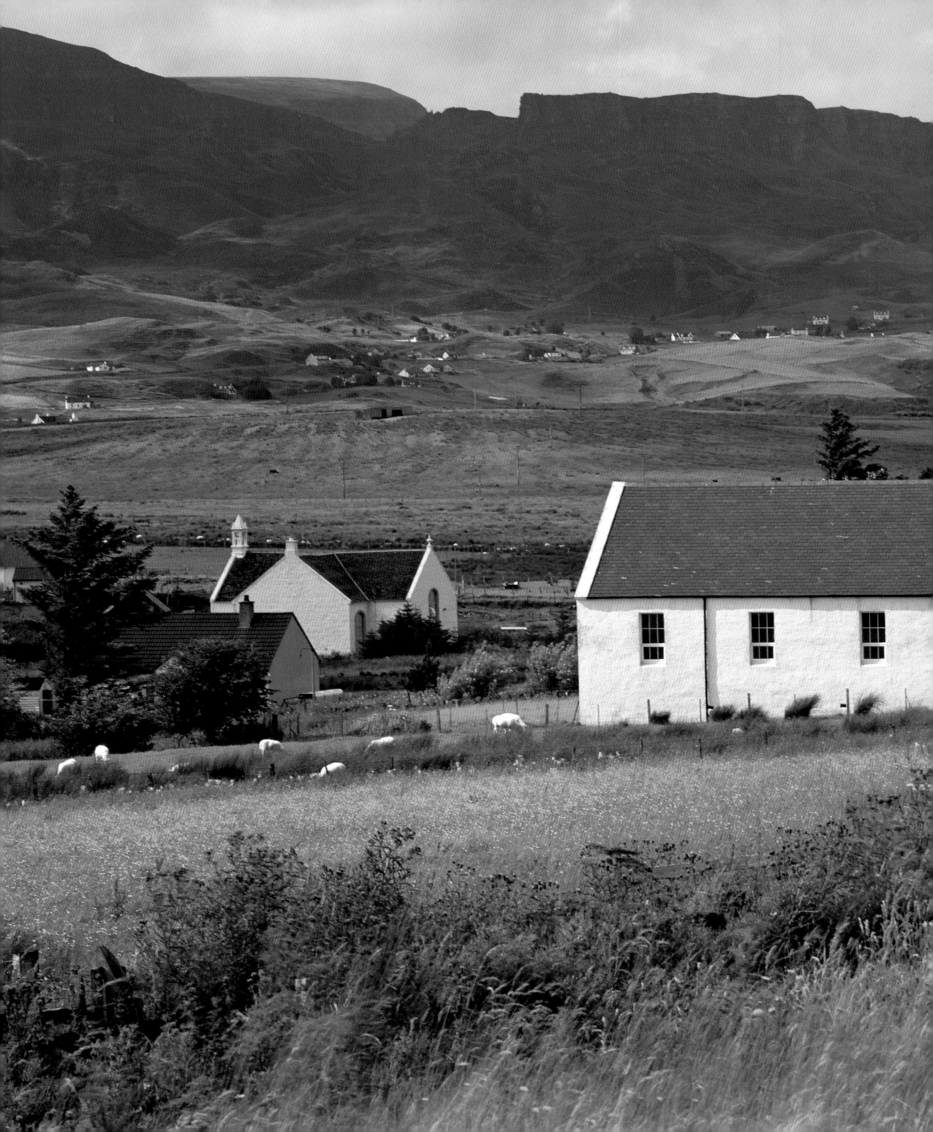

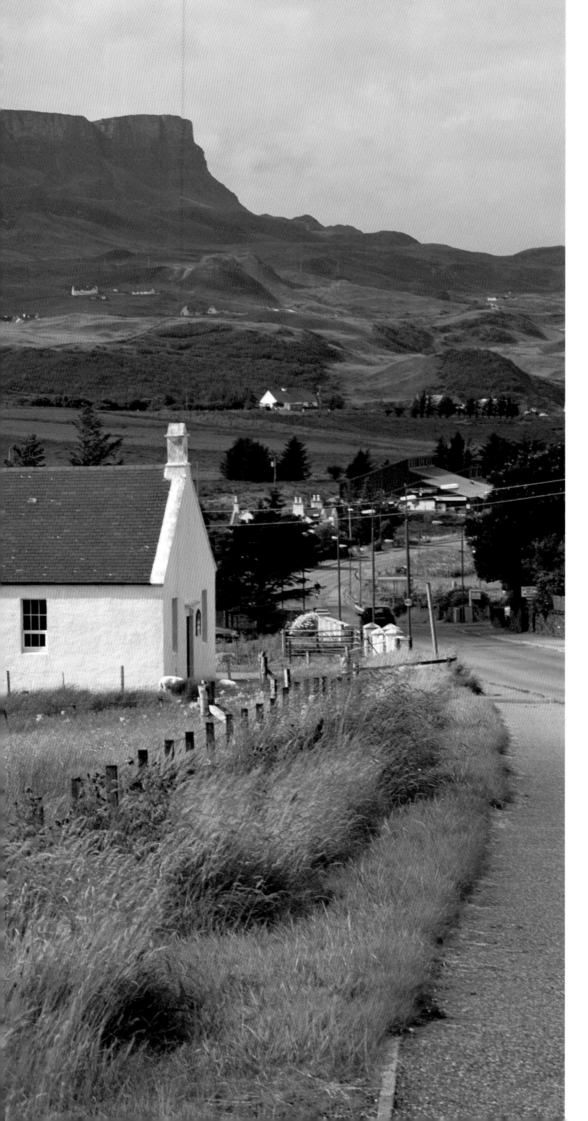

Staffin
SKYE

SKYE, OR SKUYÖ ('ISLAND OF MIST') as the Vikings called it, is the wildest of the Inner Hebrides, although it lies so close to the Scottish mainland as to be almost part of it. Now a bridge has been built across to the island from the former ferry-head on the Kyle of Lochalsh, permitting easy access for summer visitors by car. Fortunately, there is still plenty of Skye left for those seeking a greater challenge. Seasoned mountaineers head for the Cuillin, one of the most demanding mountain ranges in Britain, where they can grapple with the outlandish rock formations and the less substantial but equally dangerous mist, which arrives with a sometimes fatal suddenness. These famous peaks, with their conical shapes and serrated tops, are merely the most recognizable volcanic features of the island; in fact, most of the rest of Skye was shaped by that momentous era, fifty million years ago, when huge tongues of lava pushed northwards to form what are now the mountainous peninsulas of Duirinish, Waternish and Trotternish.

Alpinists may enthuse about the ultra-hard black gabbro rock of the Cuillin, but what of the generations of Skye inhabitants, in need of something more yielding to farm? Luckily, there are patches where the underlying clay has surfaced around the volcanic crust, and here farming settlements have sprung up. Staffin, on the north-eastern edge of the Trotternish peninsula, is a good example. The scattered layout of the village, with its white-washed farmhouses dotted about the gentle slope which runs up from the coastal road, gives an idea of how a crofting community came to function in later times, with small arable plots for each family, and communal grazing on the higher ground.

This is a tight-knit community, largely Gaelic-speaking, where many of the crofts are still worked, having been handed down in the same family for generations. Some have taken advantage of the unparalleled views over to the mainland and become

*U*nder the forbidding backdrop of the Quiraing, the crofting community of Staffin on the Trotternish peninsula lies, houses dispersed across a gentle slope running down to the coastal road (left).

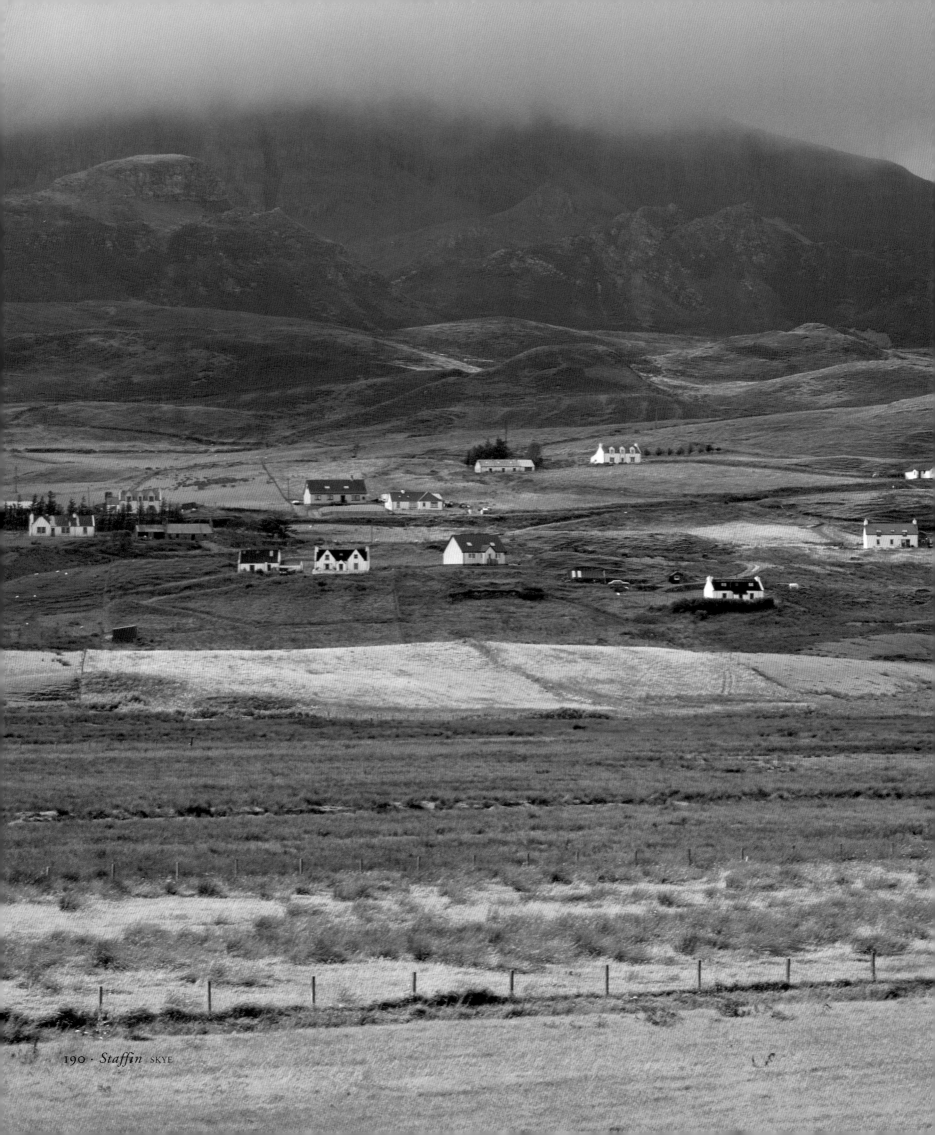

holiday homes or bed-and-breakfasts, to house the visitors who come up here to enjoy the wide sandy Staffin Bay and the nearby coast, along which stand more colossal souvenirs of Skye's geological past in the form of dramatic rock formations, including a 120-foot 'needle'. Other prehistoric presences include a number of fossilized dinosaur footprints which were uncovered in 1996.

The rock formations of the Quiraing can look savage indeed in certain weather conditions (opposite). Underneath their towering presence, the characteristic whitewashed and 'spotty' houses of Staffin (this page) have a touching air of vulnerability.

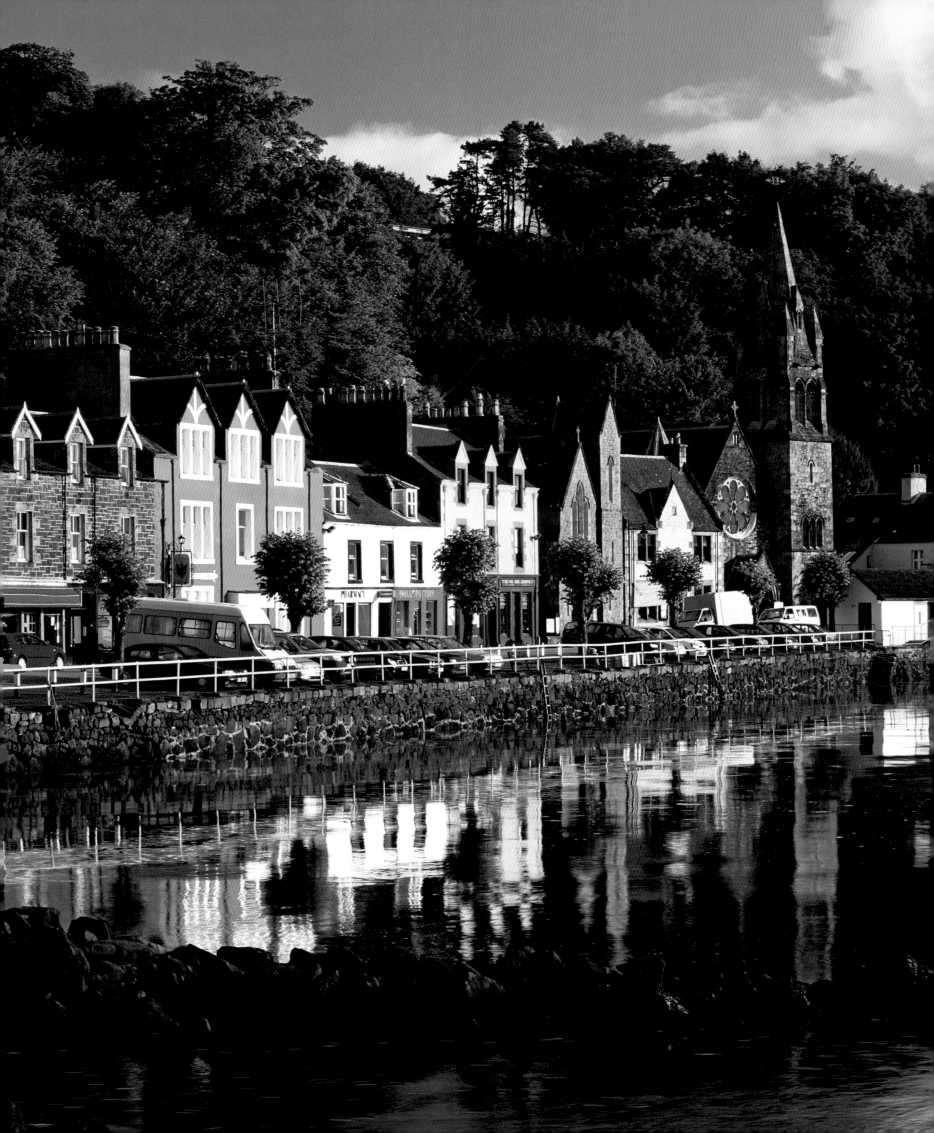

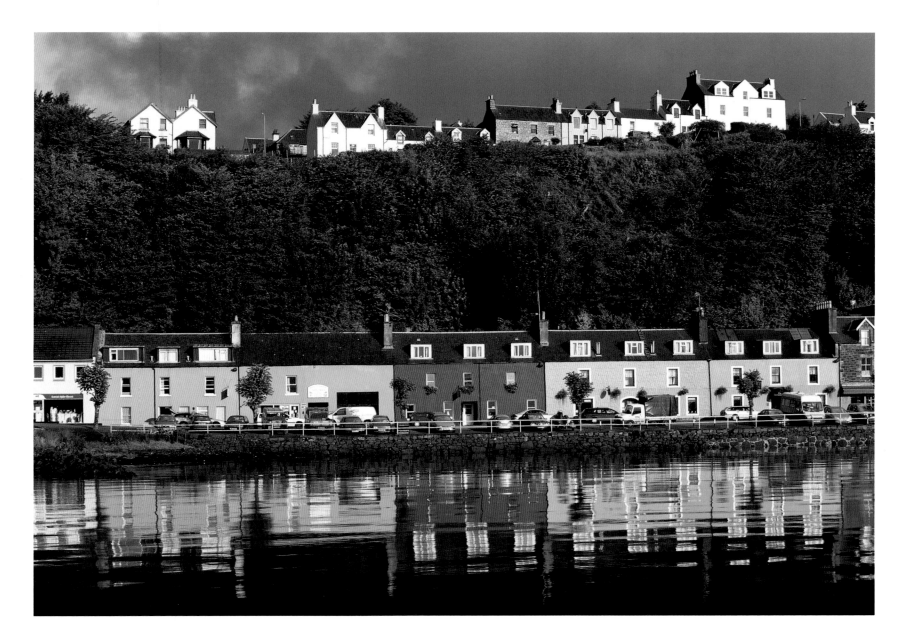

Tobermory MULL

The waterfront of Tobermory is lined by fine old houses, many of them now painted in bright colours, recalling a prosperous past (opposite). Their reflections in the waters of the harbour make a brilliant display, while above can be seen the houses built for a later generation of inhabitants (above).

MULL WAS NOT DR. JOHNSON'S FAVOURITE PLACE. 'A most dolorous country', he called it. He did cheer up, however, when his under-sized pony brought him to Tobermory. His visit in fact pre-dated, by a dozen years, that of the Society for Extending the Fisheries and Improving the Sea-Coast of the Kingdom. The dignitaries who made up this body found Tobermory, with its marvellously sheltered, wide bay, ideal for the establishment of a commercial port for the hoped-for herring boom. The scheme was not a great success. Perhaps the philanthropic provision of a spacious kitchen garden for each cottage, plus grazing rights, as an inducement to the settlers, was counter-productive; the sixty crofters thus transplanted were not much inclined to abandon the familiar round of their subsistence agriculture in favour of the challenges and uncertainties of fishing for herring, which anyway eventually deserted the waters off the Scottish coast.

The good news for present-day Tobermory is that the port, even if it did not bring the promised prosperity, has provided it with some delightful buildings. The handsome, tall Georgian houses that line the harbour front were built on a scale to suit the dignity of the various port officers they were to house. Later were added, on the hill above, rows of terraced houses for the new inhabitants, laid out in a neat grid of patriotically named streets. The effect is undeniably picturesque; the reflections of the main street of shops, now painted in bright poster-paint colours, light up the shimmering waters of the harbour. A second steamer pier was built in time to welcome the visitors who flocked in the wake of Queen Victoria to marvel at the natural wonders of Staffa and Fingal's Cave. Even after the construction in 1964 of a deep-water dock at Craignure to the east of Mull, which became the main link with the mainland, Tobermory has effectively remained the capital of the island, providing

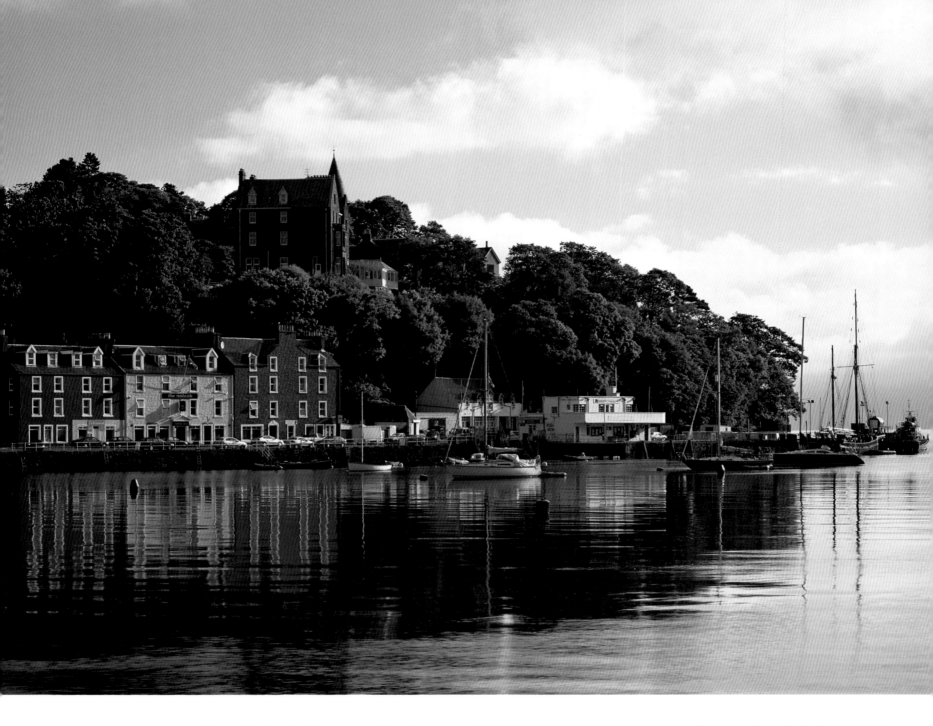

a centre for social and cultural events, as well as the
nearest shops for the inhabitants of the somewhat
isolated Morvern and Ardnamurchan peninsulas just
over the water. A more than tolerable evening, often
enlivened by singing and dancing, can be spent in
the lively pubs along the waterfront.

*The façades of shops lend a lively look to the main
street of Tobermory* (above) *as it runs beside the
little town's old harbour. Originally built as a herring
port, the harbour* (right) *was later extended to
accommodate tourist steamships.*

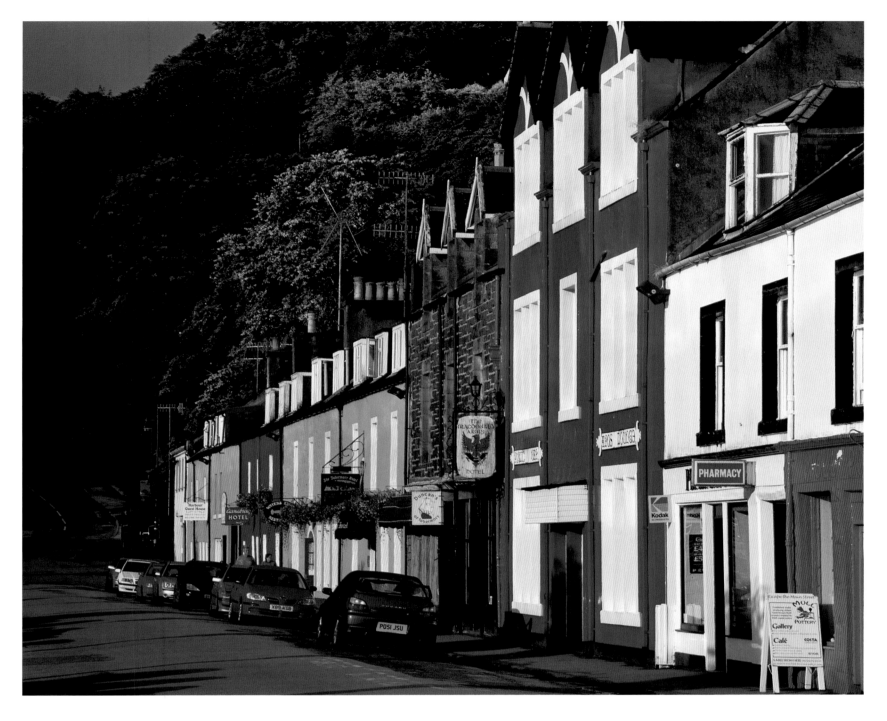

*T*he harbour waters (left) *shimmer with the reflections of the brightly painted shop fronts* (above) *which proclaim Tobermory as the centre of commercial and social life for the whole island of Mull.*

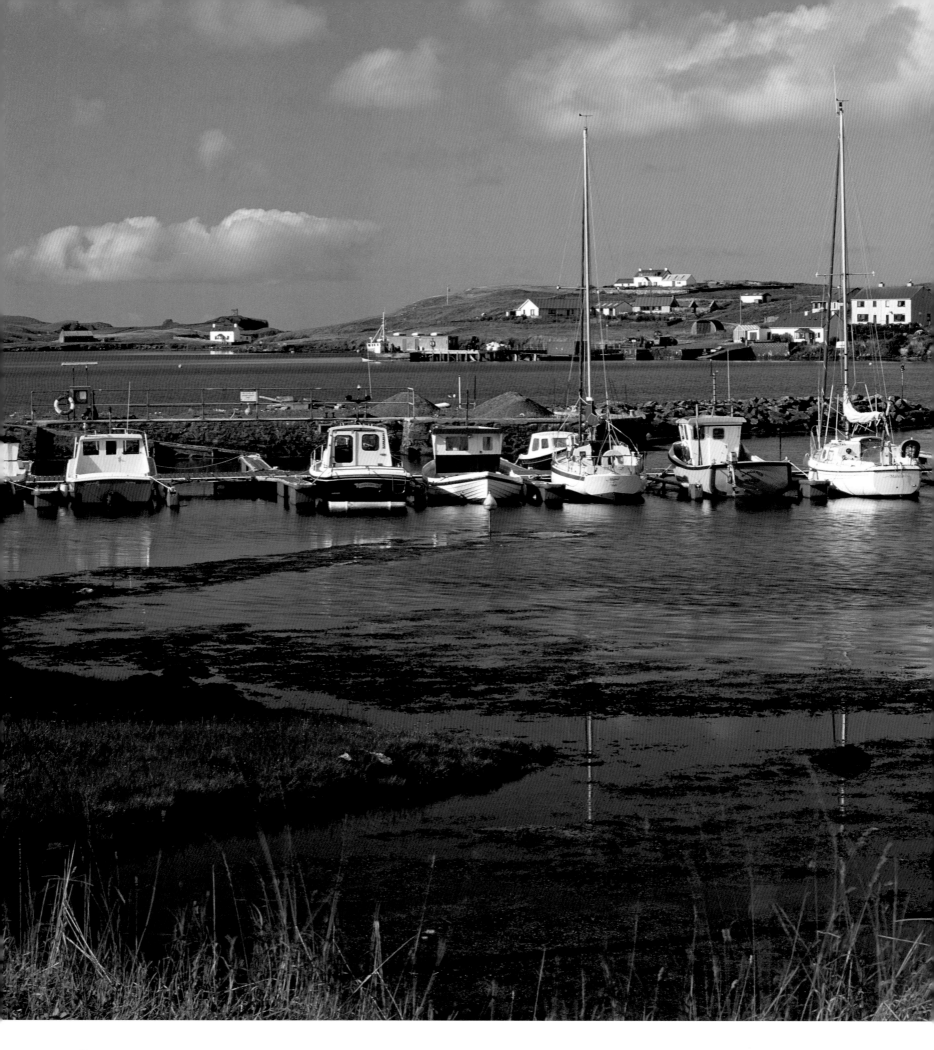

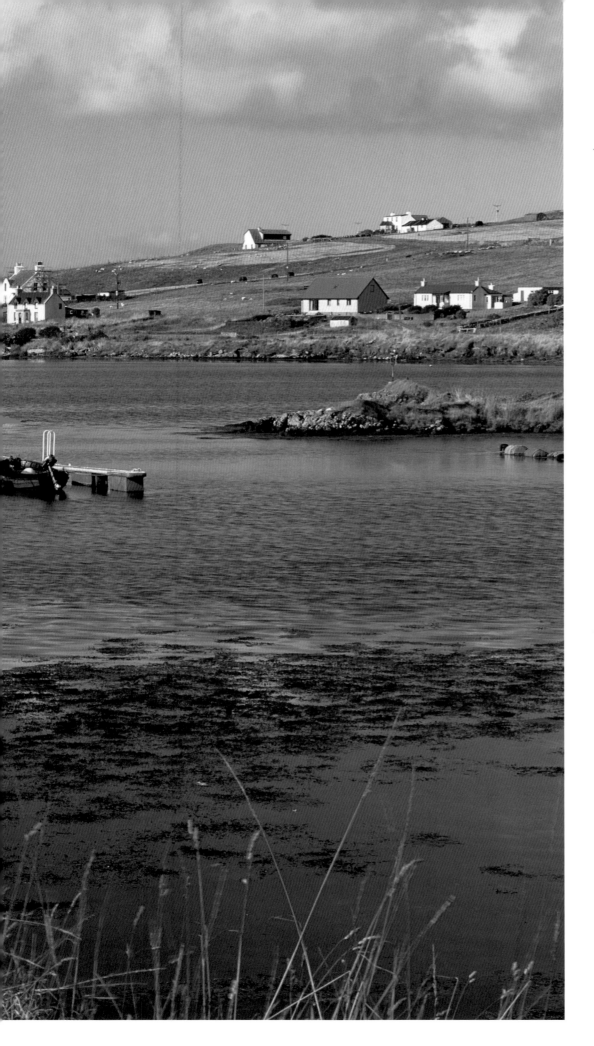

Walls SHETLAND

SHETLAND FEELS LIKE ANOTHER WORLD, or at least
another country. Its geographical position is in fact
so implausibly far north that it is closer to Norway
than to Scotland, and during the five thousand years
of its recorded human history, it has been only during
recent centuries that its people, mainly descended
from the Vikings who settled there, bothered with
the British at all. The largest of the fifteen inhabited
islands (known as the Mainland, an expression never
used by the locals to refer to Scotland) stretches north
from Sumburgh Head for some sixty-five miles, a
rocky landscape which shows every sign of its never-
ending struggle against the elements. In Shetland,
one is always close to the sea, and never further than
three miles from it. Walls, which sits on a large,
sheltered inlet to the west of the Mainland, was once
a busy fishing port; now its handful of surviving houses
look out over a tranquil marina to which only the
most adventurous yachtsmen come.

For many years, this almost inbred facility of the
Shetlanders for sea-faring under tough conditions
attracted the attentions of the visiting press-gangs
of the Royal Navy. Better prospects were promised
to merchant seamen who joined the P. & O. line,
the hugely successful merchant fleet started by Arthur
Anderson, who began his working life near Lerwick,
hired to mind the fish left to dry by the fishermen.
Even when his shipping business had made him a
fabulously wealthy man, he never forgot his Shetland
roots. In 1836, he bought the island of Vaila, which
stands at the mouth of Walls' harbour, and started
the Shetland Fishery Company, a co-operative venture
designed to help local fishermen make a decent living.

Recent years have brought the temporary stability
of oil revenues to Shetland, and improved access has
boosted the number of visitors, for whom the very
remoteness of the islands is often part of the attraction.
Some visit and never leave – it is not uncommon these
days to see a satellite dish fixed to the roof of a croft,
from which a refugee from the urban rat-race might
very well be running a global business – a remote
headquarters at the edge of the world.

*F**ormerly a busy fishing port, Walls now presides
quietly over a large, sheltered inlet on the west
of the Shetland Mainland; the marina is a place for
the experienced yachtsman* (left).

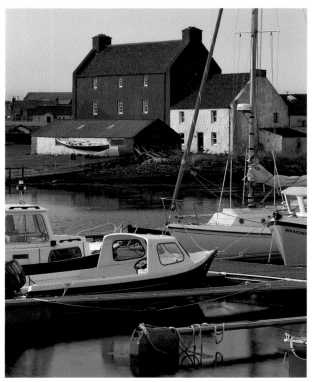

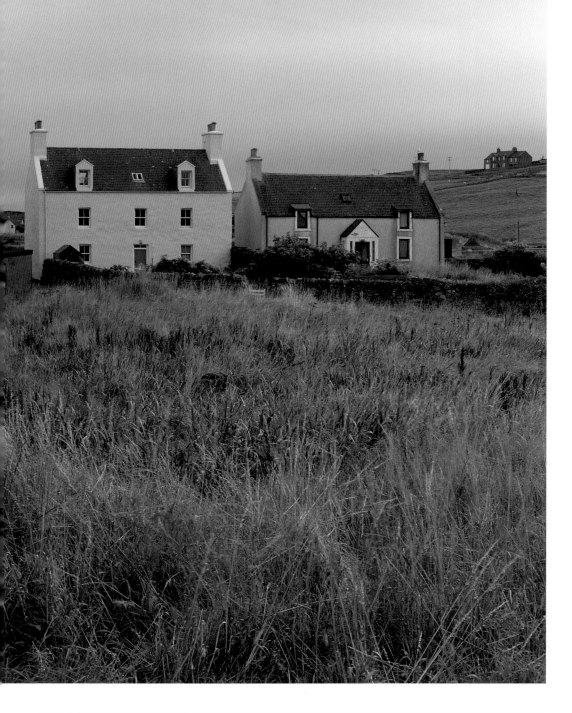

The old houses of Walls, gathered around the harbour (these pages) have been mainly kept in good repair. A few, however, have suffered at some point from the effects of depopulation and declining opportunities (left below).

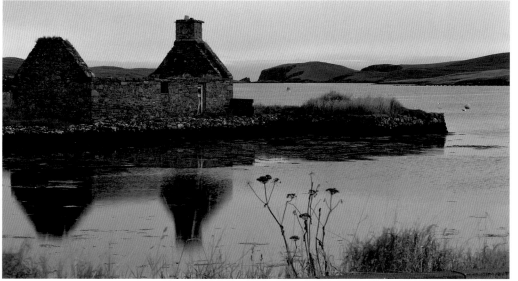

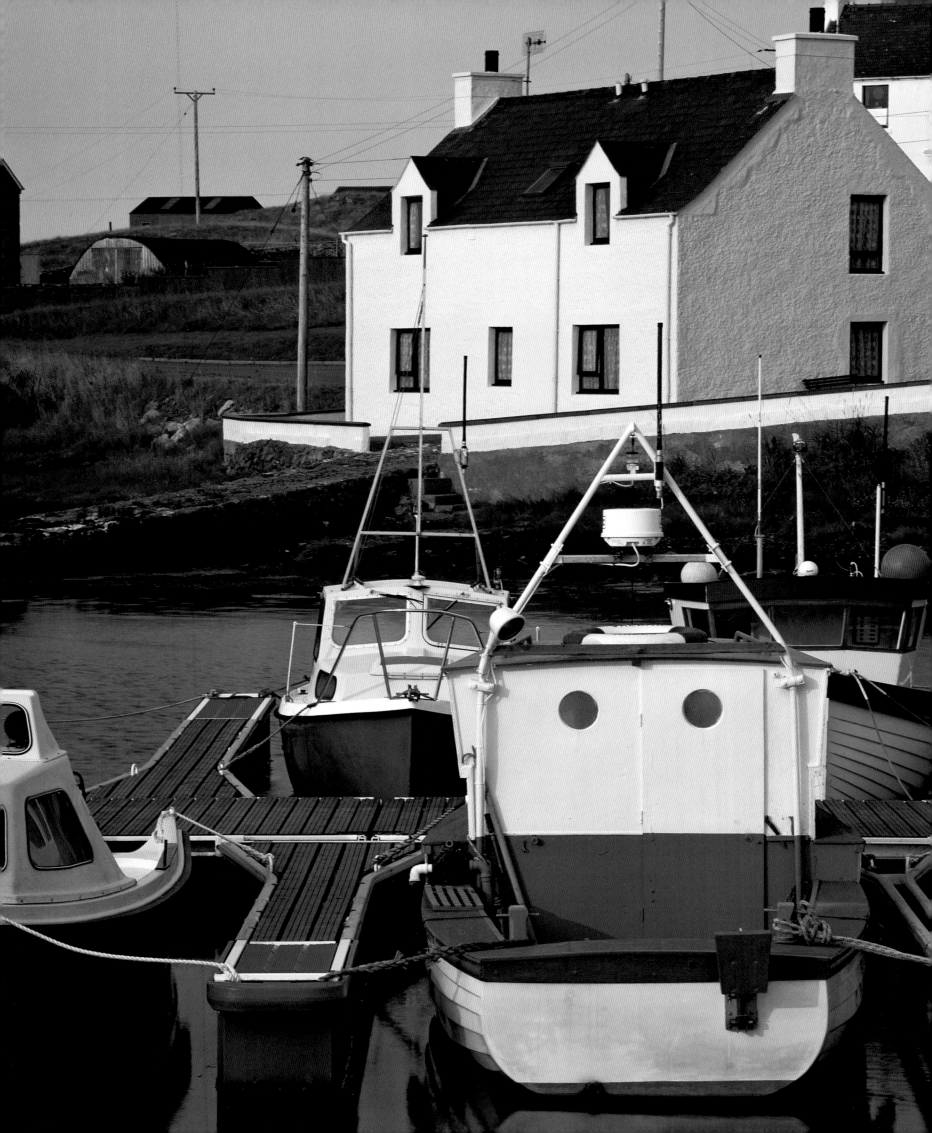

TRAVELLERS' GUIDE

Eating In Scotland

'OF THE PROVISIONS THE NEGATIVE CATALOGUE WAS VERY COPIOUS,' recorded Dr. Johnson on arriving 'weary and peevish' at the end of a long day in the saddle. 'Here was no meat, no milk, no bread, no eggs, no wine.' Today's traveller need not be anxious on the same account. The Scots themselves take great pleasure at the table, and love providing for their guests. The tradition of hearty food, and plenty of it, which has historically sustained the Scots in an often unforgiving climate, is well suited to the appetites of those visitors who come to Scotland to enjoy the great outdoors.

Quality abounds as well as quantity. Many of Scotland's homegrown specialities are justly famous, and seen on delicatessen counters the world over. Travelling gourmets will find no exception here to the rule that it is always worth paying a visit to the source, to sample national delicacies *in situ*. Tender Aberdeen Angus beef, spring lamb, venison and grouse in season, oysters and freshly caught fish on the coast – such wonderful ingredients are complemented by the inventive skills of a new generation of chefs, who can be found in even the wildest, most out-of-the-way corners of Scotland. It is not only foods that depend on their freshness that seem to taste better here; the artful skill of smoking fish is very much alive, with local variations all round the coast, using salmon, trout, herring (for kippers) and haddock (the famous 'Arbroath Smokie'). The traditional staples, oats and barley, are still much in use, oats finding their way into the famous haggis, in which they are used as a binding agent, and on a more everyday basis, presented as a bowl of steaming porridge. This most excellent breakfast dish has a miraculous central-heating effect, capable of fuelling the most ambitious fell-walker, especially with the prospect of a warming dram of whisky when the day is through.

SHETLAND

Walls
Lerwick

ORKNEY

Kirkwall
St. Margaret's Hope

Tongue

Lochinver

LEWIS

HARRIS

Rodel

Dornoch

Staffin

Strathpeffer Cromarty

OUTER HEBRIDES

Dunvegan
Portree

SKYE Plockton

Inverness

Don

Aberdeen

Ballater

Edzell

Tobermory

Fortingall

Auchmithie

MULL

Baile Mór Oban

Tay

Dundee

Earn

Crinan

Luss

Dollar
Culross North Berwick

JURA

Forth

Dean Village Edinburgh
Straiton St. Abbs

Glasgow

Clyde

ISLAY

Eaglesham West Linton Stow
New Lanark

Lochranza

Yarrow

ARRAN

Denholm

Moniaive

Canonbie

Gatehouse of Fleet

Portpatrick

50 miles

50 100 km

A modern whisky distillery, recently established on Arran for the production of single-malts.

USEFUL INFORMATION

While every effort has been made to ensure that the information given in the following entries is correct, the author and the publisher cannot be held responsible for any inadvertent inaccuracies.

LOWLANDS

Canonbie DUMFRIESSHIRE

WHERE TO STAY
Cross Keys Hotel; Canonbie DG14 0SY; tel. 013873 71382.
Miss G. Matthews; Four Oaks, Canonbie DG14 0TF; tel. 013873 71329; bed and breakfast.
North Lodge Guest House; Canonbie DG14 0TF; tel. 013873 71409.
WHERE TO EAT
Cross Keys Hotel; Canonbie DG14 0SY; tel. 013873 71382.
INFORMATION
Tourist Information Centre; Gretna Green DG16 5EA; tel. 01461 337834.

Culross FIFE

WHERE TO STAY
Davaar House Hotel; 126 Grieve Street, Dunfermline KY12 8DW; tel. 01383 721886.
St. Mungo's Cottage; Low Causeway, Culross KY12 8HJ; tel. 01383 882102; bed and breakfast.
WHERE TO EAT
The Red Lion Inn; Low Causeway, Culross KY12 8HN; tel. 01383 880225.

INFORMATION
National Trust for Scotland; West Green House, Culross KY12 8JH; tel. 01383 880359.
Tourist Information Centre; 13-15 Maygate, Dunfermline KY12 7NE; tel. 01383 720999.

Dean Village MIDLOTHIAN

WHERE TO STAY
Ballarat Guest House; 14 Gilmore Place, Edinburgh EH3 9NQ; tel. 0131 229 7024.
The Bonham Hotel; 35 Drumsheugh Gardens, Edinburgh EH3 7RN; tel. 0870 7433682.
Mrs L. Collie; 37 Howe Street, Edinburgh EH3 6TF; tel. 0131 557 3487; bed and breakfast.
Melvin House Hotel; 3 Rothesay Terrace, Edinburgh EH3 7RY; tel. 0131 225 5084.
WHERE TO EAT
Café Royal Oyster Bar; 17A West Register Street, Edinburgh EH2 2AA; tel. 0131 556 4124.
A Room in the Town; 18 Howe Street, Edinburgh EH3 6TG; tel. 0131 225 8204.
INFORMATION
Tourist Information Centre; 3 Princes Street, Edinburgh EH2 2QP; tel. 0131 473 3800.

Denholm ROXBURGHSHIRE

WHERE TO STAY
The Auld Cross Keys Inn; The Green, Denholm TD9 8NU; tel. 01450 870305.
Fox and Hounds Inn; Main Street, Denholm TD9 8NU; tel. 01450 870247.
WHERE TO EAT
The Auld Bakery; Westside, Denholm TD9 8LX.
INFORMATION
Tourist Information Centre; 1 Tower Knowe, Hawick TD9 9EN; tel. 0870 608 0404.

Dollar CLACKMANNANSHIRE

WHERE TO STAY
Castle Campbell Hotel; Bridge Street, Dollar FK14 7DE; tel. 01259 742519.
Strathallan Hotel; 6 Chapel Place, Dollar FK14 7DW; tel. 01259 742205.
WHERE TO EAT
King's Seat; 23 Bridge Street, Dollar FK14 7DE; tel. 01259 742515.
INFORMATION
Dollar Museum; Castle Campbell Hall, 1 High Street, Dollar FK14 7AY; tel. 01259 742895; weekends only.
Mill Trail Visitors Centre; Glentana Mill, West Stirling Street, Alva FK12 5EN; tel. 01259 769696.

Eaglesham RENFREWSHIRE

WHERE TO STAY
Mrs F. Allison; New Borland, Glasgow Road, Eaglesham G76 0DN; tel. 01355 302051; bed and breakfast.
Crosskeys Inn; 68 Main Street, Eaglesham G76 0AS; tel. 01355 302356.
WHERE TO EAT
The Hamlet Coffee Shop; 6 Glasgow Road, Eaglesham G76 0JQ; tel. 01355 302094.
The Pepper Pot Restaurant; 3 Montgomery Street, Eaglesham G76 0AS; tel. 01355 302002.
INFORMATION
Tourist Information Centre; 9a Gilmour Street, Paisley PA1 1DD; tel. 0141 889 0711.

Gatehouse of Fleet KIRKCUDBRIGHTSHIRE

WHERE TO STAY
The Bobbin Guest House; 36 High Street, Gatehouse of Fleet DG7 2HP; tel. 01557 814229.
Jean Clements; 48 Catherine Street, Gatehouse of Fleet DG7 2JB; tel. 01557 814826; bed and breakfast.
Murray Arms Hotel; Ann Street, Gatehouse of Fleet DG7 2HY; tel. 01557 814207.
WHERE TO EAT
The Masonic Arms; Ann Street, Gatehouse of Fleet DG7 2HU; tel. 01557 814335.
INFORMATION
Tourist Information Centre; Car Park, High Street, Gatehouse of Fleet DG7 2HP; tel. 01557 814212.

Moniaive DUMFRIESSHIRE

WHERE TO STAY
Craigdarroch Arms Hotel; 7 High Street, Moniaive DG3 4HN; tel. 01848 200205.
Woodlea Hotel; Moniaive DG3 4EN; tel. 01848 200209.
WHERE TO EAT
The Green Tea House; Chapel Street, Moniaive DG3 4EJ; tel. 01848 200131.
INFORMATION
Tourist Information Centre; 64 Whitesands, Dumfries, DG1 2RS; tel. 01387 245550.

New Lanark LANARKSHIRE

WHERE TO STAY
New Lanark Mill Hotel; Mill One, New Lanark ML11 9DB; tel. 01555 667200.
WHERE TO EAT
The Courtyard Restaurant; 3 Castlegate, Lanark ML11 9DZ; tel. 01555 663900.

The Mill Pantry; New Lanark ML11 9DB.
INFORMATION
Tourist Information Centre; Horsemarket, Ladyacre Road, Lanark ML11 7LQ; tel. 01555 661661.
Visitor Centre; New Lanark, ML11 9DB; tel. 01555 661345.

North Berwick EAST LOTHIAN

WHERE TO STAY
The Marine Hotel; Cromwell Road, North Berwick EH39 4LZ; tel. 0870 400 8129.
Tantallon House; 2 West Bay Road, North Berwick EH39 4AW; tel. 01620 892873; bed and breakfast.
WHERE TO EAT
The George Café; 118-120 High Street, North Berwick EH39 4HA; tel. 01620 892635.
The Grange; 35 High Street, North Berwick EH39 4HH; tel. 01620 893344.
INFORMATION
Tourist Information Centre; 1 Quality Street, North Berwick EH39 4HJ; tel. 01620 892197.

Portpatrick WIGTOWNSHIRE

WHERE TO STAY
Carlton Guest House; South Crescent, Portpatrick DG9 8JR; tel. 01776 810253.
Downshire Arms Hotel; Main Street, Portpatrick DG9 8JJ; tel. 01776 810300.

*B*arley – the raw material of the national drink.

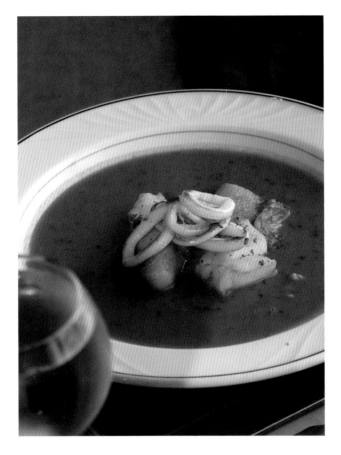

Fine cuisine can now be found in all parts of the Scottish mainland and islands.

Portpatrick Hotel, Heugh Road,
 Portpatrick DG9 8TQ; tel. 01776 810333.
WHERE TO EAT
Campbell's Restaurant,
 1 South Crescent, Portpatrick DG9 7JR;
 tel. 01776 810314.
Crown Hotel, 9 North Crescent,
 Portpatrick DG9 8SX; tel. 01776 810261.
INFORMATION
Tourist Information Centre;
 28 Harbour Street, Stranraer DG9 7RA;
 tel. 01776 702595.

St. Abbs BERWICKSHIRE

WHERE TO STAY
Castle Rock Guest House,
 Murrayfield, St. Abbs TD14 5PP;
 tel. 01890 771715.
Springbank Cottage, The Harbour, St. Abbs
 TD14 5PW; tel. 01890 771477; bed and
 breakfast.
WHERE TO EAT
The Anchor, School Road, Coldingham TD14
 5NS; tel. 01890 771243.
The Old Smiddy, Northfield Farm, St. Abbs
 TD14 5QF; tel. 01890 771707.
INFORMATION
Tourist Information Centre; Auld Kirk,
 Mansfield Road, Eyemouth TD14 5HE;
 tel. 01890 750678.

Stow MIDLOTHIAN

WHERE TO STAY
Killochyett, 5 Craigend Road, Stow TD1 2RJ;
 tel. 01578 730323; bed and breakfast.
White Swan Hotel, Earlston TD4 6DE;
 tel. 01896 848249.
WHERE TO EAT
The Ginger Jar Café, Edinburgh Road,
 Galashiels TD1 2EY; tel. 01896 757525.
INFORMATION
Tourist Information Centre; 3 St John Street,
 Galashiels TD1 3JX; tel. 0870 608 0404.

Straiton AYRSHIRE

WHERE TO STAY
Black Bull Hotel, 21 Main Street, Straiton
 KA19 7NF; tel. 01655 770240.
Drumellan Country House, Drumellan,
 Maybole KA19 7JG; tel. 01655 882279;
 bed and breakfast.
WHERE TO EAT
Jock's Restaurant, Patna Road, Kirkmichael
 KA19 7PJ; tel. 01655 750499.
INFORMATION
Tourist Information Centre; 22 Sandgate,
 Ayr KA7 1BW; tel. 01292 678100.

West Linton PEEBLESSHIRE

WHERE TO STAY
Linton Hotel, Main Street, West Linton
 EH46 7EA; tel. 01968 660228.
Mrs J. Muir, Jerviswood, Linton Bank Drive
 West Linton EH46 7DT; tel. 01968
 660429; bed and breakfast.
Mrs M. Thain, 4 Robinsland Drive,
 West Linton EH46 7JD; tel. 01968 661798;
 bed and breakfast.
WHERE TO EAT
Garrads, Main Street, West Linton EH46 7EA;
 tel. 01968 660830.
INFORMATION
Tourist Information Centre; High Street,
 Peebles EH45 8AG; tel. 0870 608 0404.

Yarrow SELKIRKSHIRE

WHERE TO STAY
Gordon Arms Hotel, Yarrow Valley TD7 5LE;
 tel. 01750 82222.
St. Mary's House, Yarrow Feus, Selkirk TD7
 5NE; tel. 01750 82287; bed and breakfast.
Tibbie Shiels Inn, St. Mary's Loch, Yarrow
 Valley TD7 5LH; tel. 01750 42231.
WHERE TO EAT
The Coach House, 51 Ettrick Terrace,
 Selkirk TD7 4JS; 01750 20696.

The Cross Keys Inn; Ettrickbridge,
 Selkirk TD7 5JN; tel. 01750 52224.
INFORMATION
Tourist Information Centre; Halliwell's
 House, Market Place, Selkirk TD7 4BL;
 tel. 01750 20054.

HIGHLANDS

Auchmithie ANGUS

WHERE TO STAY
Harbour House Guest House, 4 Shore Road,
 Arbroath DD11 1PB; tel. 01241 878047.
Rosely Country House Hotel, Forfar Road,
 Arbroath DD11 3RB; tel. 01241 876828.
WHERE TO EAT
But 'n' Ben; Auchmithie DD11 5SQ;
 tel. 01241 877223; closed Tuesdays.
INFORMATION
Tourist Information Centre; Market Place,
 Arbroath DD11 1HR; tel. 01241 872609.

Ballater ABERDEENSHIRE

WHERE TO STAY
The Belvedere, Station Square, Ballater
 AB35 5QB; tel. 013397 55996.
Inverdeen House, 11 Bridge Square, Ballater
 AB35 5QJ; tel. 013397 55759; bed and breakfast.
Monaltrie Hotel, 5 Bridge Square,
 Ballater AB35 5QJ; tel. 013397 55417.
WHERE TO EAT
The Green Inn, 9 Victoria Road,
 Ballater AB35 5QQ; tel. 013397 55701.
INFORMATION
Tourist Information Centre; Station Square,
 Ballater AB35 5RB; tel. 013397 55306.

A traditional Scottish breakfast
of porridge.

Crinan ARGYLLSHIRE

WHERE TO STAY
Crinan Hotel, Crinan PA31 8SR;
 tel. 01546 830261.
Tigh Na Glaic, Crinan, PA31 8SW;
 tel. 01546 830245; bed and breakfast.
WHERE TO EAT
Crinan Hotel, Crinan PA31 8SR;
 tel. 01546 830261.
INFORMATION
Tourist Information Centre; Lochnell Street,
 Lochgilphead PA31 8JL; tel. 01546 602344.

Cromarty ROSS AND CROMARTY

WHERE TO STAY
Mrs Robertson, 7 Church Street, Cromarty
 IV11 8XA; tel. 01381 600 488; bed and
 breakfast.
Royal Hotel, Marine Terrace, Cromarty
 IV11 8YN; tel. 01381 600217.
WHERE TO EAT
The Cromarty Gallery, 20 Church Street,
 Cromarty IV11 8XA; tel. 01381 600816;
 tea shop.
Thistles Restaurant, 20 Church Street,
 Cromarty IV11 8XA; tel. 01381 600471.
INFORMATION
Cromarty Courthouse Museum;
 Church Street, Cromarty IV11 8XA;
 tel. 01381 600418.

Dornoch SUTHERLAND

WHERE TO STAY
Dornoch Castle Hotel, Castle Street,
 Dornoch IV25 3SD; tel. 01862 810216.
Trevose Guest House, Cathedral Square,
 Dornoch IV25 3SD; tel. 01862 810269;
 bed and breakfast.
WHERE TO EAT
Cathedral Café, 2 High Street, Dornoch
 IV25 3SH; tel. 01862 810119.
2 Quail Restaurant, Castle Street, Dornoch
 IV25 3SN; tel. 01862 811811.
INFORMATION
Tourist Information Centre; The Post Office,
 The Square, Dornoch IV25 3SD;
 tel. 01862 810400.

Fortingall PERTHSHIRE

WHERE TO STAY
Fortingall Hotel, Fortingall PH15 2NQ;
 tel. 01887 830367.
Kinnighallen Farm; Duneaves Road,
 Fortingall PH15 2LR; tel. 01887 830619;
 bed and breakfast.

WHERE TO EAT
Ailean Chraggan, Weem, by Aberfeldy
PH15 2LD; tel. 01887 820346.
INFORMATION
Tourist Information Centre; The Square,
Aberfeldy PH15 2DD; tel. 01887 820276.

Lochinver SUTHERLAND

WHERE TO STAY
The Albannach Hotel, Baddidarroch,
Lochinver IV27 4LP; tel. 01571 844407.
Mrs J. G. McBain, Davar, Lochinver IV27 4LS;
tel. 01571 844501; bed and breakfast.
WHERE TO EAT
Larder Riverside Bistro; Main Street,
Lochinver IV27 4JY; tel. 01571 844356.
INFORMATION
Assynt Visitor Centre; Main Street,
Lochinver IV27 4LX; tel. 01571 844330.

Luss DUNBARTONSHIRE

WHERE TO STAY
The Lodge on Loch Lomond, Luss G83 8PA;
tel. 01436 860201.
Shantron Farm; nr. Luss G83 8RH;
tel. 01389 850231; bed and breakfast.
WHERE TO EAT
Inverbeg Inn; Luss G83 8PD; tel. 01436 860678.
INFORMATION
Luss Visitor Centre; Luss; tel. 01301 702285.

*O*nce part of the staple diet
on both east and west coasts,
mussels have acquired an enhanced
status in the preparations of a new
generation of Scottish chefs.

Plockton ROSS AND CROMARTY

WHERE TO STAY
The Haven Hotel; Innes Street, Plockton
IV52 8TW; tel. 01599 544 223.

Seabank; 6 Bank Street, Plockton IV52 8TP;
tel. 01599 544221; bed and breakfast.
WHERE TO EAT
The Haven Hotel; Innes Street, Plockton
IV52 8TW; tel. 01599 544223.
The Plockton Hotel; Harbour Street,
Plockton IV52 8TN; tel. 01599 544274.
INFORMATION
Tourist Information Centre; Car Park,
Kyle of Lochalsh; tel. 01599 534276.

Strathpeffer ROSS AND CROMARTY

WHERE TO STAY
Brunstane Lodge Hotel; Golf Course
Road, Strathpeffer IV14 9AT;
tel. 01997 421261.
Craigvar; The Square, Strathpeffer IV14 9DL;
tel. 01997 421622; bed and breakfast.
WHERE TO EAT
Museum Coffee Shop; The Old Station,
Strathpeffer IV14 9DH; tel. 01997 421136.
INFORMATION
Tourist Information Centre; Main Square,
Strathpeffer; tel. 01997 421415.

Tongue SUTHERLAND

WHERE TO STAY
Ben Loyal Hotel; Tongue IV27 4XE;
tel. 01847 611216.
Rhian Cottage Guest House; Tongue IV27 4XJ;
tel. 01847 611257.
Tongue Hotel; Tongue IV27 4XD;
tel. 01847 611206.
WHERE TO EAT
Ben Loyal Hotel; Tongue IV27 4XE;
tel. 01847 611216.
Tongue Hotel; Tongue IV27 4XD;
tel. 01847 611206.
INFORMATION
Tourist Information Centre; Sangomore,
Durness IV27 4PZ; tel. 01971 511259

ISLANDS

Baile Mór IONA

WHERE TO STAY
Argyll Hotel; Baile Mór PA76 6SJ;
tel. 01681 700334.
Iona Cottage; Baile Mór PA76 6SJ;
tel. 01681 700569; bed and breakfast.
WHERE TO EAT
Iona Heritage Centre Coffee Shop;
Isle of Iona PA76 6SJ; tel. 01681 700439.
The Martyrs' Bay; Isle of Iona PA76 6SW;
tel. 01681 700382.

INFORMATION
Tourist Information Centre; Main Street,
Tobermory PA75 6NU; tel. 01688 302182.

Dunvegan SKYE

WHERE TO STAY
Atholl House Hotel; Dunvegan IV55 8WA;
tel. 01470 521219.
Roskhill House, Roskhill, Dunvegan IV55
8ZD; tel. 01470 521317; guest house.
WHERE TO EAT
Lochbay Seafood Restaurant; Stein,
Waternish IV55 8GA; tel. 01470 592235.
The Three Chimneys Restaurant; Colbost,
Dunvegan IV55 8ZT; tel. 01470 511258.
INFORMATION
Tourist Information Centre; 2 Lochside,
Dunvegan IV55 8WB; tel. 01470 521581.

Lochranza ARRAN

WHERE TO STAY
Apple Lodge; Lochranza, Isle of Arran
KA27 8HJ; tel. 01770 830229; guest house.
Catacol Bay Hotel; Catacol KA27 8HN;
tel. 01770 830231.
Vicki Hudson; Castlekirk, Lochranza
KA27 8HL; tel. 01770 830202.
WHERE TO EAT
Harold's Restaurant; Arran Distillery,
Shore Road, Lochranza KA27 8HJ;
tel. 01770 830264.
INFORMATION
Tourist Information Centre; The Pier,
Brodick KA27 8BB; tel. 01770 302140.

Rodel HARRIS

WHERE TO STAY
Caberfeidh House; Leverburgh HS5 3TL;
tel. 01859 520276; guest house.
Rodel Hotel; Rodel HS5 3TW; tel. 01859
520210.
WHERE TO EAT
An Clachan Tea Shop; Leverburgh HS5 3TS;
tel. 01859 520370.
Scarista House; Sgarasta Bheag HS3 3HX;
tel. 01859 550238.
INFORMATION
Tourist Information Centre; Harbour Street,
Tarbert PA29 6UD; tel. 01880 820429.

St. Margaret's Hope ORKNEY

WHERE TO STAY
Bellevue Guest House; St. Margaret's Hope
KW17 2TL; tel. 01856 831294.

The Murray Arms Hotel; Back Road,
St. Margaret's Hope KW17 2SP;
tel. 01856 831205.
WHERE TO EAT
The Creel Restaurant; Front Road,
St. Margaret's Hope KW17 2SL;
tel. 01856 831311.
INFORMATION
Tourist Information Centre; 6 Broad Street,
Kirkwall KW15 1NX; tel. 01856 872856.

Staffin SKYE

WHERE TO STAY
Flodigarry Country House Hotel; Staffin
IV51 9HZ; tel. 01470 552203.
The Old Schoolhouse; Staffin IV51 9JX;
tel. 01470 562256; bed and breakfast.
WHERE TO EAT
Glenview Hotel; Culnacnock, Staffin IV51 9JH;
tel. 01470 562248.
INFORMATION
Tourist Information Centre; Bayfield House,
Bayfield Road, Portree IV51 9EL;
tel. 01478 612137.

Tobermory MULL

WHERE TO STAY
Strongarbh House; Tobermory PA75 6PR;
tel. 01688 302328; guest house.
Thornliebank; Argyll Terrace,
Tobermory PA75 6PB; tel. 01688 302551;
bed and breakfast.
Western Isles Hotel; Tobermory PA75 6PR;
tel. 01688 302012.
WHERE TO EAT
Mishnish Hotel; Tobermory PA75 6NU;
tel. 01688 302009.
INFORMATION
Tourist Information Centre; Main Street,
Tobermory PA75 6NU; tel. 01688 302182.

Walls SHETLAND

WHERE TO STAY
Burrastow House; Walls ZE2 9PD;
tel. 01595 809307.
Mrs C. Jamieson; Skeoverick, Brunatwatt,
Walls; tel. 01595 809349; bed and
breakfast.
WHERE TO EAT
Burrastow House; Walls ZE2 9PD;
tel. 01595 809307.
INFORMATION
Tourist Information Centre; Market Cross,
Lerwick ZE1 0LU; tel. 11595 693434.

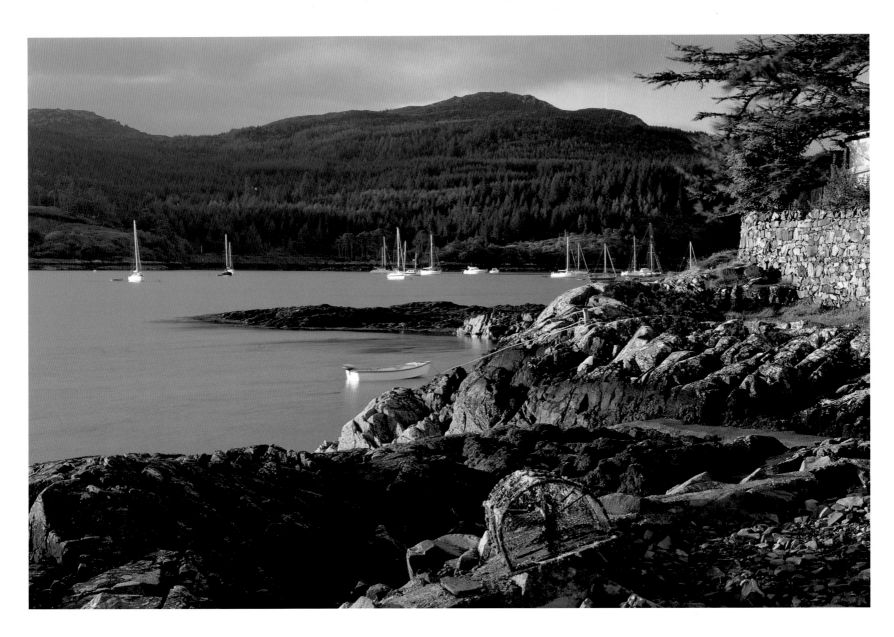

Quintessential Scottish coastal village: the harbour at Plockton, Ross and Cromarty.

FURTHER READING

Humphreys, Rob, Reid, Donald and Tarrant, Paul,
 The Rough Guide to Scotland, London, 2000.

Johnson, Samuel, *A Journey to the Western Islands of Scotland*, London, 1775.

Maclean, Fitzroy, *Scotland: A Concise History*, London, 1981.

Magnusson, Magnus, *Scotland: The Story of a Nation*, London, 2000.

Miers, Richenda, *Scotland*, London, 1987.

Miller, Hugh and Robertson, James, ed.,
 Scenes and Legends of the North of Scotland, Edinburgh, 1994.

Prebble, John, *The Highland Clearances*, London, 1963.